BOWMAN LIBRAT

MENLO SCHOOL AND

Gift of

The John W. Bowman Family

in memory of

Timothy Dillon Bowman

The Meeting of EASTERN AND WESTERN ART

An employed mit.

ANTITES.

EST STATES THE

The Meeting of

EASTERN AND WESTERN ART

From the Sixteenth Century to the Present Day

MICHAEL SULLIVAN

with 159 illustrations
12 in colour

New York Graphic Society Ltd

Acknowledgments

One of the pleasures of authorship is the contacts it brings with people who share one's interests and enthusiasms. In the writing of this book, I am happy to acknowledge the help I have had from old friends and new, from colleagues, students, collectors and many others who have been fascinated by one aspect or another of the East–West confrontation in art, and in various ways have helped me to bring this diverse material together.

Among those to whom I am especially grateful are Madeleine Barbin of the Bibliothèque Nationale; Chiang Fu-tsung, Chuang Yen and Marshall Wu of the National Palace Museum, Taipei; Kurata Bunsaku of the National Museum, Tōkyō; Homma Masayoshi of the National Museum of Modern Art, Tōkyō; Fujio Naruse of the Museum Yamato Bunkakan, Nara; Orimo Yasuo of the Kōbe Municipal Museum of Namban Art; Alan Fern and K. T. Wu of the Library of Congress; Philip Stern and Thomas Lawton of the Freer Gallery, Washington; Graham Reynolds and R. W. Lightbown of the Victoria and Albert Museum, London; Chandler Kirwin; and Max Loehr at Harvard.

Information and suggestions have also been most kindly given to me by John Addis, Edith Dittrich, George Loehr, Fang Chao-ying, Richard Barnhart, Laurence Sickman, Roderick Whitfield, the late Rudolf Wittkower, Tadashi Sugase, and members of my graduate seminar at Stanford, especially Mayching Kao. I should also like to express my gratitude to all the individual collectors and museum directors who have permitted pictures in their collections to be reproduced. Without their kind help this book could never have appeared.

The manuscript has been read by F. E. McWilliam, to whom I am indebted for some valuable comments and suggestions in the parts dealing with modern Western art, and by Donald Davie, who at some critical points in the text helped me to express what I wanted to say with far more clarity and grace than I myself could command.

Once again, Carmen Christensen has spent many devoted hours in typing the final draft, and I am happy to acknowledge the help that she and her husband Allen have given me towards the writing of this book, and towards other activities connected with the study of Oriental art at Stanford.

I should like to thank Michael Graham-Dixon, Elizabeth Clarke, Alan Wilbur and Jean Ellsmoor for the thought and care they have given to the production of the book.

My research has also been aided by grants from the Carnegie Foundation and from the Center for East Asian Studies at

Stanford, to which my thanks are due.

Of the part played in this book by my wife I can give only a hint. Quite apart from the work she has put into every stage of its making, this is, in a very special sense, her book. Not only has she opened doors and built bridges for me everywhere, but in our often strenuous discussions of her civilization and mine, her own experience, understanding, and depth of feeling have helped me to see the meeting of East and West not as a conflict. or even as a reconciliation, of opposites, but as a dynamic and truly life-enhancing dialectic. Seldom can an author have been so blessed.

Stanford, M. S. April 1972

Some Important Dates in Far Eastern History since 1500

1557	The Portuguese established in Macao
	The Jesuits admitted to China
1601	Arrival of Matteo Ricci in Peking
1644	Fall of Ming Dynasty and establishment of Ch'ing Dynasty
1662-1722	K'ang-hsi emperor
	Yung-cheng emperor
	Ch'ien-lung emperor
1860	Second Opium War, and sacking of
	Summer Palace, Yüan-ming-yüan
1911-12	Fall of Manchus and establishment of
1 12 700	Republic
1937-45	Sino-Japanese War
1949	Establishment of the Chinese People's Republic
	en in the expression of them had been an age. The been
1542	Discovery of Japan by the Portuguese
1603	Establishment of the Tokugawa Shōgunate
1639	Expulsion of the Portuguese
1641	Establishment of Dutch trading station on
	Deshima
1867–8	Fall of Tokugawa Shōgunate and restora-
	tion of Emperor; inauguration of Meiji
	Period
1912-24	Taishō Period
1924-	Shōwa Period
	1644 1662-1722 1723-36 1736-96 1860 1911-12 1937-45 1949 1542 1603 1639 1641 1867-8

Introduction

I feel that I owe it to the reader to explain the scope of this book, why it covers the ground it does, and in particular why it does not deal with the interaction between the West on the one hand and India and the Islamic world on the other, but only with the West and the Far East. It is not that the Indian and Islamic influences are not important. On the contrary, the influence of the Near East on the art of Europe in classical and mediaeval times was enormous, while Europe and America have had a profound effect on the art of southern and western Asia, particularly in the twentieth century. Since the sixteenth century Indian crafts have enriched European textiles, while a few Western artists, notably Rodin, Gauguin and Epstein, have admired and understood Indian sculpture. Moreover, the breaking down of traditional religious and philosophical prejudices has made people in the West, and particularly the younger generation, receptive as never before to Indian ideals, and to the expression of these ideals in art. Every pad has its mandala.

But to have included these areas would have made the book much too long, and could have blurred the picture I am attempting to give. A great deal has been written recently on cultural interaction between Europe and Asia, and even in some of the most scholarly books the reader is left wondering just what part of Asia the writer is dealing with. At one moment he speaks of Indian, or of Chinese, motifs in European textiles, at another of Islamic elements in mediaeval architecture or early Renaissance painting. 'Oriental influence' can mean, in fact, just what the writer wishes it to mean at the moment. It may be that to sixteenth-century Europe 'Indian' often meant Chinese', and 'Oriental' anything non-European from Morocco to Japan, but we can afford to be a little more precise.

To have embraced the whole of Asia and the Islamic world, moreover, would have shifted the balance of the book from what used to be called 'fine art', and particularly painting, to archaeology and the decorative arts. My concern is with artistic influences at the higher creative levels. Here, the interaction between the West and the Far East, though intermittent and fraught with misunderstandings, has been no mere matter of motifs and techniques. It has significantly altered and enlarged

the vision of artists, and sometimes of their public as well. At this level, the protagonists have not merely borrowed ornamental motifs from each other; they have been at least partly aware of each others' aims and aesthetic ideals. Chinese scholars and Japanese painters wrote from time to time very discerningly about European art, comparing it with their own; and if Europeans were less discerning about the art of China, they were nevertheless continually conscious of it as a manifestation of the great civilization they admired for other reasons, and they took from it what they could use. In fact, as any study of eighteenth-century European taste must show, they were more deeply affected than they realized, while in the nineteenth century, Japanese influence was of crucial importance. This is much more than can be said of the interaction between Europe and the Indian subcontinent, where European art merely had the effect of corrupting a great tradition without enriching it. Today, that dialogue is just beginning, but it is still chiefly in the sphere of music and the dance that contact between the West and India has been made, and a vital spark struck. For the visual and plastic arts a really fruitful cross-fertilization has vet to come.

This may suggest that I believe that the interaction between one civilization and another, or indeed between one artist and another, must produce 'better' art than either would achieve alone. I do not believe this, and would insist that in making value judgments it is only the aesthetic quality of the work of art itself that matters. In the final analysis, it is the dialogue of the painter with his medium, not of one painter with another painter, that determines whether he paints a good picture or not, however much his own talent may have been stimulated by the influences to which he is subjected. The historian, however, is concerned not only with the quality of human action in itself, but also with its results. He must often deal with works of art which are not in themselves of high quality, but which by the very fact that they were produced help us to understand history and the pattern of our cultural life.

I have been influenced too by the fact that the mid-twentieth century has seen the almost simultaneous appearance in East and West of the phenomenon of Abstract Expressionism and Action Painting. We need not worry too much about definitions; it is enough to say that the movement that links East and West is non-figurative and based on the dynamic or calligraphic gesture, whether the hand that makes the gesture holds a brush

or a dripping paint-can: it includes Pollock, Soulages, Kline, for example, and sometimes Tobey and de Kooning, but not Rothko, Dubuffet or Appel. The break-through achieved by the New York School, immediately followed by the rediscovery by Chinese and Japanese painters of the Abstract Expressionist elements in their own tradition, provided a dramatic climax to this dialogue. Now, suddenly, they seemed to be speaking the same language, or at least to be listening to each other. Whether this was a momentary, or a purely illusory, meeting of minds, or whether it is the beginning of a deeper understanding, no one would dare to predict. But it puts the dialogue of the last four centuries in a special relationship with the present.

I will have relatively little to say in this book about chinoiserie. Not only has the story been well and often told, but it is clear that chinoiserie has very little to do with China. The arrival of Chinese arts and crafts in the seventeenth century worked no transformation on French art; rather were the exotic imports themselves transformed, beyond recognition, into something entirely French. Chinoiserie is, more than anything else, a part of the language of Rococo ornament. Even Watteau, who certainly saw Chinese paintings, and claimed on occasion to be painting in the Chinese manner, merely played with pseudo-Chinese motifs in a decorative way. So far as we know, he never really examined a Chinese painting, still less thought about it. It was quite otherwise with the writers and philosophers of the Enlightenment, whose thinking was profoundly affected by their reading of the Chinese classics in translation. Yet Chinese aesthetic concepts did eventually come to influence eighteenthcentury European taste, though in a very indirect and subtle way, as we shall see.

What is most interesting about this particular phase of the East-West dialogue is not *chinoiserie* itself but the fact that China, in spite of the enthusiasm for things Chinese, had so little direct influence on the course of European art. Like the dog in the Sherlock Holmes story that did not bark, this non-event is significant for the light it throws on the way in which influences operate – or may fail to operate at times when it would seem that all the conditions for a fruitful interaction were present. I will have more to say about this at the end of the book.

The active dialogue between Western and Far Eastern art began after 1500. But for many centuries before that there had been occasional contacts – if we can call the transmission of a motif, a craft, or a technique across Asia 'contact' at all. Chinese silk, rewoven as transparent gauze in Syria, was sold in firstcentury Rome, whose citizens professed to be shocked by the sight of women clad in this diaphanous stuff, in which 'no woman', Pliny remarked, 'could swear she is not naked'. A Chinese bronze vessel of the fourth century BC, unearthed in Canterbury, had perhaps been brought there in Roman times. A typically Han Dynasty design, on a fragment of a thirdcentury fabric from Dura-Europos in Mesopotamia, is thought to be the earliest direct imitation of Chinese art in the West; and Chinese dragons adorn fourteenth-century church vestments woven in Lucca and Venice. Across the world, Roman artifacts have been excavated at the site of the ancient port at Oc-éo in Indochina; and with the introduction of Buddhism there came to the Far East, by way of Sasanian art, motifs, such as the acanthus scroll, which originated in the eastern Mediterranean world.

We could multiply these instances. But this book is not concerned with random contacts, interesting as they are, or with the appearance at one end of Asia of occasional objects or motifs that originated at the other, but with interaction between East and West as an active, generative force in art. The events that in a given period caused it may have taken place primarily within the world of art itself, as when the Impressionists, who knew and cared nothing for Japan, seized upon the Japanese colour print, introduced almost by accident. Or artistic influence may have been the by-product of political, economic, or religious pressure, such as that brought to bear on Japan by Portuguese imperialism in the sixteenth century. Whatever the initial cause, the result was that historically decisive stimulus and enrichment of the art of a nation, or of an individual painter, that we call 'influence'.

The 'Christian Century'

By 1549 several Portuguese ships had visited the shores of Japan, and Portuguese traders had been seen in the streets of Kyōto. In that year the great Jesuit missionary Francis Xavier, bringing with him a painting of the Annunciation, and another of the Virgin and Child, landed at Kagoshima and preached to an audience of feudal lords, Daimyō, who, after two centuries of a rigidly-enforced closed-door policy, were avid for foreign contacts and trade. There were no immediate results of Francis Xavier's brief visit – he left in 1552 – but by 1568 the Portuguese Jesuits were firmly established in the favour of the Shōgun Nobunaga. He and his successors, unable to consort with their vassals on equal terms, welcomed the missionaries as socially acceptable and intellectually stimulating company, and for forty years Christianity prospered under their protection.

But when the Japanese authorities began to observe the bitter rivalry between the Franciscans and the Dominicans, and to read the dire lesson of the Spanish conquest of the Philippines, their attitude began to change. By the time Ieyasu became Shōgun in 1598 the foreigners were openly quarrelling among themselves, and denouncing each others' motives to the government. Within a few years the authorities had decided that any benefit to be derived from foreign trade was not worth the risk of further Western penetration. When Hidetada succeeded to the Shōgunate a brutal persecution was begun. Japanese were forbidden to profess the Christian faith on pain of death, and churches were torn down. Christianity lived on, however, though driven partly underground, and was not wholly suppressed even when, in 1638, the Shogun Iemitsu slaughtered over twenty thousand peasants, many of them Christians, who had rebelled and seized the castle of Shimabara. For our story it is interesting to note that, of the handful of survivors, one was a certain Emosaku, who had become a skilled painter in oils under the instruction of the Jesuits.

In 1638 Japan slammed the door to the outside world. Japanese were forbidden to leave the country or to build oceangoing vessels. All foreigners were expelled, except for the Dutch, who were little feared, for their eastward expansion had

been confined to the Indies. In 1641 the handful of Dutch traders was herded into the artificial island of Deshima, forbidden to step beyond it except when the Factor paid his annual visit to the Shōgun. For the next two hundred years this tiny parcel of reclaimed land in Nagasaki harbour remained Japan's only link with the outside world.

Although the heyday of the Catholic missionaries in Japan was short – the persecution had begun long before 1638, and the term 'the Christian century' for the period 1542–1638 is somewhat of an exaggeration – it was long enough for the Jesuit seminaries at Nagasaki, Arima, Amakusa and elsewhere to become centres for the copying of European devotional paintings and sculpture. The surviving products of these ateliers have been exhaustively studied. Most of the paintings and images which they turned out were destroyed in the persecution, but enough has survived to show how quickly Japanese painters and craftsmen became adept at copying European art.

In about 1561 Queen Catherine of Portugal had sent a painting of the Virgin and Child as a present to Yukinaga, Daimyō of Uto, and in the same year another was sent from Portugal to Hirado in Kyūshu. In 1565 Father Luis Froes had Japanese goldsmiths make two retables for his chapel at Sakai near Ōsaka. This is probably the earliest recorded instance of Japanese craftsmen working in the European manner. Not all the originals came from Portugal, however. There is in the Imperial Household Museum, Tōkyō, a painting on copper of the Sacred Face, which had arrived in Japan by 1583, and is a facsimile (without the accessories) of a copy of the well-known work of Quentin Matsys in Antwerp.

As yet there were no European painters to instruct the Japanese, who did the best they could with local materials. But in 1583 the Italian Jesuit Giovanni Niccolo, or Nicolao (1560-?), who had been trained in Naples, arrived in Nagasaki from Macao. After two years' illness he established the Academy of St Luke in Nagasaki where he trained young Japanese converts in oil and fresco painting and engraving. In 1587 his principal work was a picture of Christ as Salvator Mundi which was sent to the Church in China. Perhaps this is the painting which the great scholar-missionary Matteo Ricci took with him to Peking and presented to the Emperor in 1601.

Nicolao had a number of Japanese pupils, among them Fr Leonardo Kimura, who became a painter, engraver and Latinist, and Fr Shiozuka (1577–1616), who was listed as painter, organist and choirmaster at Nagasaki. His Virgin and Child, painted when he was nineteen, drew the favourable notice of Bishop Pedro Martinez on his official visit in 1596. A crucifixion, possibly by Kimura, was thought good enough to be sent to Rome in 1595.

With the arrival of a printing press in 1590 Nicolao began to teach engraving, and a Jesuit father reported in the Annual Letter of 1594 that the students in eight of the seminaries were so engaged. He wrote: 'They have already engraved very naturally the pictures coming from Rome, of which many have been printed to the great pleasure and satisfaction of the Christians.' He also remarks that they were so competent that their work was indistinguishable from that of their Jesuit teacher – by no means the first, or the last, instance of the eager facility that this island race has shown in copying the latest thing from abroad.

Although the Jesuits summed up Nicolao as 'a man of less than medium intelligence', his influence, until his flight to Macao in 1614, must have been considerable. Not only did he train painters for the large Christian community in Japan, but two of his pupils, Fr Emanuel Pereira (1572–1630) and Fr Jacopo Niva (1579 to after 1635), were sent to China, where they were the first artists to instruct Chinese seminarians in European techniques. Of the earliest surviving Chinese works of art that show European influence – the plates in the monograph on ink sticks, Ch'eng-shih mo-yüan (1606), discussed on page 59 – one is almost certainly copied from an engraving made in Nicolao's atelier after a Flemish original.

After 1638 Christian art was destroyed or went underground. A few specimens survived, touching evidence of the heroism of their owners rather than of the artistic merit of their creators. But secular art, European in theme or technique, may have continued till the middle of the century; indeed, at Nagasaki it never completely died out. This kind of painting the Japanese called Namban, the art of the 'Southern Barbarians' – that is, the Portuguese. It was of two kinds. In one kind are Portuguese, and later Dutch, ships, with traders, soldiers and priests, generally depicted as arriving at Nagasaki and mingling with the natives. The foreigners are all immensely tall, with jutting noses, piercing blue eyes, and red hair; hence another name for this kind of painting is $k\bar{o}m\bar{o}$, 'red haired', a term applied particularly to the Dutch, and later used, by Chinese as well as Japanese,

for Europeans in general. These pictures, generally screens (Namban byōbu – 'Southern Barbarian screens'), were entirely Japanese in style and technique. Their stylised landscapes, gorgeous colours and gold-leaf backgrounds belong to the tradition of Momoyama Period screen painting and owe nothing to European art. The earliest were probably painted in about 1580; the last, forty years later.

Examples of the second type of Namban byōbu were copied from European originals. The Jesuits, anxious always to impress their hosts with the power and splendour of Europe, brought to Japan engravings of monarchs, battles (the defeat of the Turks at Lepanto is the theme of a famous Namban screen, Henry IV of France on horseback of another), and scenes of court and aristocratic life. Among the many sumptuous volumes in the Jesuits' libraries (discussed in more detail in the next chapter) was Ortelius' great atlas of the world, Teatrum Orbis Terrarum, published in Antwerp in 1579. The engravings at the back included two depicting the Pope and rulers and nobles of the Holy Roman Empire, which were used for figures on several Namban screens. Japanese artists were immensely resourceful not only in enlarging the designs from engravings and applying harmonious colours (perhaps taken from devotional oil paintings) but also in making a few figures go a long way: the same courtier or musician might be repeated not only in different screens but several times, with slight variations, in the same screen. The artists made discreet use of linear perspective and shading, techniques which they seem to have been reluctant to apply to Japanese subjects. To the more progressive Daimyō the Namban screens not only provided a sumptuous decoration for their mansions, but brought a breath of the outside world to their claustrophobic society.

Although after 1638 the interdiction on Christianity was ruthlessly enforced, some examples of Christian art survived, as has been mentioned above, hidden at great risk by the secret communities of converts. The most remarkable instance of this must be the painting of the Virgin which hung undetected on the altar of a Buddhist temple in Kyūshu, disguised as the goddess Kannon. Another is the pastoral screen in the Atami Art Museum which shows a landscape with shepherd and sheep (then unknown in Japan), with, to one side, what looks like a Buddhist monk, reading from a book. This is almost certainly a disguised allegory of Christ as the Good Shepherd.

This delightful screen has been attributed to Nobutaka, a

Christian painter who had studied under Nicolao at Arima before 1591. Little is known about his career, but several Namban screens with European subjects have been ascribed to him, such as the famous Fête Champêtre in the Hosokawa Collection, in which a group of young nobles is shown listening to two ladies playing the lute and harp, with a Flemish-looking village in the background, and galleons riding the waters of a broad bay. This can hardly be based on any single European work and was probably concocted from several different engravings.

A fellow-pupil with Nobutaka at Nicolao's academy in Arima (where he was known as Justus of Nagasaki) was Yamada Emosaku, whom we have already encountered as one of the few survivors of the Shimabara massacre in 1638. In 1615 he had entered the service of the Christian Daimyō of Shimabara, for whom he painted European-style pictures in oils on a monthly retainer. It is said that Lord Matsudaira, leader of the Shōgun's punitive force, spared him because of his well known talent and took him to Edo, where he put him to work virtually under house arrest. Emosaku continued to paint in the European manner, though he no longer treated Christian subjects, till the end of his long life in the 1650s.

A few paintings have been tentatively identified as Emosaku's work, the most remarkable, at least as an historical document, being the banner captured at the fall of Shimabara Castle, adorned with two angels adoring the Eucharist, and the inscription LOUVADO SEIA SANCTISSIMO O SACRAMENTO. His painting of the Archangel Michael, probably based on an engraving by the sixteenth-century Flemish artist Jerome Wierix, was hidden for many years by a Christian family in Nagasaki. His most splendid works were the big Namban screens, one of which (in the Ikenaga Collection) shows pairs of Christian and Moslem knights in combat: two of the former have been identified by their coats of arms as Antoine de Bourbon (1519-63) and Prince Henry of Navarre. The other screen, in Boston, shows, in six separate panels, a European monarch and members of his court, each standing in an Italian architectural setting.

Had Nobunaga not slammed the door on the West so decisively, art in Japan during the succeeding decades might have taken a very different path. The story of the Nara period, when the arts of T'ang China became virtually the arts of civilized Japan, might well have been repeated, only this time seventeenth-century Japan might have seen the rise of a new

school of figure painting in the manner of Rubens and Caravaggio, and the Kanō school of landscape painting revolutionized by the impact of Poussin and Claude Lorrain. But after 1640 a new generation of painters grew up who had no contact whatever with European art unless they visited Nagasaki, or gained entry to the great castles where the *Namban* screens were kept. Within a short time, what had once been a swiftly flowing stream of Western influence had become a dry riverbed.

While the menace of Western expansion is enough to explain Japan's withdrawal into her fortress, there is another, much more deep-seated factor, which helps to account for the recurring pattern in her history of eager acceptance of foreign ideas followed by equally passionate rejection of them. The older major civilizations, all formed at about the same time, were able to lay a deep foundation in philosophy and metaphysics, of which their arts became, in time, one form of expression. Japan, 'a child of the world's old age', as she has been called, inherited no such legacy. She desperately needed, from time to time, a fresh infusion of ideas and forms for her immense creative energy to work upon, and a broadening of her comparatively narrow cultural base. At such times she seemed to make a total surrender to foreign influences. Then there followed the inevitable reaction, during which these influences were absorbed, sometimes totally rejected, and her own traditions were reasserted and developed. The wave of T'ang culture, for instance, was followed by the rise of the native school of landscape painting, the Yamato-e; the fashion for Sung-style ink landscapes gave way to the glitter of Momoyama screen painting; the sudden impact of European art that we have been describing in this chapter was followed by the rise of the Ukiyo-e, the popular art of Edo; and the almost total surrender to Western art in the Meiji period produced a violent reaction, and the rise of a 'New National Painting'. Nothing is inevitable in history; but, given the geographical situation of Japan, such a pattern of alternating acceptance and rejection is not difficult to understand. It is, in fact, precisely this dialectical rhythm that gives Japanese art its peculiar power and fascination.

The Eighteenth Century

It was not until well after the turn of the eighteenth century that the stream of European art began to flow once more into Japanese soil – weakly at first, but with a slowly increasing volume, until with the Meiji Restoration of 1868 it became a flood that threatened to engulf the native tradition altogether. In 1720 the total ban on the import of Western books was lifted to allow manuals on science and technology to enter Japan. These were avidly seized upon, their texts were haltingly translated, and their illustrations were copied by many nameless artisans.

Of this new generation, the earliest Japanese artist to be strongly influenced by European art was Hiraga Gennai (1728–79), a well known writer and botanist from Shikoku who had been sent by his Daimyō to learn the Dutch language and Western science at Deshima. He must have studied oil painting, though the picture most often attributed to him, a copy of a rather dashing portrait of a young European woman, is very roughly executed. Very few of his pictures have been identified, and these are of indifferent quality, but he was one of the men chiefly responsible for spreading a knowledge of Western painting in eighteenth-century Japan, especially in the northern city of Akita, which for a time became a centre of 'Dutch' painting.

A more considerable artist was Maruyama Okyo (1733-95). He was embarking on the conventional path as a pupil of a Kanō school painter when one day he saw a European peepshow. He was so fascinated by its perspective and illusionisms that he began to study Western painting. He became an expert in making peepshows, and one that he made is preserved, with his camera obscura, in the Namban Museum in Kōbe. He was soon receiving commissions to execute 'European' landscapes and screens in the Western manner, and was probably the first Japanese artist to make life drawings from the nude. The fact that he was also influenced by Shen Nan-p'in, an academic Chinese flower painter who stayed at Nagasaki from 1731 to 1733, is an indication of the indiscriminate enthusiasm with which he, and indeed many of his contemporaries, seized upon any foreign art that was available, no matter where it came from.

Ōkyo's examination of the natural world, inspired by Western science and art, is illustrated by his minutely observed sketches of plants and animals, such as the set of leaves, now mounted as a hand-scroll, in the Nishimura Collection in Kyōto, in which each plant is carefully labelled after the manner of the European botanical books which he had seen. Ōkyo's triumph

was that he was able to exploit his new knowledge of the appearance of things in works on a large scale which were both realistic and decorative in the Japanese way. The most famous of these syncretic paintings is the huge screen, *Pinetrees in the Snow*, in the Mitsui Collection in Tōkyō. Here, perspective, texture and light and shade are handled in a thoroughly European way, yet the picture as a whole achieves a cool, impersonal decorative splendour uniquely Japanese.

One of Hiraga Gennai's best pupils was Shiba Kōkan (1738-1818), who had begun his apprenticeship as a maker of dagger-hilts and had graduated to forging wood-block prints in the manner of Harunobu. While still a young man he mastered the Chinese literary style of landscape painting (wen-jen-hua) and once gave a dazzling performance of the art, painting for twelve hours without stopping. It was partly his dissatisfaction with the techniques of the Chinese style as practised in his day that led him towards oil painting. He loved Mount Fuji and longed to paint it, but there was no convention in the Chinese literary style for that famous cone. Why then not use the Japanese style? For Kōkan, there was no such thing. Japanese painting, he wrote, 'is derived entirely from China . . . nothing whatever has been invented in Japan'. On the other hand, he said, 'if one follows only the orthodox Chinese methods of painting, one's picture will not resemble Fuji'. There was only one way out. 'The way to depict Fuji accurately,' he declared, 'is by means of Dutch painting.'

Kōkan's studies of European painting were spurred on when, in about 1784, the famous Dutch factor at Deshima, Isaac Titsingh, gave him a copy of Gerard de la Lairesse's popular manual on painting, Groot Schilderboek (1728-29), which he went through with Gennai's help. Some of the illustrations in this manual were published in 1787 in Morisima Chūryo's Kōmō Zatsuwa, 'Miscellaneous Chats about the Red-hairs', that is, Westerners. Just how much he understood of Western principles of composition, perspective, shading and cast shadows is illustrated by his curious Barrel Makers in the Mori Collection. Another 'progressive realist' was Odano Naotake, whose landscape with a vase of flowers is an adroit blend of the kind of landscape that Aōdō Denzen made so popular in his etchings, and the technique of flower painting that, at about the same time, Giuseppe Castiglione was perfecting at the court of Ch'ien-lung in Peking.

At the middle of the century the Dutch imported several

copper plates, but no one knew what to do with them, for the art of engraving had been lost after the closing of the Jesuit press in 1614. Kōkan obtained, probably also from Titsingh, Egbert Buys' New and Complete Dictionary of the Arts and Sciences, and studied the parts dealing with copper-plate engraving. He set to work, and in 1783 was able to publish the first print in this medium to appear in Japan for nearly two hundred years. We illustrate his charming hand-coloured etching of the Serpentine in Hyde Park, adapted from an English print. Another pioneer was Aōdō Denzen, whose name Aōdō, given him by the Prime Minister, begins with the character for Asia and Europe. He had been a textile designer, and liked to give his plates the appearance of a piece of silk with frayed edges.

There is something remarkable in the care that these artists devoted to mastering a new and alien art. It is hard to imagine any Chinese or Western artists, apart from mere decorators, doing this. But the Japanese painters, even the most prominent of them, were inspired both by an eagerness to seize upon anything new and foreign, and by a concern for craftsmanship for its own sake. Unlike the Chinese and Europeans, they asked no questions, but humbly met the challenge and did their best.

European Influence in Nanga Painting

The indirect influence of Western realism on the Japanese masters of the Chinese literary style of landscape painting is a remarkable instance of Japanese artistic eclecticism. Japanese painters in the eighteenth century much admired the work of the Chinese gentlemen artists, which they called Nanga, 'Southern (School) painting'. Such pictures are often sketchy, spontaneous and sensitive, intimately related to poetry and scholarship, belonging to a tradition in which the expression of personal feeling and sensibility means more than the correct representation of nature. Indeed, they are anything but realistic. In the seventeenth century the Chinese 'Southern School' had become the vehicle for political ideals as well, for its scholarly exponents, turning their backs on the corruption of court life and patronage, saw themselves as the heirs of the scholar painters of the Yüan Dynasty, who had likewise refused to compromise with authority during the Mongol occupation of China.

In the hands of Japanese artists, however, Nanga was not always, as it was to the Chinese literati, at the same time an idle pastime and the expression of a whole way of life. It was often regarded simply as one more style of painting, which could be learned, just as other styles – the Tosa or Kanō, for example – could be learned. So it was not incongruous, as it certainly would have been in China, for a Japanese Nanga painter to be a student of Western realism as well. Under Western influence, these artists, as Kōkan's little treatise shows, had come to realize that the conventional forms of traditional Far Eastern art, however much enlivened by the calligraphic movement of the brush, did not reflect reality. The Chinese literary style was feeding, not upon nature, but upon itself. Western painting seemed to point the way to a rediscovery of the natural world.

Matsumura Goshun (1752-1811), a follower of the great poet-painter Yosa Buson, and in his youth a pure Nanga painter, became a realist under the influence of his friend Okyo. Tani Bunchō (1763-1840), often regarded in Japan as the founder of the 'Chinese style' in Edo, was thoroughly eclectic, although his attempts to marry Chinese brushwork and Western realism are not always very happy. One of his most notable works is a spectacular pair of paintings of flowers in vases, after the copies of panels by the Dutch court painter Willem van Royen (1654-1728) which had been given to the Shōgun by a Dutch sea-captain. Goshun's pupil Watanabe Kazan (1793-1841), working always in the Oriental medium of silk or paper, ink and watercolour, achieved a more successful synthesis. He was a versatile and powerful artist, who saw Western realism not simply as another style, but as a means of getting closer to nature. More than that, it was in itself a symbol of the contact with the outside world which increasing numbers of Japanese scholars and reformers were working for. He joined the movement of protest against the rigid exclusion laws, was condemned to the 'foreign traitors' prison, and committed suicide. His realism, and that of other eclectic artists before the Meiji restoration, was as much a political gesture as had been the style of the Chinese literati in the seventeenth century. These Japanese painters felt, moreover, that Western realism was a useful tool for the spread of knowledge and education, as the Chinese style could never be. 'Western oil painting,' Shiba Kōkan roundly declared, is an instrument in the service of the nation.'

Another great champion of the spread of Western learning through Western art was Honda Toshiaki, who wrote in his 'Tales of the West' (Seiki Monogatari, 1798):

European paintings are executed with great skill, with the intention of having them resemble exactly the objects portrayed so that they will serve some useful function. There are rules of painting that enable one to achieve this effect. The Europeans observe the division of sunlight into light and shade, and also what are called the rules of perspective. For example, if one wishes to draw a person's nose from the front, there is no way in Japanese art to represent the central line of the nose. In the European style, shading is used on the sides of the nose, and one may thereby perceive its height.

Because the kind of pictures these artists saw were chiefly of a practical kind, they naturally assumed that the sole purpose of Western art was to illustrate and instruct.

Artists such as Okyo, Gennai and Goshun were essentially traditional painters who were intrigued by one aspect or another of Western technique. But there were other, on the whole lesser artists, to whom Western subject-matter was of more immediate importance than style and technique. They clustered in and around the Dutch settlement at Deshima, where some were servants and interpreters. Their work is called Nagasaki-e. They translated Dutch books - the banraku, books on foreign peoples - and copied European engravings and maps. Many of their paintings and prints illustrate the cramped life of the Dutch on Deshima, and the annual expedition of the Dutch Factor to Edo accompanied by his Indian and Javanese servants and Negro slaves. Most of the men who turned out these prints and drawings in such prodigious quantities were anonymous craftsmen, but among them were a few men whose names are known, such as Araki Genkei (d. 1799), his son Ishizaki Yushi, who was a skilled oil painter and expert in perspective, and Araki Jogen, born about 1773. Jogen became an official (that is, Kanō) painter and art connoisseur, but he was also a painter of portraits in oils, an art that he may have learned from the Dutch physician in Deshima, Herman Feilke. The last and perhaps the most significant of the Nagasaki painters was Kawahara (or Kawara) Keiga, whose known works include a portrait of Opperhofd (Factor) Jan Cock Blomhoff and his family, painted in 1818, of which at least five

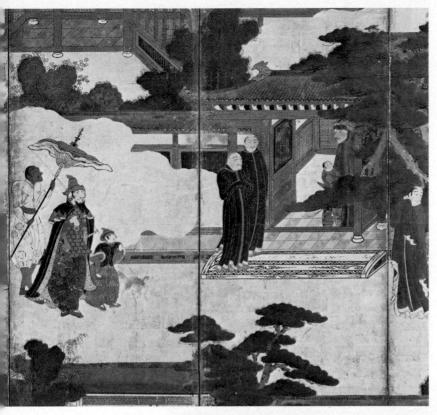

I Anonymous. Portuguese and Catholic priests.
Detail from a six-panel Namban screen. Ink, colour and gold on paper.
Japanese, Momoyama or early Edo period, seventeenth century

2 Anonymous. Horsemen at the Battle of Lepanto, 1571. Detail from a *Namban* screen. Ink and colour on paper. Japanese, early seventeenth century

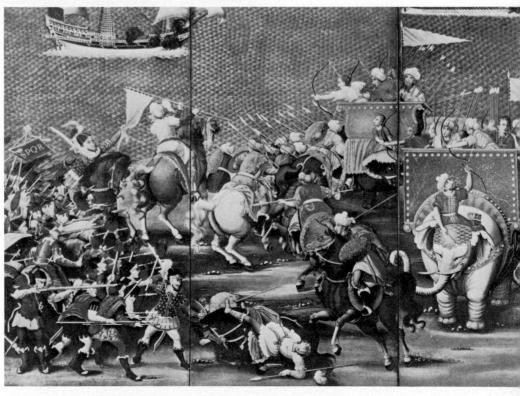

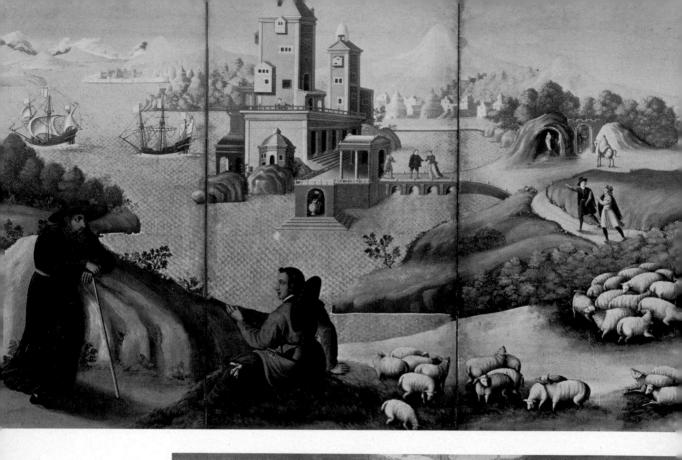

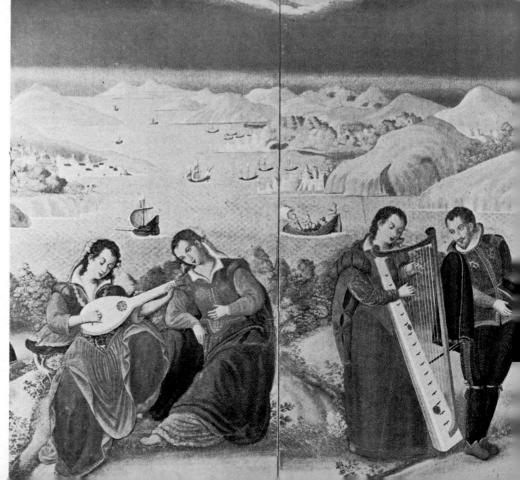

Opposite page

- 3 Anonymous. Pastoral scene with shepherd and sheep. Panels from a screen. Ink and colour on paper. Japanese, seventeenth century
- 4 Anonymous. Westerners playing their music. Two panels from a six-panel *Namban* screen. Ink and colour on paper. Japanese, seventeenth century

- 5 Attributed to Hiraga Gennai (1728–79). Young European woman. Colour on
- 6 Maruyama Ōkyo (1733–95). Sketches of human figures (detail). Ink on paper

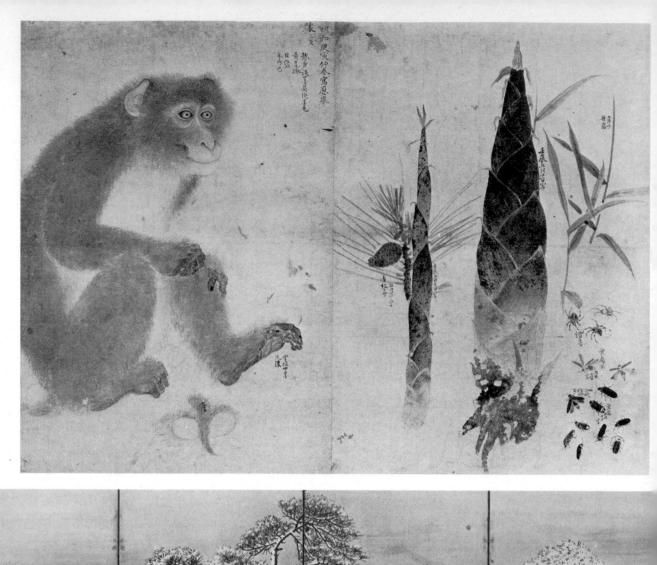

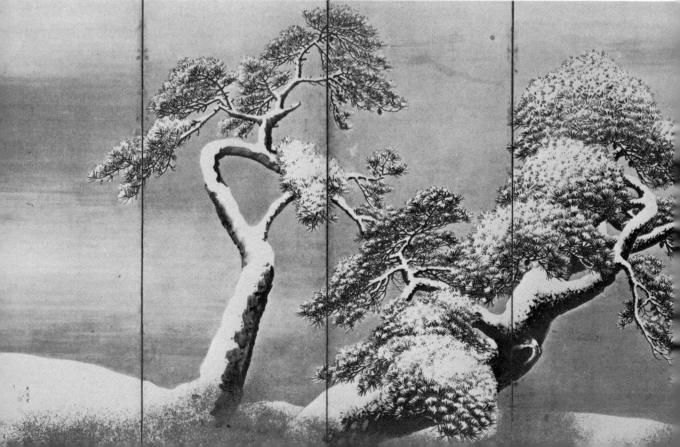

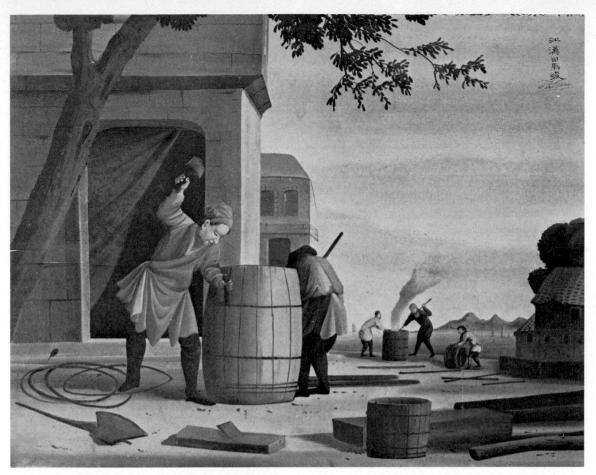

- 7 Maruyama Ōkyo. Sketch of plants and animals. Page from sketchbook. Ink and colour on paper. 1770–72
- 8 Maruyama Ōkyo. *Pinetrees in the Snow*. One of a pair of folding screens. Ink and colour on paper
- 9 Shiba Kōkan (1738–1818). Barrel Makers. Oil. Eighteenth century

10 Odano Naotake (1749-80). Landscape with a vase of flowers. Ink and colour on silk

12 Watanabe Kazan (1793–1841). Portrait of Takami Sanseki. Colour on silk. C. 1837 >

11 Shiba Kōkan. The Serpentine, $Hyde\ Park$. Hand-coloured copper-plate etching. Eighteenth century

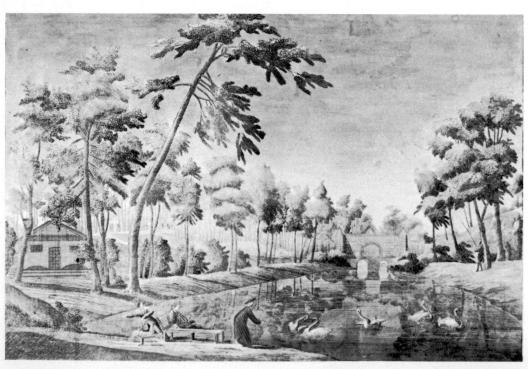

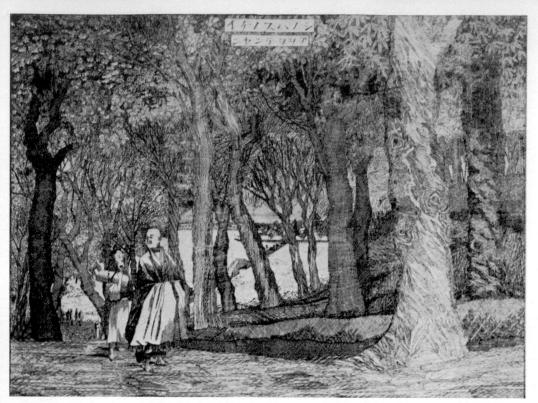

13 Aōdō Denzen (1748–1822). Landscape with figures in a wood. Etching

15 Katsushita ▷ Hokusai (1760—1849). Page of drawings of animals, from his manual 'Quick Lessons in Drawing' (Haya Shinan). Woodblock reproduction of brush drawing.

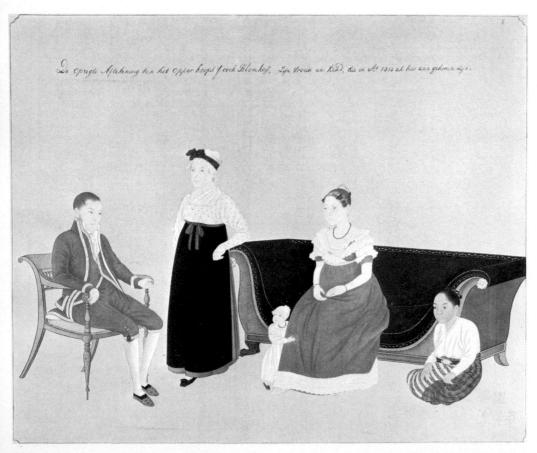

16 Attributed to ▷ Okumaza
Masanobu
(1686–1764). A
Game of Backgammon in the
Yoshiwara. Handcoloured woodblock print

14 Kawahara Keiga (b. 1786). The Blomhoff family. Screen. Colour on silk. 1818

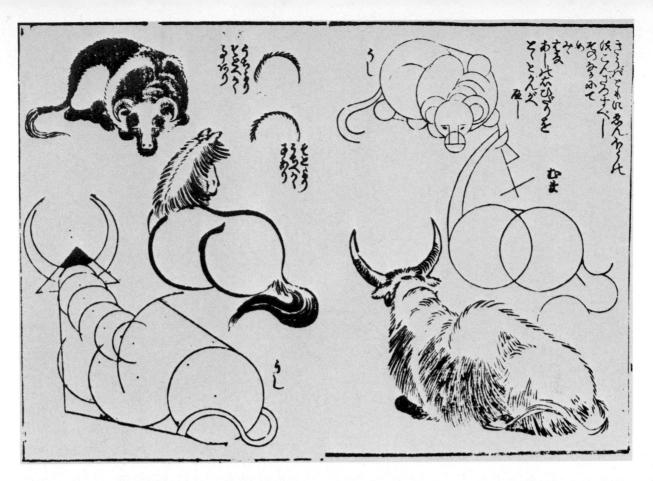

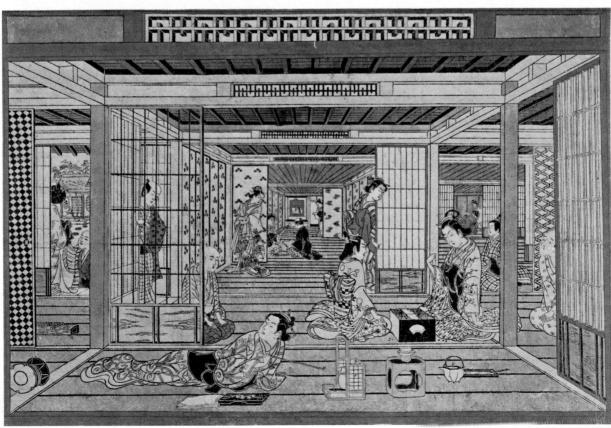

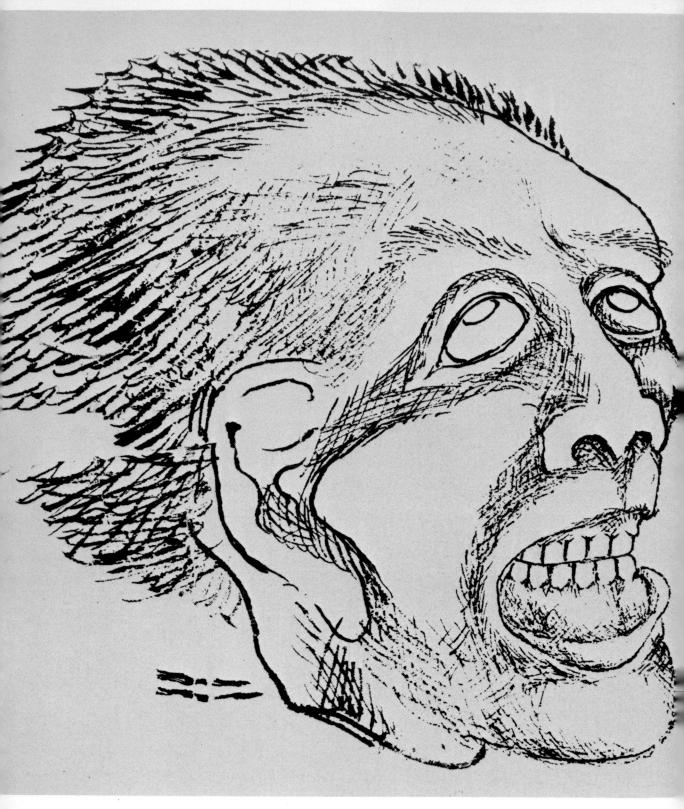

17 Katsushita Hokusai. Spectral Face. Brush drawing

18 Katsushita Hokusai. View at Yotsuya. Woodcut print. Late 1790s

19 Katsushita Hokusai. Mount Fuji from the Nihonbashi, Edo, from 'Thirty-six Views of Fuji'. Woodcut print. C. 1822

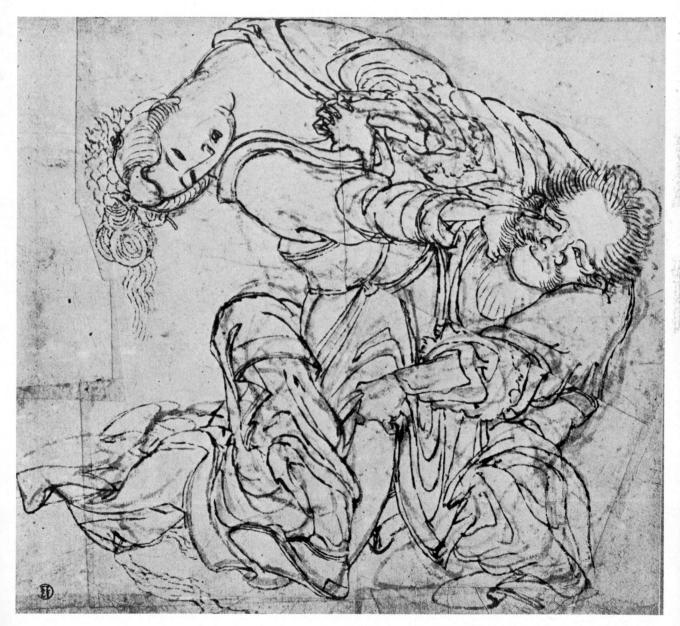

20 Katsushita Hokusai. The Rape. Brush drawing with pentimenti

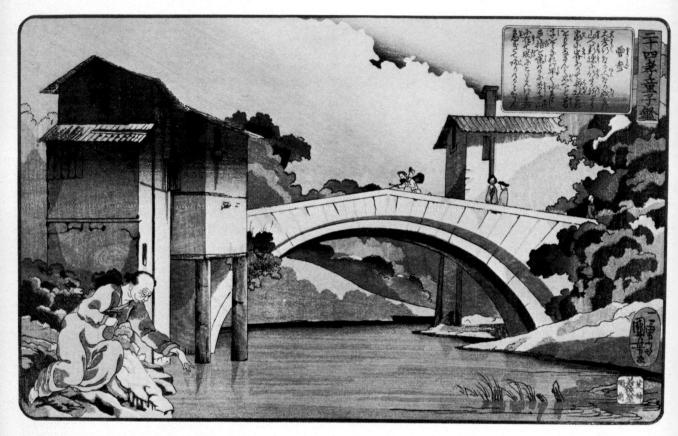

21 Utagawa Kuniyoshi (1798–1861). Sosan returning to his Mother. Illustration from The Twenty-four Paragons of Filial Piety. Woodcut print. C. 1840

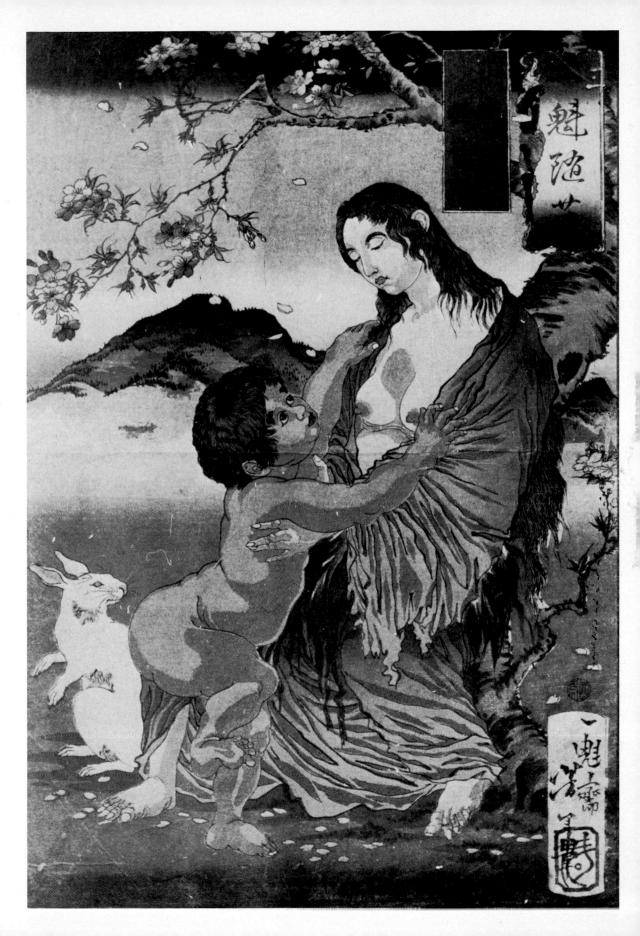

的學家

versions exist. He composed a delightful genre scene called *De Groote Partij*, depicting a grand social gathering at the Dutch Factory, and executed a number of views of Nagasaki harbour thronged with foreign ships. He also drew many original designs for Von Siebold's work *Nippon* (1823–30), notably the Flora and Fauna Japonica.

The Nagasaki-e provide an inexhaustible mine of source material on Japan's growing cultural and technological contacts with Europe during the eighteenth and early nineteenth centuries. But few of them are of much aesthetic merit. The colouring is often crude, and Western techniques such as shading and perspective are adopted for purely utilitarian ends, to make the pictures as clear and informative as possible.

Western Influence in the Japanese Colour Print

The Japanese print came into being to record the delights of the red light district and theatres of Edo, a world equally remote from the Dutch at Nagasaki and from the scholarpainters who were using foreign art as an instrument of reform. The pioneer print-makers, at least in the early decades after 1680, showed no interest in Western art as such, though they found the new perspective useful for depicting the interiors of tea-houses, theatres and brothels. Masanobu claimed, in about 1740, to have been the inventor of these uki-e, or 'perspective pictures'. Certainly he and Moromasa, the son of a pupil of Moronobu, showed an easy mastery in the handling of simple perspective, in which the straight lines of the post and frame construction of a large tea-house not only precisely define the space and the relationships of the figures within the space, but also create a striking formal counterpoint to the voluminous rhythmic curves of the figures - a contrast that had already been exploited in earlier Japanese narrative scroll painting. The convincing Western-style perspective of these uki-e, moreover. gives a new flavour to the age-old tension in Japanese art between pictorial depth and two-dimensional decorative pattern-making. In the hands of a master such as Moromasa, these conflicting claims are held in subtle balance, for the architectural grid is a semi-abstract pattern in itself. Later, when the sense of design was increasingly sacrificed to pictorial realism, this balance was often lost.

Utagawa Toyoharu (1735-1834) may have been in touch

23 Andō Hiroshige. Sudden Shower at Ohashi, from 'Hundred Famous Views of Edo'. Woodcut print, 1856–8 with Kōkan or Gennai, or may have known more directly about Western art through a friend in Nagasaki. In any event, the Western flavour in his prints goes beyond perspective, and he was more willing to experiment. Among his adaptations of European engravings is a remarkable plate taken from a print of Armenian medicinal herbs, with figures in a Baroque setting on one side and a rather feeble Japanese landscape on the other. A more skilful adaptation is his *Perspective View of Holland in Snow*, published some time in the 1770s, a strange mixture of Dutch landscape and Japanese architecture, executed in very fine lines in imitation of European engraving.

It was above all in the landscape prints produced after 1780 that Western methods were successfully absorbed. The seashore prints of Utamaro, poetically entitled 'Gifts of the Ebb Tide', show people wandering along the beach, searching for shells under an open sky. In these serene landscapes, space and depth are fully mastered, and there is little of that tension between two dimensions and three that is characteristic of Japanese pictorial art as a whole. Whether the subordination of decoration and design to a natural spatial effect is due to Utamaro's study of Chinese or of Western art, or of both, is hard to say.

Of all Japanese print-makers, Katsushita Hokusai (1760-1849) seems to have been the most relentlessly energetic in his search for new material, and in his skill and resource as a draughtsman. One might expect that his curiosity would have led him into many experiments in Western techniques. He certainly studied Western paintings and engravings, and in 1812 produced a little manual, Quick Lessons In Drawing, in which he says that lines of designs consist of circles and squares, a theory which he illustrates with stereometric diagrams and drawings of animals derived from them, after the manner of the section on drawing in C. Van Passe's Encyclopaedia (1643), which had been circulating in Japan for some time. Apart from this there is singularly little in his large corpus of drawings, and prints made from his sketch books (the Manga), that shows much curiosity about Western art. The most striking experiments in Western techniques attributed to him are the two extraordinary 'spectral faces', one of which is obviously an imitation of Western pen drawing, the other positively Picassoesque in its handling of ink wash. Perhaps the outlandish subject demanded an outlandish style: centuries earlier, Chinese Buddhist artists, in painting portraits of Indian monks, had likewise deliberately resorted to an exotic un-Chinese technique.

15

Hokusai made exaggerated use of Western perspective in his colour prints of the early 1800s, such as the Fuji from Takahashi, theatre interiors, and the illustration from the drama Chūshingura of which Hillier remarks, 'Even the trees with their tall leafless trunks are perfunctorily drawn as if with the trees of the Dutch polders, remembered from the third-rate prints that found their way into Japan, in mind.' The splendid View at Yotsuya, designed in the late 1790s, is perhaps Hokusai's most successful synthesis of East and West. The composition has the balance and solidity of a Poussin, and yet has a swinging rhythmic movement that is purely Oriental. Darker shapes in the foreground provide both modelling and chiaroscuro, and contribute to the overall design; and Hokusai carries off the daring contrast in texture between formalised landscape and naturalistic watercolour sky with great assurance. As if to tease the viewer into thinking that this is Western landscape, he writes the title and signature sideways in the upper left corner.

In his later work Hokusai moved away from this kind of deliberate synthesis. If he used perspective, as in the first of the famous 'Thirty-six Views of Fuji' (about 1822), in which long receding lines of warehouses along the river lead the eye back to the distant mountain, he did so almost playfully, distorting the perspective, and subordinating optical truth to flat decorative pattern-making in colour. It is not the most pleasing of the 'Thirty-six Views', but it restores purely Japanese qualities to the woodcut, and represents the triumph of the print designer

over the pictorial realist.

Hokusai's passionate 'search for form' shows a kinship with Western art that goes surprisingly deep, yet may not be due to Western influence at all. In the preparatory drawings for some of the prints, such as The Rape, he goes over the line again and again in his search for the most telling contour, giving this sheet and the extraordinary Woman with Octobus almost the quality of a seventeenth-century Italian drawing. Elsewhere we see him blocking out a figure composition very much in the Western manner. Perhaps other Japanese masters of the woodcut did this also, but their drawings have not survived. They too must, like Hokusai, have been concerned primarily with problems of composition in which the design was deliberately worked out, and not preconceived and executed, as in China, in a spontaneous flourish of the brush. In this respect, the methods of the Japanese print designer were closer to Europe than to China, and the question of influence need not necessarily arise.

If Hokusai is the resourceful craftsman, moulding nature to his own ends, borrowing techniques from any source in the interests of greater visual impact and arresting design, Hiroshige (1797–1858) is the lyric poet who seeks to convey the appearance and mood of a scene without undue distortion or technical bravura. His greatest achievement was the 'Fifty-three Stages of the Tōkaidō', produced in 1833 and 1834. Here, Western influence has been so completely absorbed that it never obtrudes, although some of these prints would be impossible to account for without it, notably No. 15, Mount Fuji from Yoshiwara. Not only are the perspective and foreshortening in this print masterly, but Hiroshige has created a convincing tunnel of enclosed space between the twisted pines which has no precedent in Japanese art. Yet the ultimate effect is unmistakably Japanese.

Occasionally, Hiroshige reverts to a cruder Western-style perspective. To the somewhat mechanical recession in the Night View in Saruwaka-chō, from the 'Hundred Famous Views of Edo' published in 1856–8, he adds shadows cast by the full moon overhead. This series, coming at the very end of his life, is among his less inspired works, but the attempt to suggest nocturnal lighting effects foreshadows the night scenes that were to become so popular in the art of the early Meiji period.

The last major print-maker to experiment with Western techniques before the Meiji restoration swept European art over Japan in an engulfing flood was Utagawa Kuniyoshi (1708-1861). Not only did he master perspective, but he went so far as to take Western pictures as models for subjects drawn from classical Chinese literature. Several of his illustrations to the Chinese Twenty-four Paragons of Filial Piety show the result of this extraordinary marriage. The story of Sosan (Tseng Ts'an) returning to his mother is set in a conventional Italianate landscape, while the print of the paragon Yü Ch'ien-lou galloping back to his sick father is obviously based on a picture of St George, minus his dragon. To call Kuniyoshi an eclectic is hardly explanation enough. It seems that by the 1840s the hackneved old Chinese theme could no longer inspire: it was Western art, fresh and exciting, and with its hint of a new era about to dawn for Japan, that provided the stimulus. Western art could even give a new glamour to popular Japanese themes. When in 1873 Kuniyoshi's pupil Yoshitoshi Taiso (1839–92) illustrated the story of the mountain woman Yamauba and her son, the wild Kintarō, his inspiration was clearly a picture of

the Virgin and Child. The result is a marriage of Western solidity and flat Japanese pattern-making that is not ineffective.

With the death of Hiroshige and Kuniyoshi the classical 'Art of the Floating World', ukiyo-e, came to an end. But before they died their world had already begun to change. In 1854 Admiral Perry returned to Edo, to sign with the Shōgun the treaty that was to throw open the doors of Japan to the outside world. Is this change reflected also in Hiroshige's later prints, and if so, did photography play any part in it? The painter Sakurada Kinnosuke, who has been called 'the father of Japanese photography', is thought to have taken up the art after seeing a Daguerrotype for the first time in 1844. It has been suggested that the influence of photography may be seen in some of Hiroshige's 'Hundred Famous Views of Edo', published in 1856-8. If so, it is hard to discern, and the series as a whole represents a sad falling-off from his earlier work. The designs are mostly uninteresting, the colours crude. The series is chiefly important because it was the late, and on the whole bad, prints such as these that were to have so profound an influence on the Impressionists. Whistler's Falling Rocket was inspired by Hiroshige's Fireworks at Ryōgoku; van Gogh was to make a careful copy in oils of the Sudden Shower at Ohashi; Gauguin's Puppies Feeding is clearly derived from a composition by Kuniyoshi. It is ironic that the traditional Japanese print began to influence European art only with its dying gasp.

The Seventeenth Century

The Jesuits formed the spearhead of European cultural penetration of China, as they did of Japan. It was their pictures, prints and books that produced the first signs of European influence in Chinese painting, and their writings that in turn brought seventeenth-century Europe the first detailed account of the arts of China. But long before the Jesuits appeared on the scene foreign travellers had gazed in admiring incomprehension at Chinese paintings. An Arab merchant who visited China in the ninth century had reported that 'the Chinese may be counted among those of God's creatures to whom He hath granted, in the highest degree, skill of hand in drawing and in the arts of manufacture'.

Marco Polo, in the service of Kublai Khan in the last decades of the thirteenth century, had plenty of opportunities to see Chinese paintings, but he only mentions the gaudy decorations in the imperial palaces. In the palace at Khanbalik (Peking), for instance, 'the walls and chambers are all covered with gold and silver and decorated with pictures of dragons and birds and horsemen and various breeds of beasts and scenes of battle'. He found similar paintings in a hall of the former Sung imperial palace at Hangchow, and, in P'ing-yang-fu in Shansi, a castle whose hall was decorated 'with admirably painted portraits of all the kings who ruled over this province in former times'. Beyond this he has nothing to say about Chinese art.

Fifty years later Ibn Batuta, 'The Traveller', was much more enthusiastic. 'The people of China of all mankind,' he wrote, 'have the greatest skill and taste in the arts. This is a fact generally admitted; it has been remarked in books by many authors and has been much dwelt upon. As regards painting, indeed, no nation, whether of Christians or others, can come up to the Chinese, and their talent for this art is something extraordinary.' After this, it is a little disappointing to find that what Ibn Batuta admired so much was not the towering landscapes of the literati, which he obviously never saw and would not have understood in any case, but the skill in catching a likeness shown by those professional painters at frontier stations whose job it

was to record the features of strangers entering and travelling about the country.

We hear nothing more of Chinese art until the arrival of the Jesuits. By 1557 they were established in the Portuguese colony of Macao, more open and accessible to foreigners than Deshima, but even more remote from the capital. Soon their influence and that of their Dominican and Franciscan competitors spread to Canton and beyond. But our story properly begins with the arrival in Macao in 1592 of the great scholar and missionary Matteo Ricci. Born in Ancona in 1552, Ricci had entered the Jesuit order in 1571 at the age of nineteen, and left Genoa for the Far East six years later. This priest of formidable learning, energy and presence was destined by his scholarship and writings to engage the interest of Chinese intellectuals in European culture, and that of European scholars in Chinese culture, as did no other man in this momentous era of mutual awakening.

Ricci remained in Macao and Kwangtung until 1595, when he headed north. A premature invitation from an official to come to Peking to work on the calendar brought him to the gates of the city, where he waited for two months before returning to Nanking, and it was not until the spring of 1600 that he tried again. Meantime he had not been idle. During the years of waiting he had consolidated the mission in Nan-ch'ang and in Nanking, which during the next fifty years was to become the centre of the one school of Chinese scholarly landscape painting that seems to show unmistakable signs of European influence.

On his way northwards in 1600 Ricci paid his respects to the Viceroy of Shantung at Tsining, to whom he showed a painting of the Virgin and Child with St John the Baptist that he was taking to the Emperor. The Viceroy's wife liked it so much that Ricci gave her a copy painted by a young man of their mission in Nanking; but who this painter was is a mystery. Ricci arrived in Peking in midwinter, and on 25 January 1601 was received in audience by the Wan-li Emperor.

Ricci had only nine more years to live, but in this brief time he laid the foundation for nearly two hundred years of Jesuit influence at the Chinese court. His reputation seems to have preceded him to Peking, for very soon he numbered among his friends many leading intellectuals, some of whom – men of the calibre of Hsü Kuang-ch'i, Li Chih-tsao, and Yang T'ing-yün – became converts. They must have shown him pictures in their collections, for he has a paragraph on Chinese painting in his

wonderful account of China, which until recently was known only in Father Trigault's heavily edited Latin version. It is not very complimentary. 'The Chinese use pictures extensively,' he wrote, 'even in the crafts, but in the production of these and especially in the making of statuary and cast images they have not at all acquired the skill of Europeans. They know nothing of the art of painting in oil or of the use of perspective in their pictures, with the result that their productions are lacking any vitality.' Evidently the paintings and engravings which Ricci brought with him were already being copied, for he goes on, 'I am of the opinion that the Chinese possess the ingenious trait of preferring that which comes from without to that which they possess themselves, once they realize the superior quality of the foreign product.' Here, for once, he was wrong.

He must have been gratified, though hardly surprised, at the intense interest that his own works of art aroused among the gentry. He had with him engravings of Venice, devotional pictures sent from Rome and the Philippines, and a large altarpiece by Giovanni Nicolao, the Portuguese painter-priest 'of less than medium intelligence' whose academies at Nagasaki and Arima were the training ground for Japanese icon painters. Of one of these pictures – very probably a copy of the sixth-century Virgin of St Luke in the church of Santa Maria Maggiore, Rome - the scholar Chiang Shao-shu wrote in the brief section on Western painting in his 'History of Silent Poetry' (Wu-sheng shih-shih, 1646): 'Li Ma-tu [Matteo Ricci] brought with him an image of the Lord of Heaven in the manner of the Western countries; it is a woman bearing a child in her arms. The eyebrows and the eyes, the folds of the garments, are as clear as if they were reflected in a mirror, and they seem to move freely. It is of a majesty and elegance which Chinese painters cannot match.'

The first recorded copies of European paintings had been made in Peking for the Italian priest Jean de Monte Corvino, who visited China early in the fourteenth century. The next instance occurred three hundred years later, when Ricci presented to the Emperor an engraving of souls in purgatory, including the Pope, a duke, and an emperor, because Wan-li wanted to know how such dignitaries dressed in Europe. Ricci accompanied the engraving with a description, but as the detail was too fine, the Emperor had his court artists paint an enlarged version in colour, under Ricci's supervision.

It was not until Ricci had been two years in Peking that he had a resident painter of his own attached to the mission. In 1602

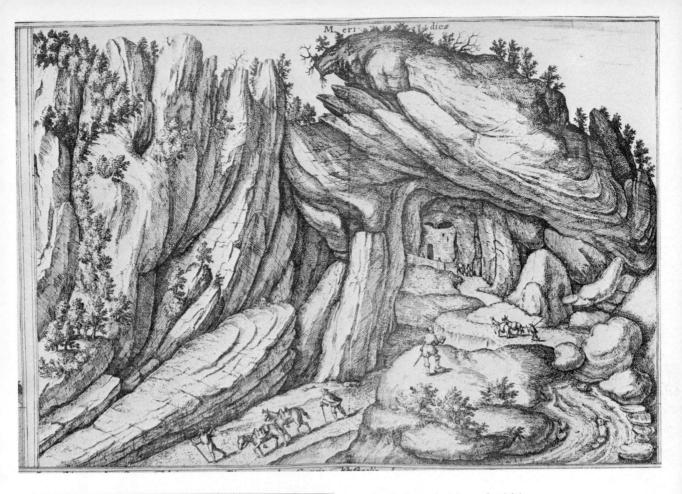

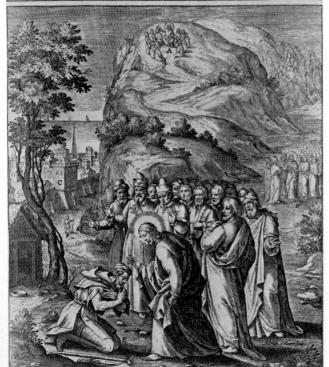

24 G. Hofnagel. Mount St Adrian. Engraving (1667) from Georg Braun and Franz Hogenberg, Civitates Orbis Terrarum (edition published c. 1598)

25 Mundator Leprosus ('Healing the Leper'). Engraving from Nadal's Life of Christ, Evangelicae Historiae Imagines (1593)

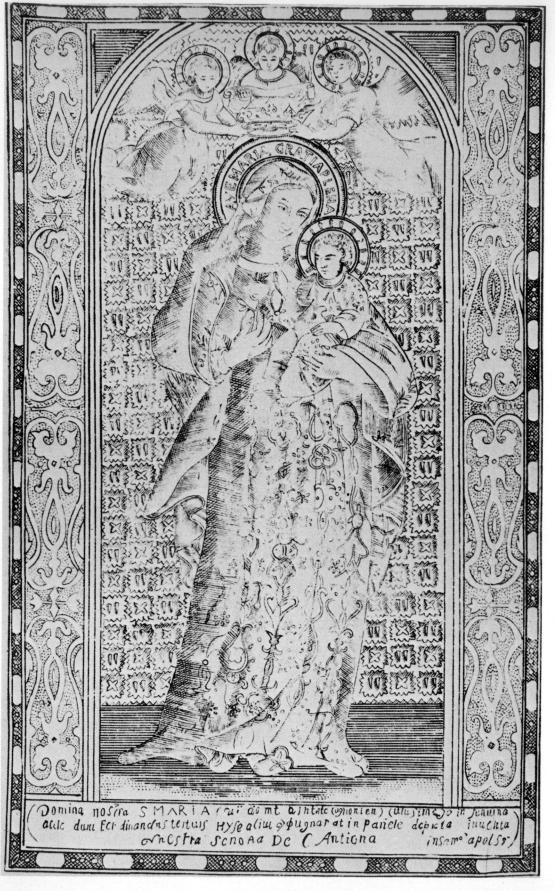

26 Nuestra
Señora de
l'Antigua, Seville.
Chinese woodcut print, after
Jerome Wierix,
in 'Mr Ch'eng's
Ink Remains'
(Ch'eng-shih moyüan; 1606)

27 Chiao Pingchen (fl. c. 1680– 1720). Rural landscape (detail). Hanging scroll. Ink and colour on silk

28 Kung Hsien (c. 1640–1689). Landscape. Ink on paper

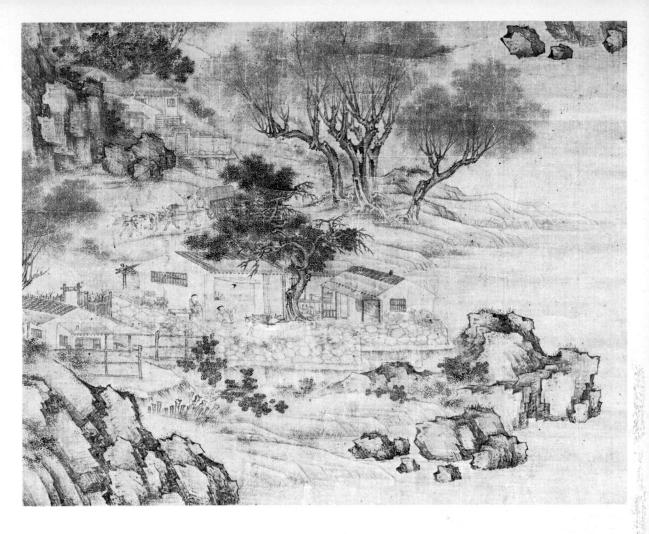

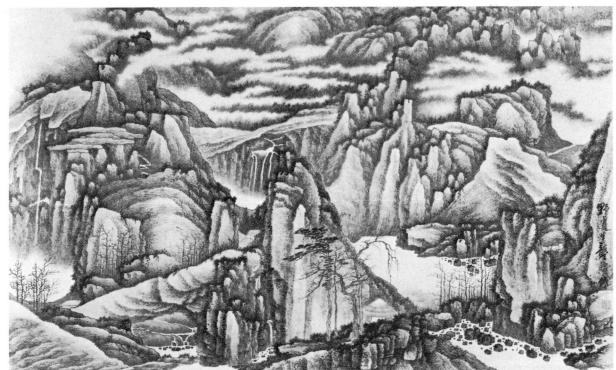

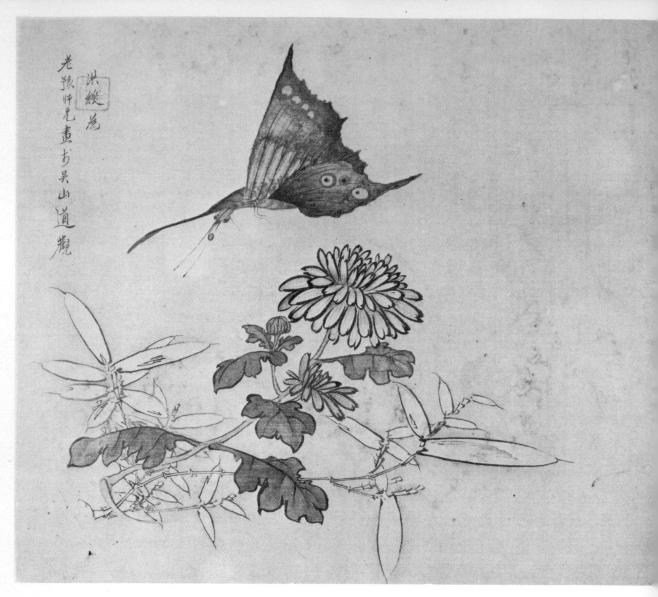

29 Ch'en Hung-shou (1598–1652). Studies of flowers and butterflies (detail). Album leaf. Ink and colour on si

DOMINICA III. ADVENTVS.

Mittunt Iudai ad Ioannem.
Ioan. i. Anno xxix.

ll iij

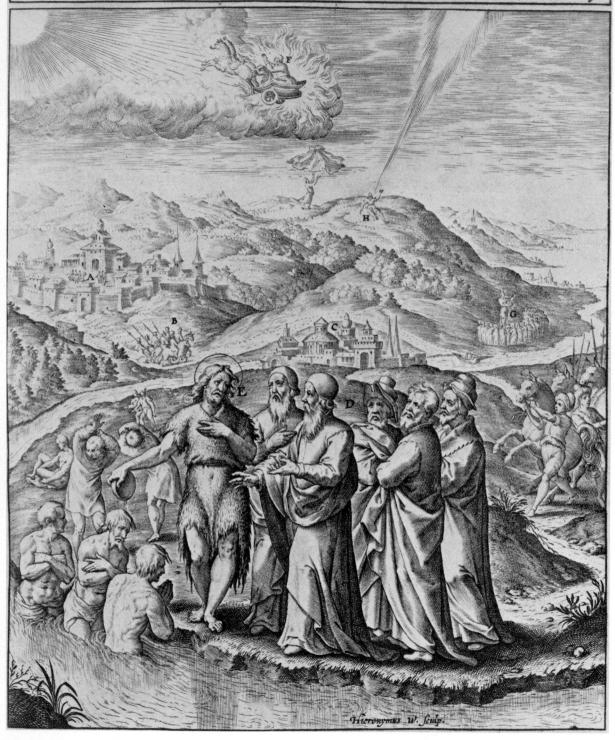

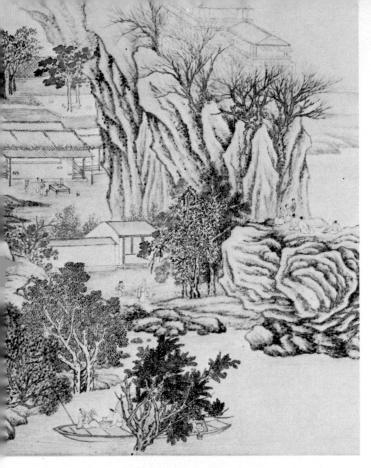

31 Mittuant Iudaei ad Ioannem (paraphrase: 'Priests and Levites confront John the Baptist'). Engraving from Nadal's Life of Christ, Evangelicae Historiae Imagines (1593)

32 Wu Pin (c. 1568–1626). Occupations of the Months (detail). Handscroll. Ink and colour on silk. 1608

33 Wu Pin. Occupations of the Months (detail). Handscroll. Ink and colour on silk. 1608

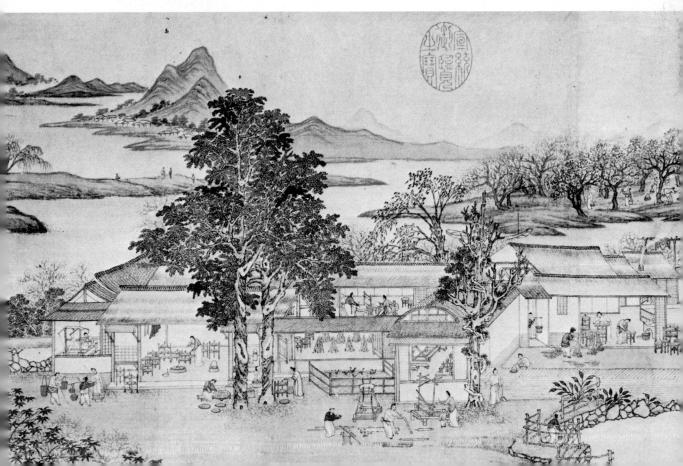

34 Fan Ch'i (1616-after 1692). Landscape. Album leaf. Ink and colour on paper

35 Fan Ch'i. Landscape on the Yangtze River (detail). Handscroll. Colour on silk. Second half of the seventeenth century

Jacopo Niva, son of a Japanese father and Chinese mother, arrived from Japan, where he had been a pupil of Nicolao. In 1604 Niva made a copy of the Virgin of St Luke for the high altar of the church in Peking, and in 1606 was decorating the new church in Macao. In the capital he worked in secret with only two Chinese Christian helpers, because he was afraid that if his skill became known he would have to spend all his time painting for the Emperor and high officials, a fate which did indeed befall the Jesuit artists in Peking a century later. In 1610 Niva was sent to decorate a church in Nan-ch'ang, and in the following year executed the wall-paintings for the Buddhist temple which had been given by the Emperor as a tomb for Ricci. Ricci had noted that the Chinese were amazed at his pictures, which seemed to them more like sculpture than painting. Alas, the churches which he decorated were all rebuilt or destroyed, and not a scrap of his work survives.

Among Ricci's presents to the Wan-li Emperor was Ortelius' great folio atlas of the world, *Teatrum Orbis Terrarum* (Plantin, 1579), which included five large engravings: two of the Pope and rulers and nobles of the Holy Roman Empire, a view of Daphne in Greece, another of the Vale of Tempe, and one of the Escurial. We know that this book must have reached Japan as well, for the figure subjects appear from time to time, cleverly

adapted and varied, in Namban screens.

Far more richly illustrated was a big six-volume work on the cities and towns of the world, Braun and Hogenberg's Civitates Orbis Terrarum, published in Cologne between 1572 and 1616, of which several volumes had by this time reached Peking. Ricci had written of the importance of such books to impress the Chinese literati with the splendours of Western civilization. When he was staying near Canton ten years before he had noted how visitors to the mission were especially attracted by the books on cosmology and architecture. Braun and Hogenberg filled the bill admirably. Father Longobardi was even more imaginative in his requests: when Father Trigault went on his European tour to gather support and material for the China mission Longobardi asked him to bring back a bird of paradise, a lion and a rhinoceros.

In view of the curiosity about Western perspective that was later to be shown at the Chinese court, it is interesting to note that the Jesuit library in Peking contained a number of books on architecture published before 1600 which could well have reached the mission in Ricci's day or shortly after. One copy of

Palladio was brought back by Trigault in 1618; there were three copies of Vitruvius and there was one of Giovanni Rusconi's Della Architettura, published in Venice in 1590. Ricci also asked for books on ancient Rome – evidently not in vain, for the library also contained a copy of Theodore de Bry's Topographia Orbis Romae (Frankfurt, 1597), in three volumes, illustrated with engravings of the city from its beginnings, showing streets, public baths, monuments, sarcophagi and inscriptions.

We may well wonder what possible relevance such books had to late Ming China, or in forwarding the spiritual aims of the mission. But from the start the Jesuits had visions of building new Renaissance cities in China, such as they were creating in Mexico, South America and the Philippines. Indeed, flushed with their first extraordinary success in Peking, they looked forward to the time, not too many decades hence, when China would be a Christian country, her emperor himself a convert, her cities crowned with magnificent Baroque churches decorated by Chinese followers of Bernini and Rubens.

While the oil paintings brought by the Jesuits were greatly admired it was the illustrated books and engravings that were probably more influential in the long run, for they were more widely circulated and they could much more easily be copied or adapted by Chinese wood-engravers. In 1598 Father Longobardi had written to Rome for devotional books by Father Nadal. 'Particularly to help illiterates,' he added, 'it would be especially valuable if you could send me some books which represent the figures of the faith, the commandments, the mortal sins, the sacraments, and so on. Here all such books are considered very artistic and subtle because they make use of shadows, which do not exist in Chinese painting.'

In 1605 there arrived in Nanking a copy of Nadal's Life of Christ, Evangelicae Historiae Imagines, published by Plantin in Antwerp in 1593 with 153 engravings, chiefly by the Wierix brothers, after paintings by Bernardino Passeri and Martin de Vos. Ricci at once wrote for another copy for the Peking mission. These exquisite engravings, in which successive events in the life of Christ are illustrated in detail, with masterly perspective and a dramatic use of chiaroscuro, must have made a profound impression. The simpler European engravings too aroused admiration, even at second hand, and Ricci tells of presenting to a mandarin a copy of Aesop's Fables, probably engraved in Japan by students of Nicolao, which the gentlemen treasured 'as if it were a masterpiece of Flemish printing'.

The big volumes in which the cities and landscape of Europe are spread across a double folio page, such as Braun and Hogenberg's Civitates Orbis Terrarum, achieved another effect which Ricci does not mention, and certainly would not have thought important. There are features in the style and technique of some seventeenth-century Chinese landscape painters that can only be explained by supposing that they had seen some of these engravings. I will have more to say about this later.

Only in two or three cases can we be sure that the painter actually knew the Jesuit missionaries personally. In 1597 the landscapist and critic Li Jih-hua (1565-1635) wrote a rather extravagant ode to Ricci; ten years later in Peking the painter Chang Jui-t'u was one of a stream of gentlemen visitors who called on the great Jesuit. Ricci gave him a Chinese translation of his essay on friendship, De Amicitia. Did Ricci know the great landscape painter and critic Tung Ch'i-ch'ang? Arthur Waley thought he had found a connection between them, which has not been substantiated, and a set of very bad paintings of Christian subjects found by Berthold Laufer in Sian many years ago bear Tung's most improbable signature. If they ever did meet, it would have been through Tung's associates in the Tung-lin Society, a movement dedicated to the reform of the Ming administration. Several of its most prominent members were Christians and very close to Ricci. Such an encounter between the great Jesuit and the most formidable painter and art critic of his day, if indeed it ever took place, would have been a summit meeting indeed.

Towards the end of 1605 the scholar and bibliophile Ch'eng Ta-vu came to Peking from Anhui with a letter of introduction to Ricci from the Viceroy in Nanking, especially to ask him for some specimens of writing to include in a huge miscellany which he was compiling. Ricci obliged, giving him among other things four engravings: of the destruction of Sodom by Crispin de Passe; of Christ and St Peter, by Anton Wierix after Martin de Vos; of Christ on the way to Emmaus, from Nadal's great book, and - an intriguing instance of the peregrinations of a masterpiece - an engraving made in 1597 in Nicolao's academy in Arima after a plate by Wierix, taken from the painting of Nuestra Señora de l'Antigua in Seville. These all appear, somewhat transformed, in 'Mr Ch'eng's Ink Remains' (Ch'eng-shih mo-yüan) of 1606, which has the added distinction of being one of the first books ever produced with woodblock illustrations - though not the Biblical ones - in full colour.

By now interest in European art was lively enough for a Father Sambiaso to be able to publish, in 1649, a little monograph in Chinese, Hua ta, Réponses sur la peinture allégorique, with a preface by Ricci's friend and collaborator Li Chih-tsao. When, in about 1672, Father Verbiest brought out a large map of the world, Father Aleni accompanied it with a two-volume work on cosmography, K'un-yü t'u-shuo (1672), which contained engravings of animals real and imaginary, and of the seven wonders of the world and the Colosseum, the latter derived from the plates engraved by Heemskerck in about 1580. The Seven Wonders were to appear again and again in Chinese illustrated books, and eventually found their way, as did some of the Wierix engravings, into the decoration of early Ch'ing porcelain.

The idea of plasticity, of the rendering of three-dimensional objects as solid forms occupying space – rather than the rendering of space itself – was always foreign to Chinese art. Arbitrary shading and 'painting in relief', as the Chinese critics called it, had been introduced with Buddhist art a thousand years earlier, and had been admired and imitated in some quarters: but these were always looked on as foreign techniques, appropriate for foreign subjects, and faded away as Buddhism lost its hold over China. Now perspective and chiaroscuro aroused the same sort of curiosity. There is in the Bibliothèque Nationale in Paris a volume of finely engraved plates demonstrating the rules of perspective, with the text in Chinese, adapted from the Perspectiva pictorum et architectorum (1698) of Andrea Pozzo, the Jesuit painter whose most spectacular achievement was the decoration of the ceiling of the church of St Ignazio in Rome with a vast allegory of Jesuit missionary work in the four continents. In Peking Father Buglio instructed court painters in the art, and du Halde records that 'he exhibited copies of these drawings in the Jesuits' garden in Peking. Driven by curiosity, the Mandarins came to see them, and were amazed. They could not imagine how one could, on a single sheet, represent the halls, galleries, gateways, roads and alleyways so convincingly that at first glance the eye was deceived.' So fascinated was the Emperor K'ang-hsi by this new art that he asked the Jesuits to send out, with enamellers - another foreign technique for which he had a passion – an expert in perspective.

The mission chose Giovanni Gherardini, a native of Bologna who had worked there and in Modena before he was summoned in 1684 to Nevers, where he decorated the Jesuit church of St Pierre. He then moved on to Paris where he painted

frescoes - strong in perspective, it was said, but weak in colour - for the library of the Jesuit headquarters, now the Lycée Charlemagne. In March 1698 he set sail for China with Father Bouvet and seven other Jesuits on the famous voyage of the Amphitrite (see page 96). Arriving in Peking in February 1700, he decorated the new Jesuit church with illusionistic frescoes, including a 'dome' on the ceiling, which amazed Chinese visitors, and gave instruction in perspective and oil painting to students in the Palace. Eleven years later Father Ripa met seven or eight of his pupils and watched them painting Chinese landscapes, in oils, on tough Korean paper. Gherardini, a layman, evidently found the Jesuit discipline too much for him. By 1704 he was back in Europe, and the sole relic of his journey is his frivolous and highly implausible Relation du voyage fait à la Chine, which the connoisseur and engraver Mariette dismissed, in his Abécédario, as un badinage continuel.

In an appendix to his biography of the academic painter Chiao Ping-chen in the History of Silent Poetry, Chiang Shao-shu puts into the mouth of Ricci a little lecture on Western art, emphasizing its effects of relief and chiaroscuro. Chiang says that Chiao Ping-chen grasped the idea and modified it somewhat, but that 'it did not correspond to scholarly taste, and consequently connoisseurs have not adopted it'. Chiao Pingchen, who probably learned perspective from Father Verbiest in the Imperial Observatory, where he was employed, put his skill to good use in the well known series of forty-eight paintings which he made for the Keng-chih t'u, 'Illustrations of Rice and Silk Cultivation', executed for the Emperor in 1696 and soon after engraved on wood and widely circulated. Much less well known are his scroll paintings. The country scene illustrated on page 51 combines with immense charm and delicacy a traditional composition, an almost Dutch feeling for genre, and a sound, if

somewhat timid, use of Western perspective.

The landscape painter Wu Li (1632–1718) is the best known among all the Chinese artists who came in contact with European culture. A native of Chekiang, he grew up in scholarly circles in Ch'ang-shu, where the French Jesuits had a mission. He got to know them well, and in 1676 painted a landscape, Spring Colours in Lake and Sky, for Father Louis de Rougemont, a protégé of the pious Candide Hsü. In 1681 he was baptised, and in the same year set off for Macao en route to Rome. Afraid, it has been suggested, of a long sea voyage, he chose to stay in Macao, and began his training there as a novice in 1682.

61

After his ordination as Père Acunha in 1688 Wu Li returned to Kiangsu, to spend the rest of his life, chiefly in the Shanghai area, in the service of the church, to which he gave himself humbly and completely. We know practically nothing of his later years. For a time he seems to have lost touch with many of his former friends and associates. Louis Pfister, quoting an unnamed nineteenth-century manuscript biography of Wu Li, says that he repented of his pagan youth, and called in and destroyed as many of his old pictures and poems as he could lay his hands on, because they contained 'superstitious matter', and that he now composed, instead of poems to his friends, sacred songs to God, the Virgin, and the angels. But an unknown Chinese writer says that the later paintings became even freer and more original. It seems that he did stop painting for a considerable time, only returning to it, and to some of his old friendships, after about 1680. None of his work shows any obvious Western influence, although the negative effects of his isolation from his scholarly friends may perhaps be discerned in a certain hardening of his brushwork in paintings having dates in the 1680s and 1690s. One of his later poems suggests that he never had practised Western techniques. A quatrain that he wrote on a painting for a parting friend in 1704 ends with these lines:

In my old bag [that is, my repertoire] are no Western things at all, So I paint a plum branch and present it to you.

Nevertheless, Wu Li must certainly have seen a great deal of Western painting and engraving in the Jesuit mission churches and libraries, and he wrote a brief and sensible account of the differences between Chinese and Western art that is worth quoting. After speaking of customs, he goes on:

In writing and painting, the differences are just as striking: our characters are made by gathering dots and strokes, and the sound comes afterwards; they begin with phonetics, then words, making lines by scattering hooks and strokes in a horizontal row. Our painting does not seek physical likeness [hsing-ssu], and does not depend on fixed patterns; we call it 'divine' and 'untrammelled'. Theirs concentrates entirely on the problems of dark and light, front and back, and the fixed patterns of physical likeness. Even in writing inscriptions, we

write on the top of a painting, and they sign at the bottom of it. Their use of the brush is also completely different. It is this way with everything, and I cannot describe it all.

None of the Chinese seventeenth-century landscapes which seem to hint at the possibility of Western influence are actually direct copies of European works. Rather what emerges, here and there, is a new approach to the rendering of form in nature, and a little widening of the range of subject-matter that can be depicted. In painting mountains, rocks and terrain generally, there is sometimes a sharper edge and a more calculated grading of tone to render form more objectively; the continuously receding ground is made more explicit; the transitions from light to dark produce a more telling and illusionistic chiaroscuro; shading is used to suggest a single light source; most important, the free, calligraphic brushstroke is replaced by an even, close-knit texture of dots and strokes that sometimes suggests engraving, and in the process the ink wash inevitably loses some of its transparency.

Many of these qualities can be found in the landscapes painted by the professional artist Wu Pin in about 1605, and by the Kiangsu painter Chao Tso, active about 1600-30, when the first little wave of Western influence was at its height. That morose eccentric Kung Hsien (c. 1640-1689), the greatest of the Nanking painters, achieved a powerful chiaroscuro by stippling. For the 'uncalligraphic' ink blob there is the august precedent of the Sung master Mi Fu; but Mi Fu's ink was, we assume, wet, luminous and transparent, while Kung Hsien's dry, opaque surfaces produce a deadening effect, giving his landscapes an un-Chinese coldness and stillness. Such movement as they possess is expressed in the contorted shapes of rocks and hills rather than in the brushstroke itself. It is hard to believe that Kung Hsien had not seen, possibly at the Jesuit mission in Nanking, engravings such as those in Braun and Hogenberg's Civitates Orbis Terrarum.

Occasionally a subject seems to be borrowed straight from Western art. Ch'en Hung-shou's studies of butterflies hovering over flowers may have been inspired by engravings such as those in Pierre Vallet's botanical work Le Jardin du Roy très Chrestien Louis XIII de France, published in 1608; while the motif of a group of men seated in a circle on a flattened hilltop, which occurs several times in Nadal's Evangelicae Historiae Imagines, is repeated in Wu Pin's handscroll Occupations of the Months

32, 33

(National Palace Museum, Taipei), and in a woodcut view of the scenery near Nanking in the 1608 edition of the Ming pictorial encyclopaedia San-ts'ai t'u-hui. Both these motifs, how-

ever, appear also in Sung Dynasty painting.

But it is chiefly in details rather than in composition or general theme that these new elements emerge in Chinese seventeenthcentury landscape painting: a building carefully mirrored in the water (Wu Pin); a sunset (itself a rare subject outside early Buddhist painting) reddening the sky and reflected in the water, or shooting out its rays in radiating lines (Wu Pin again); smoke curling up from a cottage chimney (Wu Pin); continuously receding ground line (Fan Ch'i); the horizon at sea shown by a sharp straight line across the picture with islands sitting on it, rather than being indicated only by the islands and land-spits (Fan Ch'i); objects shaded to suggest volume (Ting Kuan-p'eng); accurate perspective and foreshortening (Chiao Ping-chen). Most inexplicable except in terms of direct Western influence is a new boldness and realism in the use of colour which appears for the first time after 1600 in the work of artists such as Lan Ying and Hsiang Sheng-mou. A leaf from an album of 1649 by the latter artist depicts with thoroughly un-Chinese realism a bare tree against a blue mountain, the sky behind reddened by the setting sun. Such colouristic effects must have seemed much too obvious for cultivated Chinese taste, for they were not repeated in the painting of the literati.

Some of these effects – foreshortening, shading and the receding ground-line, for example – appear in that remarkable monument of late Northern Sung realism, the handscroll Going up River at Ch'ing-ming Festival Time, by Chang Tse-tuan. But now, after a lapse of five hundred years, they appear again in company with others that are entirely new. It seems that the revival, or perhaps the rediscovery, of some elements of realism, and the first appearance of others, can only be explained by the stimulus of European art. Every one of these effects that does not involve the use of colour could be accounted for by supposing that the artists had seen engravings like those in

Nadal.

Not far from Nanking lies Yangchow, the prosperous city at the junction of the Yangtse and the Grand Canal which by the end of the seventeenth century had become a centre of liberal patronage and eccentric painting. Perhaps in the work of the Yangchow artists Yüan Chiang and Li Yin we see a hint of Western influence, grafted on to their very original interpreta-

38

34

35

37

tion of the landscape style of Northern masters such as Fan K'uan and Kuo Hsi. In fact, the marriage is not an unnatural one, for Northern Sung painting was – on its own terms – highly realistic, and these later painters may have found that the study of European engravings helped them to obtain a monumental antique effect, although the direct evidence for this is lacking. Yüan Chiang was summoned, some time after 1723, to the Palace, where for nearly twenty years he worked alongside the Jesuit painters and craftsmen under conditions bordering on slavery. But the style that suggests that he knew something of Western art was formed long before then, and the datable landscapes of his later years seem to be far less 'European' than those he had painted in Yangchow.

One area in which we might expect to find Western influence is that of portrait painting, for the traditional Chinese portrait is seldom a physical likeness of the subject. It is rather an attempt to capture his 'spirit', or his rôle as emperor, official, scholar or poet; the features, unless he has striking peculiarities, are of little importance. Chinese connoisseurs found in Western portraits a new kind of realism. Writing of those by the Fukienese artist Tseng Ch'ing, who died in Nanking in 1650, the author of the History of Silent Painting describes how 'their eyes seem to move and follow you like the eyes of living people', and notes that Tseng Ch'ing used several layers of colours in painting the faces. His surviving portraits are all in ink with only slight colour, but they look straight out of the picture, and the faces are modelled in light and shade. In their directness and realism they have - though the modelling is much subtler something in common with Ming ancestral portraits, done by craftsmen who so far as we know had no contact whatever with Western art, and whose 'likenesses' were achieved by assembling features out of a pattern-book shown to the subject while alive, or to the grieving relatives after his death.

Certain eighteenth-century court painters, notably Leng Mei, Tsou I-kuei, and Shen Yüan, show unmistakable signs of Western influence in their work. There were other early Ch'ing painters such as Fa Jo-chen, Shang-kuan Chou and Lu Wei in which Western influence is less obvious but still discernible. In the little album-leaf by Lu Wei from the Vannotti Collection, the definition of planes by contrasts of light and dark, the skilful foreshortening of the fence, and the straight row of trees in the distance are technical innovations that the artist might have picked up from the study of Western engravings. Such borrowings

are elusive and difficult to substantiate; they need to be further investigated.

The Eighteenth Century

With the arrival in Peking, in December 1715, of Giuseppe Castiglione, a young Milanese Jesuit trained in Genoa, the court at last acquired a European painter of some quality – a man who was destined to have a considerable impact on Chinese court taste for over half a century. En route, he had spent four years in Portugal, where he had decorated the chapel of the Jesuit Novitiate in Coimbra with frescoes of the life of St Ignatius Loyola. But if he imagined that his career in China would likewise be dedicated to the decoration of Christian churches, he was in for a cruel shock.

Within a short time of his arrival in Peking Castiglione, bearing the Chinese name Lang Shih-ning, found himself at the work-benches in the dismal atelier that occupied one corner of K'ang-hsi's huge, rambling country palace, the Yüan-mingyüan. In these crowded, malodorous workshops, 'full of corrupt persons', as one of the Jesuits put it, Lang Shih-ning and Father Matteo Ripa, another recent arrival, slaved away at enamelling on porcelain. The Jesuits were prepared to do almost anything to further the aims of the mission - tout pour l'amour de Dieu - but this was too much. They petitioned to be excused, and only succeeded by painting so clumsily that the Emperor reluctantly released them, though not to the kind of freedom which they had hoped for. Jean-Denis Attiret, who joined Lang Shih-ning in 1738, complained bitterly that they were forced always to work in the Chinese medium, and never had the time, or energy, for the devotional pictures which they longed to paint. Though loaded with honours, Lang Shih-ning and Attiret found no relief from unremitting labour. In 1754, when he had been working night and day for several weeks in Jehol, painting portraits and commemorative pictures for the Emperor, Attiret wrote to Father Amiot in Peking: 'Will this farce never come to an end? So far from the House of God, deprived of all spiritual sustenance, I find it hard to persuade myself that all this is to the glory of God.' Lang Shih-ning spent the rest of his life in the service of three emperors, K'ang-hsi, Yung-cheng and Ch'ien-lung, gradually perfecting a synthetic style in which with taste, skill and the utmost discretion, Western perspective

and shading, with even on occasion a hint of chiaroscuro, were blended to give an added touch of realism to paintings otherwise entirely in the Chinese manner.

From April 1723, reported Father Amiot,

Our most dear Castiglione has been daily occupied in the Palace, with his art . . . which has been thoroughly investigated by the 13th Prince and by the Emperor [Yung-cheng], first in enamel painting, then in the usual technique, whether in oil or in watercolour. By imperial order he had to send the ruler whatever he did. It can be said that his works have succeeded in winning the Emperor's favour, for he has on various occasions benignly praised the artist, and sent him gifts, even to a greater degree than his deceased parent. Frequently . . . dishes were sent from the Imperial table; again, the Emperor rewarded him with twelve rolls of the best silk, accompanied by a precious stone, carved in the shape of a seal, with the effigy of Christ our Saviour, on a cross. Latterly he was presented with a summer hat, which gift denotes great honour.

The Emperor Ch'ien-lung (1736-96) was as lavish in his praise of Lang Shih-ning as his father and grandfather before him, and as exacting in his demands. Before long the Jesuit found himself appointed chief architect for the new complex of buildings in the north-east corner of the Yüan-ming-yüan, Ch'ien-lung's 'Garden of the Everlasting Spring', Ch'angch'un-yüan. There Lang Shih-ning designed a series of palaces, pavilions and terraces in an ornate, pseudo-rococo style which vastly pleased the Emperor. These structures, the product of the Jesuit's fertile imagination, lack of professional training, and remoteness from any possible critics, must have given him enormous pleasure too, for this seems to be the one occasion in his career at court when he was able to do exactly what he pleased. Between his pavilions stood huge fountains, worked by machinery designed by Father Benoist, that were Ch'ienlung's special pride.

Ch'ien-lung filled these remarkable buildings with the furniture, clocks, pictures and mechanical toys sent out by Louis XIV and Louis XV. On the walls of one of the pavilions he hung tapestries designed by Boucher, the *Teintures Chinoises*, which were said to have been based on sketches made in the Forbidden City by Lang Shih-ning's young Jesuit colleague Attiret. Could Ch'ien-lung have imagined that these charming chinoiseries were meant to depict his own court? Perhaps he thought they represented Versailles. Another pavilion was built to accommodate the set of Gobelins tapestries sent out by Louis XV in 1767.

Just as it amused Louis XV to attire his court on occasion in Chinese dress, so in reverse, with Ch'ien-lung. He had himself and his lovely Mongolian consort Hsiang Fei painted dressed up in European armour and helmet, and there exists a charming portrait of the 'Fragrant Concubine', as she was called, dressed en paysanne, with a shepherd's crook and a basket of flowers – a figure straight out of Boucher, possibly painted by Attiret or one of his pupils.

When not employed in painting portraits of the Emperor, or historical events in his reign, or decorating the walls of the Yüan-ming-yüan, Lang Shih-ning devoted himself to painting scrolls depicting the Emperor's favourite pets, auspicious plants and horses. Occasionally he painted landscapes, and his tall landscape in the National Palace Museum is, except in some details, a clever pastiche of the manner of the seventeenthcentury orthodox literary painter Wang Hui. Perhaps his most successful blending of Chinese and European methods was attained in the long hand-scroll, A Hundred Horses in a Landscape, which he painted for Yung-cheng in 1728. The continuous perspective, required by the hand-scroll format, is of course Chinese, but the depth achieved by means of a continuous ground plane is Western, as are the reflections and shadows. But the extreme restraint with which they are used is a concession to Chinese taste; while Chinese conventions for mountains, rocks and trees are transformed by a quite Western realism in the drawing. In all, this is a brilliant synthesis, cleverly calculated to give the Emperor enough of Western realism to delight him, but not so much as to disconcert.

The large panel on silk from a private collection in London seems to belong to this group of courtly portraits painted by the Jesuits and their pupils. An elegant young lady sits in a foreign chair, wrapped in velvet, with a fur-trimmed muff, looking tranquilly down at the little servant girl warming her hands at the charcoal brazier, while another brings what looks like a Dutch coffee pot, jug and teapot on a tray of mother-of-pearl. The setting is subdued rococo; the painting of many details, such as the glass bulb-bowl, the landscape over the door, the furniture and brackets, and above all the lively, delicate treat-

42

43

IV, 44

V

ment of the lady's face, with its deft highlights and shadows, proclaim the hand of a European, possibly working with Chinese assistants.

Who this European was is not known. The peculiar charm of the figures is French rather than Italian. In a letter of November 1743 Attiret wrote that he painted chiefly in water-colours on silk, or in oil on glass, and seldom in the European manner, except for his portraits of 'the brothers of the Emperor, his wife and several other princes and princesses of the blood, and certain favourites and other seigneurs'. Not only is the central figure disproportionately large, but her face is painted with a care and realism not devoted to the others. This suggests that it is a portrait, and not merely a decorative composition, though whether it is indeed by Attiret we cannot of course be certain.

In his large compositions Lang Shih-ning sometimes cooperated with a Chinese court painter, the Jesuit putting in the figures, the Chinese the landscape. Among Lang Shih-ning's known collaborators were Ting Kuan-p'eng, Ch'in K'un and T'ang-tai. There was formerly in the Imperial Palace collection an album of illustrations to a section of the ancient Book of Odes, in which the landscapes are by T'ang-tai, the buildings by Lang Shih-ning, and the figures and animals by Shen Yüan, one of the artists who produced a series of forty views of the

Yüan-ming-yüan.

Perhaps it is the hand of T'ang-tai, collaborating with Lang Shih-ning, that we see in a huge and remarkable painting now hanging in the Stanford Museum, known as the Night Market at Yang-ch'eng. The picture is signed with Lang Shih-ning's name and the date 1736, but this may have been added later. The Night Market depicts with a wealth of fascinating detail the life along a river bank outside a city wall on a summer night. There are pedlars and boatmen, wine-shops and roadside stalls, drawn in the Chinese medium yet obviously by a European, who has exchanged his pen for a Chinese brush. His handling of light and shadow, of human anatomy and the very texture of walls and roofs could not have been learnt in Peking; and there are details, such as the gentleman stepping ashore from a sampan and a girl in a boat drawing water from the river, which look very French, as though the painter had studied engravings after Watteau and Boucher. In the distance there rises a mountain landscape bathed in moonlight, and executed, unlike those in the Hundred Horses scroll, by an unmistakably Chinese hand. It may be that the Night Market represents no actual place, but

was painted to give Ch'ien-lung an idea of how his subjects might spend a hot summer night. The origin and history of this painting before the twentieth century are a mystery. It bears no imperial seals, and, like many of the works of the court painters, may have been painted simply as a wall decoration for one of the pavilions of the Yüan-ming-yüan. If so, it must have been taken down long before that great, rambling complex of buildings and gardens began to decay, for it is still in excellent condition.

In 1762 Ch'ien-lung completed the conquest of Turkestan, and his generals returned in triumph to Peking. The Jesuits had shown him engravings after the panoramic battle pictures of Georges Philippe Rugendas of Augsburg (1666-1743), and possibly also others after Jacques Courtas, le Bourguignon (1621-76), and these seem to have inspired the Emperor to celebrate his own victories in similar fashion. Sixteen pictures were executed under the direction of the Jesuits, who presumably made the preliminary drawings and supervised the making of the enlarged coloured versions. In addition to Lang Shih-ning and Attiret, the work was directed by Ignace Sichelbarth (1708-80), who had arrived in 1745 and a few of whose wretched Castiglionesque paintings survive in the National Palace Museum, and by Jean-Damascène Sallusti, an Augustinian father who became Bishop of Peking after the suppression of the Jesuit order in 1773. The sixteen huge battle paintings were hung in the Tzu-kuang-ko, a hall in the western part of the Forbidden City where foreign ambassadors were received. Above them were arranged the portraits of fifty victorious generals, mostly painted by Attiret.

In July 1765 the Emperor ordered the Jesuits to make ink copies of the battle pictures to be sent to Europe to be engraved. Lang Shih-ning intended them for Rome, but when the first batch of four reached Canton the French mission there intercepted them and persuaded the Viceroy to direct them to France, whose engravers, they said, were the best in Europe. The drawings arrived in Paris in the autumn of 1766. Bertin, Minister to Louis XV, saw that they were put into the hands of the Director of the Royal Academy, the Duc de Marigny, who, on seeing them, wrote to Attiret that his drawing was very much in the Chinese manner. This must have pleased the Jesuit, for he had said of himself that his own taste, since he had been in China, had become 'a little Chinese'.

The remaining twelve drawings reached Paris by 1772 and

the set of sixteen magnificent plates, meticulously engraved by Le Bas, Saint Aubin and others under the direction of Cochin, was completed two years later. By this time the style had, apart from a vaguely exotic treatment of the mountains, lost all its Chinese flavour. With the exception of a few sets kept back in Paris, the whole edition of two hundred impressions, with the original drawings and the plates, was, at the express order of Ch'ien-lung, sent back to Peking in December 1774.

The Emperor presented sets to imperial relatives and deserving subjects, and they were immensely admired. He then set out to show that his own engravers could do just as well. He can hardly have been aware of how little developed the art of copperplate engraving was in China. Very shortly after arriving in Peking in 1711 Father Matteo Ripa had been obliged by K'anghsi to execute some Chinese landscapes in oils, for which he was ill-fitted. 'I recommended my efforts to the direction of God,' he wrote, 'and began to do what I had never before undertaken.' The Emperor was satisfied. 'Thus I continued to paint till the month of April, when His Majesty was pleased to command that I betake myself to engraving.' Of this latter art Ripa knew even less. When called upon to engrave the huge maps prepared by the Jesuit Fathers, he had to build his own press and make his own ink. K'ang-hsi was so pleased with the result that he ordered Ripa to make thirty-six engravings, after paintings by court artists, of the summer palace at Jehol. In these, the first copperplates (apart from the maps) engraved in China, Ripa with naïve and cunning charm manages to convey something of the quality of the Chinese brush technique. When these engravings later appeared in England they, and Ripa's descriptions, exerted a major influence on the revolution of English garden design initiated by William Kent.

Ripa left for Europe in 1723, but Lang Shih-ning kept the craft going in the Imperial Printing Office, Ts'ao-pan ch'u, and supervised the delightful set of plates of his fantastic Sino-rococo pavilions in the Yüan-ming-yüan, engraved in 1786. In Ch'ien-lung's lifetime five more sets of campaign engravings were produced by his Chinese craftsmen. The sixth and last, cut in about 1830 after designs by Ho Shih-k'uei, depicts in ten plates the suppression of the rebellion of Jehangir in East Turkestan. These later plates, by many hands, are varied in style and sometimes awkwardly composed, but they show a determined attempt to follow the model of the original Conquests series, even using the same landscape elements over and

over again. Interesting as they are, however, they represent a stream in eighteenth-century court art which had little influence

outside the Palace, and soon dried up altogether.

The halcyon days of the Yüan-ming-yüan ended with the abdication of Ch'ien-lung in 1796. By then Father Benoist had long been dead, and his defunct mechanical fountains were being supplied, on special occasions only, by chains of men with buckets. Ch'ien-lung's successors continued to use the royal apartments of the Yüan-ming-yüan, but Chia-ch'ing (1796-1820), weighed down with debts, was rigidly economical, and there were no more extravagances. Already the Yüan-mingyüan was becoming a place of ghosts and memories, while neglect and pilfering were beginning to take their toll. When Lord Elgin's punitive force put it to the torch in October 1860 only the royal apartments were in decent order. In fact, contrary to popular belief, the British and French managed to destroy only a small part of this vast complex of over two hundred buildings. In spite of the looting that went on for years afterwards there was enough still standing for the Empress Dowager to embark in the early 1870s on a costly restoration. But in the face of popular protests this was abandoned in 1874. and the dismantling was resumed; even the wooden piles were dug up and sold for fuel. Today Ch'ien-lung's great fairy palace, in which, long ago, the Jesuits had staged an Italian light opera, and Hsiang-fei had dressed up as a French peasant girl, has disappeared off the face of the earth.

In 1772 Father Giuseppe Panzi arrived from Paris as a replacement for Attiret. Though his patron dismissed him as obsequious, he sounds from his letters a delightful man, charitable, modest and gay. 'Tout pour l'amour de Dieu!' he wrote home. Je suis le peintre, ou mieux le serviteur de la mission pour l'amour de Dieu.' He painted a portrait of the Emperor soon after his arrival, and other portraits of high officials and Jesuit missionaries; but little is known about his work, and it is doubtful whether, with Ch'ien-lung old and tired, and his successor Chia-ch'ing immersed in his inherited problems, Panzi was able to sustain his enthusiasm. He died, very old and obscure, in Peking in about 1812 or a little earlier. We hear of two more European painters in the service of the Chinese court before the curtain descends: Joseph Paris, a mechanic, clockmaker and painter of sorts sent out by the Lazarists in 1784, who worked in Peking for twenty years; and Father de Poirot, who lingered on till 1814.

36 Chang Tse-tuan (Northern Sung, early twelfth century). Going up River at Ch'ing-ming Festival Time (detail). Handscroll. Ink and slight colour on silk.

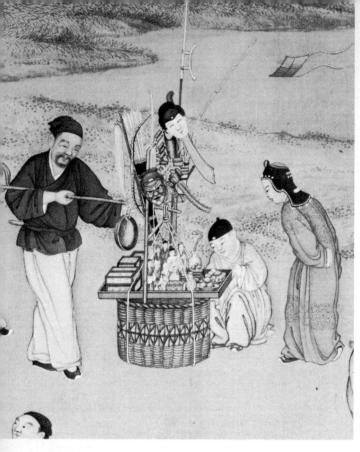

37 Ting Kuan-p'eng (fl. c. 1714–60). Toyseller at New Year (detail). Handscroll. Ink and colour on silk. Mid-eighteenth century

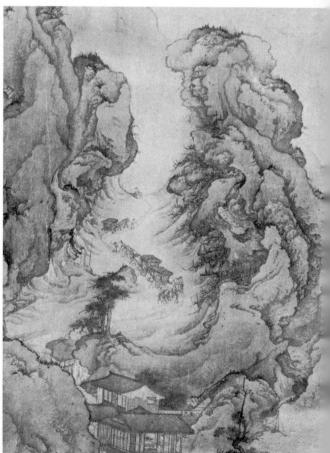

38 Yüan Chiang (fl. c. 1750). Carts on a winding mountain road (detail). Hanging scroll. Ink and colour on silk. 1754

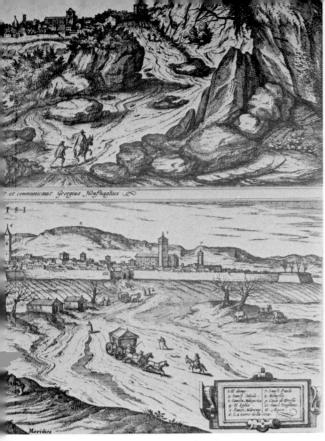

39 Aquapendente and Tarvisi. Engravings from Georg Braun and Franz Hogenberg, Civitates Orbis Terrarum (edition published c. 1598)

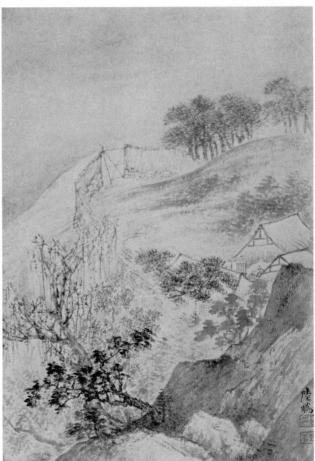

40 Lu Wei (fl. c. 1700). Landscape. Album leaf. Ink on paper

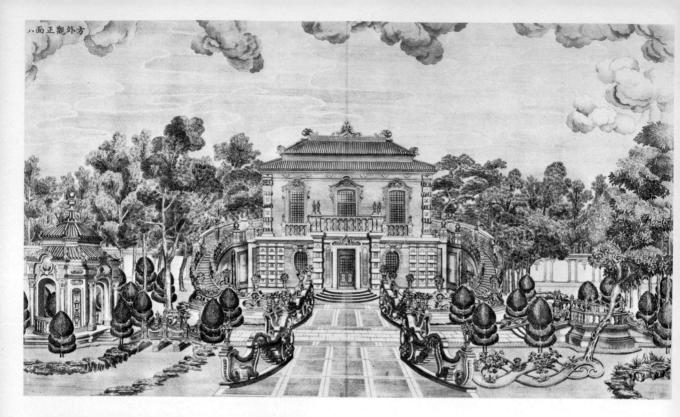

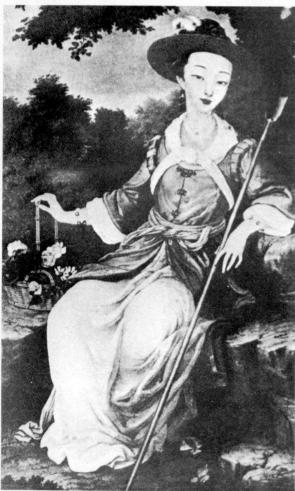

41 Anonymous follower of Lang Shih-ning (Giuseppe Castiglione, 1688–1766). Foreign building in the Yüan-ming-yüan. Engraving. 1783

42 Anonymous. Portrait of Hsiang Fei dressed en paysanne. Mid-eighteenth century

43 Lang Shih-ning. Landscape with scholar reading. Hanging scroll. Ink and colour on silk

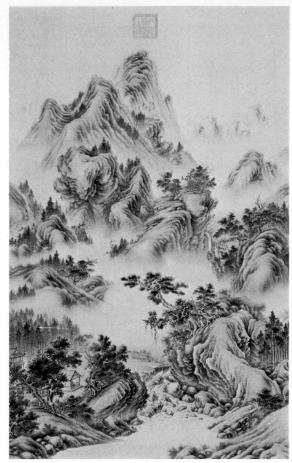

44 Lang Shih-ning. A Hundred Horses in a Landscape (detail). Handscroll. Ink and colour on silk. 1728

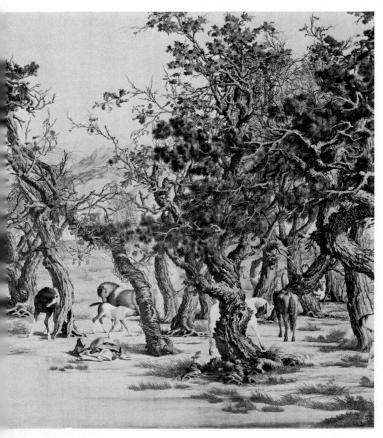

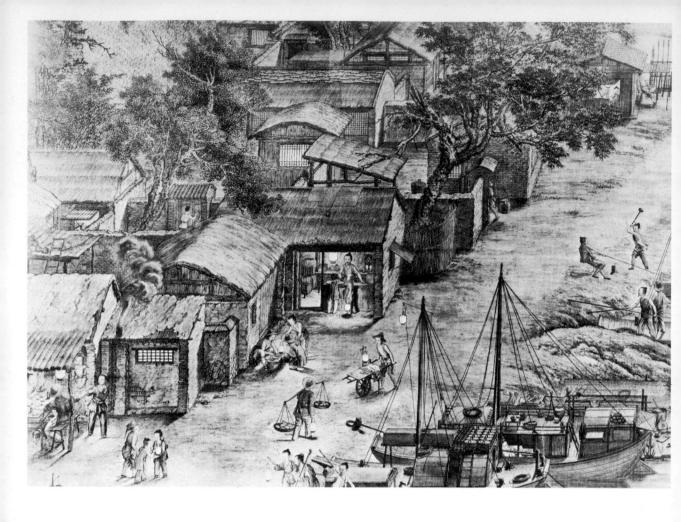

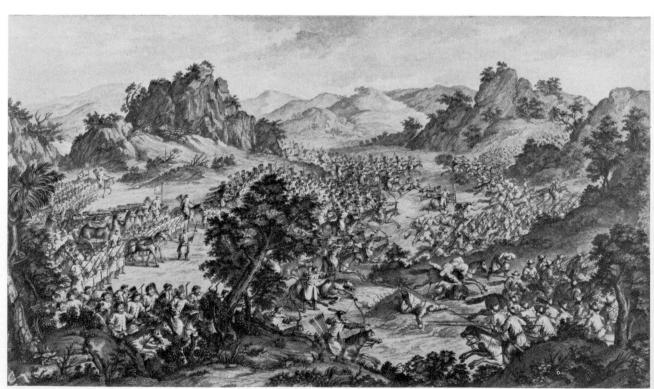

46 Anonymous. Ch'en-lung's conquest of Turkestan. Engraving made in Paris after a painting by Jean-Damascène Sallusti. 1770

Trien in ioniciony - Ligura del (illo prifetant distribus - Vetutos del Tempio dell'Addi, che L. Impi alle me donne divina. Questo Tompio e uficiato ecuparito notale di da implii Sacerioti dell'Idile, ma questi son tutti Lanuchi. Sià vituato si d'un Islatta religion -

47 Matteo Ripa. Copperplate engraving from 'Thirty-six Views of the Pi-shu Shanchuang' (Summer Palace at Jehol).

48 Anonymous. Page from one of a set of albums containing Chinese landscape paintings, executed for A. E. von Braam Houckgeest, Dutch Ambassador to the court of Ch'ien-lung. Ink and colour on paper. 1704

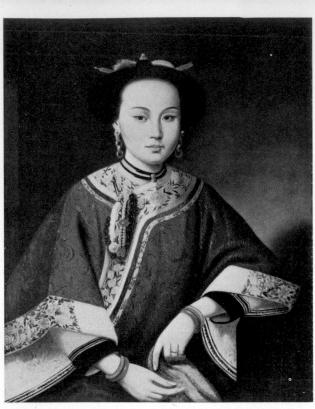

49 Anonymous follower of Chinnery. Portrait of a Chinese girl. Oil. Early nineteenth century

50 Lamqua. Riverside at Canton: one of a pair of paintings. Oil. $\it C$. 1830

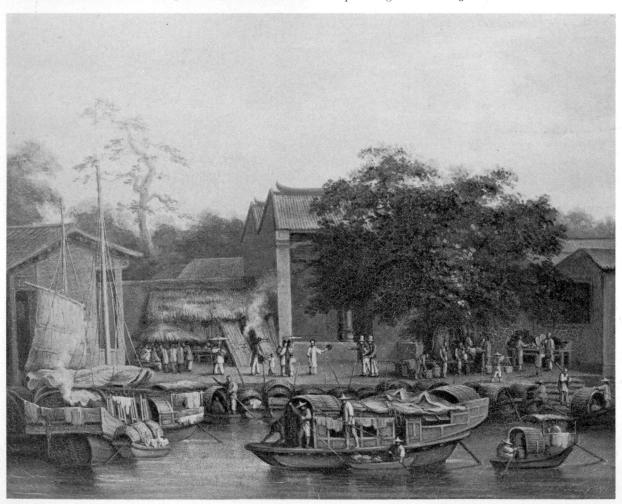

51, 52 Rembrandt van Rijn (1606–69). Two Indian noblemen of the Mughal court: man with a falcon and Abd al-Rahim Khan with bow and arrow. Pen and ink with touches of chalk gouache on Japanese paper.

C. 1654–6. (Below) Winter Landscape. Reed pen and bistre ink with added wash. C. 1647

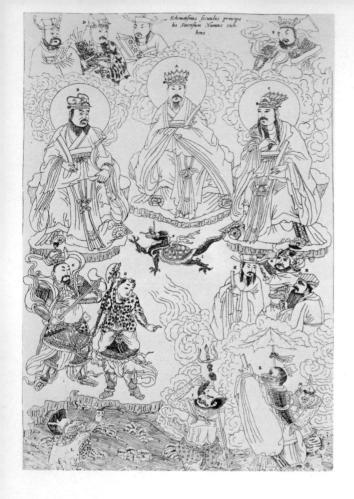

53 Anonymous. Chinese deities. Engraving from Athanasius Kircher, China Illustrata (1665)

54 Anonymous. Lady with a bird. Engraving from Athanasius Kircher, China Illustrata (1665)

55 Anonymous. Higiemondo. Engraving from Joachim von Sandrart, Teutsche Akademie der Bau-, Bildhauer- und Malerkunst . . . (1675)

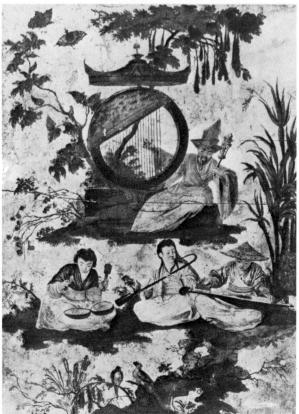

56 Antoine Watteau (1684–1721). *Chinoiserie*. Panel from Château de la Muette

57 Antoine Watteau. *Chinoiserie*. Panel from a harpsichord. Oil on panel. 1708

Empereur Chinois En habit de Ceremonie a la Chinoise This is a good moment to ask ourselves what the missionary artists accomplished during their two hundred years of dedicated work in China. When we think of the intense interest which they aroused in the seventeenth century we cannot help being surprised that their ultimate achievement was so meagre. Although in the eighteenth century they only painted for the emperors, many scholars and officials at court must have seen their work. Yet hardly one thought it worth mentioning. The influence of Western art, if it did not peter out altogether, trickled like sand down to the lower levels of the professional and the craftsman painters, where it stayed till modern times.

The explanation is not far to seek. In the late Ming period some enlightened intellectuals - as in Japan a century later looked to the Jesuits for leadership or support, and Western culture was eagerly studied. This was the only time when the literati took Western art seriously. But with the re-establishment of stable authority under the Manchus they no longer needed, or perhaps no longer dared, to associate too closely with the foreigners. From the time of K'ang-hsi until the Opium War, China felt she could afford to ignore European culture. As Ch'ien-lung made plain in his celebrated letter to George III. she needed nothing from the 'Outer Barbarians'. Western thought was almost unknown, Christianity was kept very firmly in its place, Western technology and the Western arts were confined to serving Ch'ien-lung's own domestic and courtly needs. Besides, Western painting had one fatal flaw, which the court artist Tsou I-kuei summed up in these words:

The Westerners are skilled in geometry, and consequently there is not the slightest mistake in their way of rendering light and shade [yin-yang] and distance (near and far). In their paintings all the figures, buildings, and trees cast shadows, and their brush and colours are entirely different from those of Chinese painters. Their views (scenery) stretch out from broad (in the foreground) to narrow (in the background) and are defined (mathematically measured). When they paint houses on a wall people are tempted to walk into them. Students of painting may well take over one or two points from them to make their own paintings more attractive to the eye. But these painters have no brush-manner whatsoever; although they possess skill, they are simply artisans [chiang] and cannot consequently be classified as painters.

'No brush-manner whatsoever' - there is the key. To the

58 Pierre Giffart. Empereur Chinois. Engraving from Joachim Bouvet, L'Estat présent de la Chine en Figures (1697) Chinese gentleman painter who aimed at a triple synthesis of painting, poetry and calligraphy, what had the laborious realism of Western oil painting to do with fine art?

Early Nineteenth-century Contacts in South China

While the foreigners and foreign art were slowly but surely losing their foothold at court, they were beginning to make a very different kind of impact on the South China coast. Macao. a larger and much more accessible Deshima, had been the centre of Portuguese influence since early in the sixteenth century. In the eighteenth century foreign ships were trading direct with Canton. The Cantonese craftsmen were immensely skilled in imitating and adapting European styles and techniques to textiles, screens, furniture, porcelain and a dozen other products made for the European market. This export art, however, which has been exhaustively studied, made almost no impact on what we may call 'fine art' in South China. The gentlemen amateurs continued to paint in the traditional style, being if anything less curious about Western painting than had been some of the seventeenth-century literati who had consorted with the Jesuits. On the other hand, a good deal of semi-foreign painting was produced in Canton from about 1750 onwards, some of it of great charm and delicacy, and much of it wrongly attributed by dealers to Lang Shih-ning and his pupils.

The reason for the lack of any European influence in South China at a higher level was that the foreigners were for the most part merchants who had little interest in art, and formed few contacts with educated Chinese, or none at all. As for the missionaries, there were no Catholic painters to replace the Jesuits, and fine art withered in the evangelical fire of the Protestant pioneers. From this time forward such influence as the Christian missions had on Chinese painting was wholly bad.

In the century between 1750 and 1850 a number of Western painters travelled in China, or settled on the coast, and sometimes their activities were noted, if not always correctly. A Chinese historian of Ch'ing painting records that 'an envoy from England came bringing tribute during the years of Ch'ien-lung and Chia-ch'ing. As he travelled through the country he beheld the scenery of lakes and mountains. Thereupon he made some drawings which he took away with him.

48

His figures and houses clearly demonstrate the principles of chiaroscuro and perspective. The method is like *chieh-hua* ['boundary painting', that is, architectural painting done with a ruler] in Chinese painting, and even more refined.' This writer is probably fusing, or confusing, two or more of four artists: the English water-colourists Alexander and Hickey, who accompanied Lord Macartney's mission to Peking in 1792, and Abbott and Fielding, who were with the abortive Amherst mission in 1816.

Macartney's secretary John Barrow has much to say about Chinese painting in his popular account of the mission, Travels in China. He relates how in the Yüan-ming-yüan he saw two very large landscapes in a Sino-European style, and some albums of the ever-popular trades and occupations, all bearing the Chinese signature of Castiglione. When he pointed out to his Chinese guide, who admired them exceedingly, that they were painted by a foreigner, the eunuch was very annoyed and refused to show him any more. Barrow thought that the Cantonese painters were better than those in Peking, for they painted flowers with painstaking accuracy for their foreign clients, and they 'will even count the number of scales on a fish, and mark them out in their representation', while they copied exactly, even to the blemishes, the coloured prints sent out from Europe. Like most foreign observers Barrow thought Chinese painting the better, the less Chinese it was.

Other European painters visited China from time to time. John Webber was the official artist on Captain Cook's third voyage, which touched at Macao early in 1777. Thomas Daniell and his nephew William were in India – and, more briefly, in South China – between 1784 and 1794. James Wathen, a retired glover from Shrewsbury, painted charming watercolours in Macao in 1812. A more considerable artist was Auguste Borget (1808–77), an intimate friend of Balzac; he was in Macao for a few months in 1830. If any of these men had Chinese pupils there is no record of them.

By far the best of the China coast artists was George Chinnery. Born in London in 1774, he had studied with Turner and Girtin under Sir Joshua Reynolds at the Royal Academy School, and in 1795 moved to Dublin, where he set up as a fashionable portrait painter and married Harriet Vigne, who was to plague him for the rest of his life. In 1802 they returned to England, and Chinnery immediately set off, alone, to India, where he remained for seventeen years. At length his wife joined

him. He ran up heavy debts, and to escape both from them and from his wife he took ship to Macao, where he landed on 30 September 1830. There he remained for the rest of his life – paying, when he feared his wife might be coming on a convoy from India, a few visits to Canton, and, after the Opium War, to Hongkong.

Chinnery was an able portrait painter, but it is in his small landscape oils and above all in his drawings that his talent shows to best advantage. He was immensely prolific, going out at dawn to draw and paint those watercolours and architectural studies that show him to be a worthy follower of Canaletto. He was a teetotaler, a heavy eater, an entertaining conversationalist, and almost certainly had a Chinese mistress. He gave painting and drawing lessons, chiefly to foreign ladies in Macao. Was the Cantonese painter Lamqua, the 'Chinese Chinnery', one of his pupils? Chinnery denied it, but Toogood Downing, writing in about 1835, tells us that he was, and that he received from Chinnery instruction sufficient to enable him to paint in a tolerable manner after the European fashion'. Lamqua must have made good progress, for ten years later he exhibited at Burlington House a portrait of Captain W. H. Hall, R.N., probably the first work by a Chinese artist to appear in a European salon.

Whether or not Chinnery actually gave Lamqua lessons, there is no doubt that the Chinese was a close student of his work. A pair of riverside scenes in the Alexander Griswold collection (Maryland), signed by Lamqua, are almost exact copies of a pair of Chinnery paintings formerly in the Chater collection, the only difference being that Lamqua has replaced some of Chinnery's figures with top-hatted Europeans, no doubt in the hope that one of the Barbarians would buy them as a souvenir of his years in the East.

Downing gives a fascinating description of Lamqua's bottega in China Street. On the lower floor were craftsmen making figure and ship paintings on rice paper, or copying European engravings, of which Lamqua had a large collection. Some of his assistants, on the other hand, 'confine themselves merely to that style of drawing which exclusively belongs to the Chinese'. Round the corner, at 34 Old Street, was Youqua, whose stamp appears on the back of some flower and plant drawings in the Bibliothèque Nationale in Paris. On the top floor of Lamqua's establishment was the master himself, constantly occupied with painting portraits in oils, yet unfailingly courteous to the

stream of visitors who crowded into his small studio, the walls of which were lined with finished and unfinished portraits of Europeans and Parsees, merchants and sea-captains, 'while here and there may be distinguished the unassuming head of a Chinaman'.

Perhaps the most interesting passage in Downing's chapter on painting in Canton concerns the spontaneous ink paintings of the literati, which he says are very rare. He writes:

There are some sketchy kinds of landscapes in high repute among the natives at Canton, who consider them quite masterpieces. They are very scarce, and consist of rough outlines of trees, rocks, waterfalls, etc., painted with a brush dipped in a single pot of colour. Although to our eye these performances have no merit whatever, except perhaps their freedom, the Chinese reverence them somewhat in the same way as we do the rough sketches in pencil or chalk done by Raphael, Da Vinci, and others of the old masters, and tell you with a chuckle of pleasure that they are 'wery, wery, olo'.

Downing, as we would expect, remarks that these very, very old landscapes are very defective by reason of their total lack of perspective, shading and chiaroscuro; but he does notice them, and even comments on their freedom, and on the high regard in which they were held by the Chinese themselves. This must certainly be the first time in the confrontation of Eastern and Western art that any European writer even mentioned the only kind of painting that the Chinese intelligentsia took seriously.

For twenty years, from 1275 to 1295, Marco Polo was in the service of Kublai Khan. In Peking he consorted with Chinese ministers on equal and intimate terms. He must have known the great savant, calligrapher and landscape painter Chao Meng-fu, Prime Minister and Secretary to the Hanlin Academy, and may even have heard of his wife Kuan Tao-sheng, the foremost woman painter in Chinese history. Yet, as we saw in the previous chapter, never once in his account of Cathay does he mention the landscape painting of these scholarly amateurs, although he admired the historical wall-paintings which he saw in the Palace and in the mansions of the rich merchants. The sole artistic relic of his years in China - symbolic of the craze that three centuries later was to sweep over Europe - is the small vase of white porcelain in the Treasury of St Mark's in Venice, believed on uncertain authority to have been brought back by him.

For a mediaeval merchant-adventurer to have ignored Chinese landscape painting, while being enormously impressed by Chinese architecture and handicrafts, is hardly surprising. The indifference to it on the part of men of taste in the seventeenth and eighteenth centuries is rather harder to understand. On the whole, China was far more receptive to the painting of Europe than were the 'Outer Barbarians', as she justifiably called them, to hers. Europe's enthusiasm for things Chinese was confined almost entirely to the crafts and decorative painting. We are not concerned in this chapter with chinoiserie as such. It is only marginal to our theme, which is not the history of European taste, but an enquiry into how Europe got to know about Chinese art, what she thought of it, and what influence it had, or failed to have, on her own painting. But first we should mark at least some of the steps by which Europe became aware of Chinese art.

Not long after the Portuguese arrived in the Far East – they were in Malacca in 1509, Macao in 1516 – there began a trickle of Chinese ceramics westward that was later to swell into a flood. Among the earliest pieces to arrive in Europe must be the two porcelain vessels which feature in a drawing made by Dürer in 1515, now in the British Museum. This drawing shows two fantastic pillars incorporating Chinese vases – one obviously

blue and white, the other, from its tall slender shape, probably a specimen of the ivory-white Ming ware called Kiangnan Ting. This seems to be the first instance of a European painter of any stature showing interest in any product of Chinese art.

The Portuguese monopoly trade in Chinese ceramics was broken by the Dutch, whose capture of two Portuguese carracks laden with porcelain, in 1600 and 1602, and the subsequent sale in Amsterdam, mark the real beginning of the taste for things Chinese in Europe. In 1596 and 1598 some Chinese portraits appeared in Holland. By the 1630s Chinese porcelain, chiefly blue and white, was appearing in Dutch still life painting. The inventory of Rembrandt's large and heterogeneous collection of objets d'art and bric-à-brac sold at his bankruptcy includes Chinese porcelain bowls and figurines. At one time he owned several Mughal miniatures, of which his copies survive, remarkable for the degree to which he has suppressed his own dynamic calligraphy in order to capture as faithfully as he could the thin, sensitive line of the originals. These copies are on Japanese paper, imported no doubt by the Dutch East India Company from Nagasaki.

It is tempting to believe that Rembrandt might have owned, or seen, Chinese or Japanese paintings. But there is no evidence for this at all. Yet when we look at some of his drawings, notably those sketched freely in ink or ink wash, we find a combination of formal clarity and calligraphic vitality in the movement of pen or brush that is closer to Chinese painting in technique and feeling than anything in European art before the twentieth century. This, in the absence of evidence to the contrary, we must attribute to coincidence and to Rembrandt's unique gifts as a draughtsman. For if he ever did set eyes on Chinese paintings it is unlikely that these would have been the spontaneous ink sketches of the literati and eccentrics, which most resemble his own; for what Europe admired in Far Eastern art was its exquisite, fanciful craftsmanship, and it is highly improbable that any Dutch factor in Deshima would have acquired the sort of sketches that would have struck a responsive chord in Rembrandt.

A number of writers have drawn attention to the strangely Chinese-looking mountain landscapes in the background of certain Renaissance paintings, notably in Sassetta's *Journey of the Magi* and the works of Patinir and Niccolo dell'Abate. The misty crags in Leonardo's *Virgin of the Rocks* and *Mona Lisa* have the same suggestive air, and even the same form, as some

Northern Sung landscapes, particularly those of Kuo Hsi. Although Near Eastern painting seems to have influenced Venetian art in the fifteenth century, I can find no evidence that there were any Chinese landscapes in Europe before the mid-sixteenth century, or that Renaissance painters were influenced by them. The explanation of Leonardo's and Patinir's very 'Chinese' mountains may be that they are not real mountains in nature so much as 'mountains of the mind', the ideal shapes and awe-inspiring crags that we picture when we think of mountains. They may have grown out of the schematic mountains in mediaeval manuscript illumination, just as Sung mountains derived ultimately from the wave-like conventions in Han art. Patinir, Sassetta and Leonardo were not influenced by Far Eastern art but arrived, by somewhat the same psychological process, at a similar concept of what a typical, quintessential mountain should look like.

The collecting of antiquities was a popular pastime among wealthy Italian gentlemen, and the museum as we know it, with its collections catalogued, published and often accessible to the public as well, is essentially an Italian invention. Indeed, it seems that Oriental paintings, however little understood, were on display as works of art in Italy long before they were regarded in the rest of Europe as anything more than curiosities.

In 1585 four young Catholic samurai had arrived in Rome, bearing gifts which included a Japanese landscape painting and other objects which were subsequently presented to the Museum in Verona. The Milanese traveller, collector and scientist Manfredo Settala (1600-1680) owned several Oriental paintings, including a large Buddhist one. The Marchese Ferdinando Cospi presented to Bologna in 1677 a collection which included, among other Orientalia, a copy of the first book published at the Mission Press in Foochow, with engravings after Wierix. Early in the eighteenth century Conte Abate Baldini built up a museum in Piacenza which contained, in addition to very fine Mughal miniatures, two long Chinese hand-scrolls of figure subjects, and 'five pieces of the thinnest silk . . . on them painted two hundred little pictures' - figures and landscapes. Alas, Conte Baldini's heirs did not share his enthusiasm, and his collection was scattered on his death in 1725.

Although it was Italian scholars who first noticed Chinese paintings, and Italian museums that first exhibited them, Italian artists were, as we would expect, indifferent or contemptuous. To painters schooled in Renaissance ideals of form and structure, the expressive function of the line and of empty space in Oriental art would have had no meaning at all. They would have agreed with the verdict of Giovanni Gherardini, whom we have already encountered decorating the Catholic cathedral in Peking. 'The Chinese,' he wrote, 'have as little knowledge of architecture and painting as I of Greek or Hebrew. Yet they are charmed by fine drawing, by a lively and well-managed landscape, a natural perspective, but as for knowing how to set about such things, that is not their affair.' Were all Chinese as convinced as Gherardini claims of the superiority of Western art? We shall return to this question in a little while.

Soon after they were established in the Orient the Iesuits began to send Chinese books and pictures back to Rome, to make the Holy City the first centre of Oriental studies in Europe. In 1635 the German Jesuit scholar Athanasius Kircher was drawn thither by the wealth of Oriental material already to be found there. Thirty years later he published his magnificent China Illustrata, compiled from the accounts of Ricci and others. Several of Kircher's engravings are based on Chinese paintings and woodcuts brought back from Peking by Father Jean Gruber. One, showing the principal Confucian and Taoist deities, is a close copy of a Chinese wood-engraving. Another shows a lady standing by a table with a bird in her hand. The lady herself is certainly taken from a Chinese painting, but to make the scene satisfying to European eyes the composition is filled out with an invented interior and the Chinese character yao, meaning 'very pretty'. To heighten the effect of a cultivated Chinese milieu, the engraver shows a landscape scroll draped artistically over the table in a way that would horrify a Chinese connoisseur. He has even tried to copy the composition, adding a bit of stormy sky to make it more dramatic. This is, so far as I can discover, the earliest representation of a Chinese landscape painting in European art. Kircher makes no mention of it in the text.

Ten years after Kircher's great work appeared, the German art historian Joachim von Sandrart published his *Teutsche Akademie*, which is not only the first Western attempt at a comprehensive history of art, but also the first Western book on art to attempt an assessment of Chinese painting. Sandrart echoes the poor view of it expressed by Ricci and by the Jesuit scholar Alvarez de Semedo, who in 1641 had written: 'In

Painting, they have more curiosities than perfection. They know not how to make use of either Oyles or Shadowing in the Art... But at present there are some of them, who have been taught by us, that use Oyles, and are come to make perfect pictures.' If Europeans admired Oriental painting at all, it was not on aesthetic grounds. A seventeenth-century German collector shocked 'Simplicissimus' (the writer Hans Jacob Christoffel von Grimmelshausen) by preferring his Chinese scroll to an Ecce Homo, but he explained that this was simply because the Chinese painting was the greater rarity.

Sandrart describes in some detail several Chinese paintings which he says are in his possession, one of which shows a lady nursing a child at her breast – a most improbable subject for a high-class Chinese picture – another a lady holding a tame bird in her hand. This sounds so like one of the engravings in Kircher's China Illustrata, which Sandrart would certainly have known, that one doubts whether he ever saw any real Chinese paintings at all. Our doubts are reinforced by his remark that 'in their wretched painting the Indian, Higiemondo, known as the Black – although far removed from real art – was considered the best artist.' And he sets before the eyes 'of the noble reader' the likeness reproduced on page 82. The engraving could be a representation of any genial savage, but where Sandrart found the name Higiemondo is a mystery.

This is a warning to examine carefully authors' claims that their engravings are taken direct from Chinese paintings, for by this time the demand for authentic pictures of China was so great, and the supply so meagre, that illustrators stole from each other openly, and used the same figures again and again. In 1684 Father Couplet returned from China bringing with him a set of portraits of famous men and women painted on silk. Of the engravings which were allegedly made direct from these by Nolin in Paris, only one, a portrait of Candide, niece of Ricci's notable convert Paul Hsü Kuang-ch'i, is actually based on a Chinese painting. The thoroughly transformed portrait of Confucius has a Chinese original somewhere in the background; but the magnificent picture of the King of Tartary bears not the slightest resemblance to a Chinese painting in style or content. In fact all this set, except for the Candide Hsü, was cribbed from Kircher. Other sources well known in France were the Dutch engravings in the Voyages of von Lindschoten (1596), which included pictures of Chinese life and portraits of Chinese merchants, and de Geyer and de Keyser's account of 55

the Dutch embassies, published in Amsterdam in 1665-75, adorned with 150 plates, after illustrations 'made in China from life' by Jacob de Mieurs. This Dutch engraver also owned Japanese prints which he used to illustrate the *Ambassades* of de Kempen and de Noble (Amsterdam 1775). These included a seated warrior – with a dragon amid flames, depicted in a violently Japanese manner – and many genre scenes.

If Europe had had to rely upon the Italian Jesuits for her knowledge of Chinese art it is doubtful whether she would have learned very much, for the paintings which they sent back from Peking mostly stayed in Italy and became known, if at all, through engravings and the kind of descriptions that I have quoted. The situation in Paris may have been different. In 1684 Father Couplet brought a young Chinese gentleman, Shen Fu-tsung (called Chin Fo Cum, Michel Chen, or Mikeln Xin), to Paris, where he was made a fuss of, demonstrated the art of eating with chopsticks before the King at Versailles, and seemed eager to show a group of savants how to write Chinese characters with a brush. One of them describes a visit to the Iesuit Maison de Saint Louis where Shen Fu-tsung and the fathers showed him a number of Chinese portraits of famous men on silk, brought back by Couplet. Whether they looked at any landscapes or other subjects he does not say. Later, Couplet and Mr Shen visited England, and dined with Lord Clarendon. Kneller painted a portrait of the Chinese convert holding a crucifix, which hangs in the Royal collection. Kneller considered it his finest work.

The wave of enthusiasm for things Chinese spread not from Rome, but rather from Holland and France. In Holland it dates from the founding of Jan Compagnie in 1602; in France, from the time of Cardinal Mazarin, who came to power in 1624 as minister to Louis XIII, and remained at the centre of affairs under Louis XIV till his death in 1661. Mazarin was an omnivorous collector, and through the agency of one of his servants carried on a brisk trade in antiques on the side. He was also largely responsible for founding the Compagnie des Indes in 1660. There were a number of oriental objects, including lacquer, porcelain and textiles, in his first sale in 1649. He owned several painted screens, two of which he gave to Louis' queen consort Anne of Austria, Mazarin's confidante and possibly also his mistress. Screens, as we shall see, were to play an important part in introducing Chinese painting to Europe.

Louis XIV at Versailles and the Dauphin at Fontainebleau

owned quantities of oriental objets d'art. The inventory of Versailles for 1667–69 mentions twelve panels from a screen with birds and landscapes on a gold ground, brought from China, and there were many more listed in later inventories, painted with landscapes, figures, birds and flowers, and children's festivals. James II, visiting the Dauphin in his apartments at Versailles after his abdication in 1688, speaks with admiration of his Chinese paintings, meaning, presumably, not hanging scrolls but screens and possibly wall panels.

Father Bouvet, author of l'Estat présent de la Chine en Figures, had brought back from China an urgent request from the Emperor K'ang-hsi for men skilled in various arts, including that of perspective, 'in which', he noted, 'the Chinese are most ignorant'. A man of great energy and resource, Bouvet chartered a sloop, the Amphitrite, filled her with presents from Louis XIV to the Emperor and to high officials, and set sail for China in March 1698. On board were eight Jesuits, among them Giovanni Gherardini, the expert on perspective whom we have already encountered, and a case of engravings after Poussin and

Mignard.

The shrewd Bouvet had the Amphitrite registered as a warship to avoid customs duties, but they had trouble with local officials in Canton who wanted their cut, and they were only able to preserve the royal presents with some difficulty. The rest of the European goods were bartered for Chinese arts and crafts at Canton, and in January 1699 the Amphitrite left for the return voyage, bearing gifts from K'ang-hsi to Louis XIV. She docked at Port-Louis on 3 August 1700, and after the gifts had been despatched to Versailles a huge sale was held at Nantes. It included des peintures de Chine, thirty-six folding screens, three cases of unmounted screens on paper, and four cases of single-panel screens. So successful was the sale that another expedition was immediately organized. It almost ended in disaster, but the second consignment, which finally reached Nantes in 1703, included no less than forty-five cases of folding screens.

With the screens came hand-printed wallpapers and paintings on paper which could be pasted on the wall. For these, England was as big a customer as France. The China Letter Book of the East India Company, for instance, records that between 1699 and 1702 'paper pictures' were ordered in Canton to the value of £200 or £300. In 1742 Lady Cardigan bought eighty-eight 'Indian pictures' and had them pasted all over the walls of her dining room; and a well known London firm advertised

that they fitted up rooms with 'Indian pictures or prints'. A good example of this kind of decoration is the Chinese Room at Milton Hall in Northamptonshire, papered with figure subjects and still-lives, some dated between 1745 and 1750, and executed in a combination of block-printing, freehand brushwork and collage. They have great charm, but if patrons considered such pictures typical of Chinese painting, they may be forgiven for

holding so low an opinion of it.

K'ang-hsi's presents to Louis included not only works of art but also books, and the King owned what was, outside Rome, probably the finest Chinese library in Europe. A few volumes had come from Cardinal Mazarin's library; several had been brought back by Father Couplet in 1687; forty-nine books came with Father Bouvet as gifts from K'ang-hsi in 1697. By the time of his death the King's library included no less than 280 volumes of the great illustrated encyclopaedia Ku-chin t'u-shu chi-ch'eng, completed in 1729, and a book described as L'Encyclopédie chinoise, richly illustrated with pictures of scenery, towns and villages, freaks of nature, temples, architecture, and an explanation of the arts of drawing and painting, in fourteen volumes. More important still for our purposes was a copy of the Chiehtzu-yüan hua-chuan ('Painting Manual of the Mustard Seed Garden', 1679), for only this famous book fits the description in Rémusat's Catalogue: 'Un traité de l'art du Paysage et de la manière de peindre les fleurs, les oiseaux, les insectes, ou comme on dit en présent, l'Iconographie naturelle'.

In addition to the Chinese illustrated books in the Royal library, others found their way into the collections of the dealers and engravers who played a big part in bringing artists and clients together and in disseminating the fashion for chinoiseries. Jean de Julienne (1686-1766), an intimate friend of Watteau, who undertook to engrave and publish as much as possible of his work after his untimely death, owned an enormous collection of pictures also, although these are not mentioned in the sale of his collection in the year after his death. Jacques-Gabriel Huquier (1695-1722), who made many engravings after Watteau and Boucher, possessed several collections of paintings of Chinese flowers of great beauty and rarity. He owned in addition four large volumes of Chinese paintings of plants, destined for the Botanical Gardens. Watteau, Boucher, Fragonard, to say nothing of the decorators who specialized in chinoiseries such as Pillement and Huet, must all have been familiar with the collections of dealers and engravers such as these.

If only we could know what Chinese riches these collections contained! But they are all scattered. Today the Bibliothèque Nationale contains a number of Chinese pictures and albums which arrived in France in the seventeenth and eighteenth centuries, and might have been accessible to these artists. Among them are several albums of birds and flowers, and a copy of the 'Painting Manual of the Ten Bamboo Hall' (Shihchu-chai shu-hua-p'u), a famous collection of colour prints, first published in 1633, which may well have reached Paris before the end of the century. There are also in the collection four exquisite unsigned leaves from an album of landscapes possibly by Yeh Hsin, one of the members of the Nanking School of gentlemen painters who, as I suggested in the previous chapter, may have been in touch with the Jesuits, and show signs of European influence in their work.

Watteau painted several pictures in what he claimed to be. and people accepted as, the Chinese manner. Most famous were the series of Diverses Figures Chinoises et Tartares (that is, Manchu), which he painted for the Château de la Muette, the royal hunting lodge in the Bois de Boulogne. The Château and all but a few of the paintings were destroyed by the middle of the eighteenth century, and today the most famous designs can only be studied in the engravings of Boucher, Aubert and Leaurat. While the style of the figures is hardly Chinese and the settings are purely imaginary, the captions are more or less accurate transcriptions of Chinese words. A charming group of an old man and a youth, for instance, is labelled Lao Gine [Mandarin: Lao-jen] ou Vuillard, Chao Nien [Hsiao-nien] ou Jeune chinois; one of a slave, Hia-theo [ya-t'ou]. Watteau must have seen a Chinese illustrated book or album with the captions translated, but in making the pictures he has rejected the Chinese original almost completely.

The same is true of Watteau's famous designs L'Empereur chinois and La Déesse KI MA SAO dans le Royaume de Laos. Belevitch-Stankevitch considered that these two pictures, engraved by Aubert, preserve the Chinese flavour of the originals more closely than do the la Muette panels reproduced by Boucher and Jeaurat. But both are pure chinoiseries. There is only one work of Watteau's which seems to preserve a Chinese flavour, and that is a very minor one: a panel from a harpsichord decorated with figures in a garden, in the Besançon de Wagner collection, Paris. The style, if not the technique, of the rendering of the birds and flowers in the upper left corner is quite Chinese,

56

57

and could have been taken from an imported album, screen, or

wall hanging.

It is possible that Watteau owned Chinese paintings. He would certainly have known the collection of Jean de Julienne, and may possibly have seen some of the albums in the Royal collection. He also knew a young Chinese gentleman, a Mr Tsao, and made a superb portrait drawing of him, now in the Albertina, Vienna. Mr Tsao looks a casual, self-confident young man, hardly the sort to be very discriminating or knowledgeable about painting. There were a number of Chinese in Paris at this time, however, and it is conceivable that Watteau may have picked up some hints from them. But this is hardly significant, for there is nothing in any of his surviving work which shows that he knew how to handle the brush in the Chinese manner.

Perhaps the nearest approach to the Chinese brush line is in Pierre Giffart's forty-three plates for L'Estat présent de la Chine en Figures, published in 1697. These are based on Chinese paintings brought back in that year by Father Bouvet. Some of Giffart's plates appear again in du Halde's Description de la Chine (1735), which met for the eighteenth century the need that Kircher's China Illustrata had fulfilled for the seventeenth. In his dedication to the Duc de Bourgogne Bouvet notes that the Emperor, high officials and great ladies whom he presents 'are the masters of an empire celebrated for its antiquity, for the beauty of its government, and for the particular character and spirit of its people'. And he goes on to explain, as had Kircher, that his purpose in these plates is to show the dignity and modesty of Chinese dress. The copy in the Bibliothèque Nationale contains three impressions of each plate, the first of which is uncoloured and shows how skilfully Giffart has preserved the delicately calligraphic line of the original.

Even more remarkable from the technical point of view is a handsome folio volume, Collection précieuse et enluminée des fleurs les plus belles et les plus curieuses, containing a hundred engravings of birds, flowers and insects. They are taken direct from Chinese paintings, and the engraver has not merely transmitted the line, as in L'Estat présent, but has managed to suggest, with the burin, the tone of Chinese water-colour. Only when we look carefully at these pictures do we realize that they are engraved and not drawn with the brush.

The vogue for things Chinese, or pseudo-Chinese, that swept Europe is only obviously discernible in the minor and decorative

arts, in the arabesques and singeries of Huet and Pillement, in the exotic furniture, textiles and wallpapers that figure so largely in the Rococo style. It was strong enough to transform what were obviously copies of Japanese prints and Mughal miniatures into chinoiseries, as in the extraordinary Livre de desseins chinois [sic] tirés après des originaux de Perse, des Indes, de la Chine, et du Japon, etched by Fraisse and published in 1735. But the effect on high art was negligible. Boucher never, so far as we know—though he must have seen genuine Chinese paintings—consciously attempted a composition in the real Chinese manner; not a line of Watteau's suggests that he had learned the lesson of the Chinese brush.

This is hardly surprising when we consider the attitude towards Chinese painting expressed by European writers even while the fashion was at its height. After admitting that the Chinese are good at painting birds and flowers, a writer in the English journal The World (25 March 1755) goes on to say that their figures are ludicrously contorted, 'a high burlesque'. There is, of course, no perspective: 'false lights, false shadows, false perspective and proportions, gay colours without that gradation of tints, that mutual variety of enlightened and darkened objects which relieve and give force to each other, at the same time that they give ease and repose to the eye . . . in short, every incoherent combination of forms of nature . . . are the essentials of Chinese painting'. So long as people held to the view that the accurate rendering of three-dimensional objects, as opposed to three-dimensional space, was fundamental to good art, so long as they continued to believe that the structural ideals formulated by Poussin and Claude were sacrosanct, there was no hope that the aims and methods of Chinese landscape painting would be understood. The fact that even painters who might have shown a purely technical curiosity about Chinese art remained indifferent to it suggests that artists are apt to 'see' in the work of other artists only what they themselves can make use of.

China and the English Garden

Nevertheless, it would be surprising if the impact of China on eighteenth-century Europe had left no mark at all, and there are grounds for thinking that its influence was eventually felt, in a very indirect and subtle way, in landscape painting. In one sphere, that of garden design, its effect was immediate and

59 Anonymous. Page from Collection précieuse et enluminée des fleurs les plus belles et les plus curieuses, a book containing a hundred hand-coloured engravings of birds, flowers and insects. Eighteenth century

00

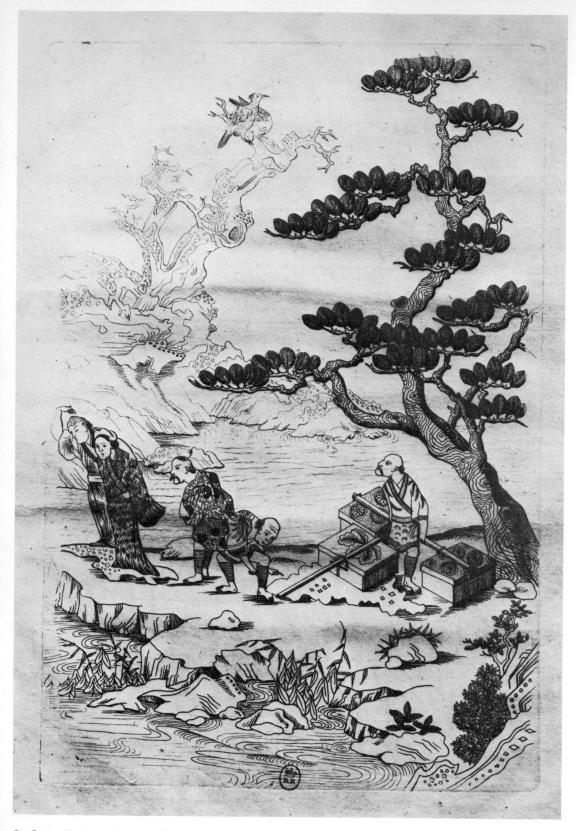

60 J. A. Fraisse. Etching from Livre de desseins chinois tirés après des originaux de Perse, des Indes, de la Chine, et du Japon (1735)

61 F. M. Piper (1746–1824). Plan of Stourhead, Wiltshire. From a sketchbook. Drawing with watercolour. 1779

62 Thomas Gainsborough (1727–88). Mountainous Landscape with a Boat on a Lake. Grey and grey-black washes on buff paper heightened with white. Late 1770s

63 G. L. Le Rouge. Engraving from Le Jardin Anglois-Chinois (1786)

64 Anonymous. Page depicting rocks. Woodcut print from the Painting Manual of the Mustard Seed Garden (1679)

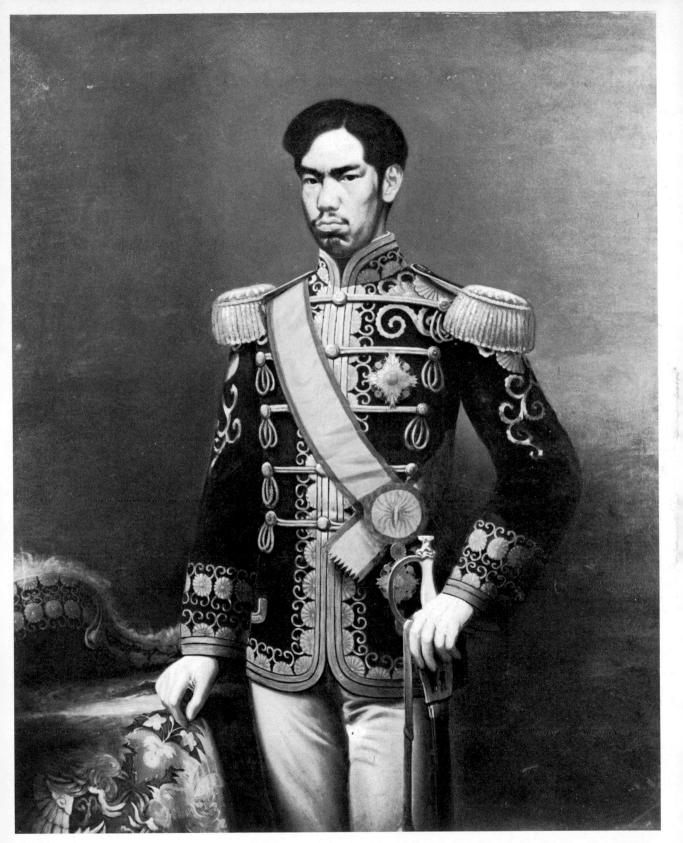

65 Takahashi Yūichi (1828–94). Portrait of the Meiji Emperor. Oil. 1870

67 Hashimoto Gahō (1835–1908). White Clouds and Red Trees. Ink and colour on silk. 1890

68 Takamura Kōun (1852–1934). Old Monkey. Wood. 1893

revolutionary. As early as 1683 Sir William Temple, himself a passionately enthusiastic gardener, had described the Chinese garden at length in his essay *Upon Heroick Virtue*. The Chinese, he says, scorn the formal symmetry and straight lines of the Western garden:

Among us, the beauty of building and planting is placed chiefly in some certain proportions, symmetries, or uniformities: our walks and our trees ranged so as to answer one another, and at exact distances. The Chinese scorn this way of planting, and say, a boy that can tell a hundred, may plant walks of trees in straight lines, and over-against one another, and to what length and extent he pleases. But their greatest reach of imagination is employed in contriving figures, where the beauty shall be great, and strike the eye, but without any order or disposition of parts that shall be commonly or easily observed: and though we have hardly any notion of this sort of beauty, yet they have a particular word to express it, and, where they find it hit their eye at first sight, they say the shraradge is fine and admirable, or any such expression of esteem. And whoever observes the work upon the best India gowns, or the painting upon their best screens or porcelains, will find their beauty is all of this kind (that is) without order.

Temple's praise of irregular beauty was echoed by Addison in his *Essays*, and by Goldsmith, whose Chinese philosopher in London comments:

The English have not yet brought the art of gardening to the same perfection with the Chinese, but have lately begun to imitate them. Nature is now followed with greater assiduity than formerly; the trees are suffered to shoot out with the utmost luxuriance; the streams, no longer forced from their native beds, are permitted to wind along the valleys, spontaneous flowers take the place of the finished parterres, and the enamelled meadows of the shaven green.

But of course the disorder which these early enthusiasts describe is not accidental at all. In fact, as a means of composing a landscape, it is a manifestation of the underlying principles of nature herself, a mode of formal control, as Gustav Ecke so

69 Takamura Kōtarō (1883–1956). *Hand*. Bronze, 1923 aptly put it in attempting to define Temple's baffling term 'shraradge', or as it is often written, 'Sharawadji', 'in which – this is the deeper meaning of Sharawadji – an apparent "disorder" is really rhythm in disguise'. This concept, so new, and so perfectly in tune with developing Rococo taste, dealt a heavy blow to the established neo-classical doctrine that beauty lay in regularity, symmetry, and visible order.

In painting his picture of the Chinese garden Temple was wiser than he knew. Some of his opponents had read du Halde's description of it as small, practical, with more vegetables than flowers, which was certainly true of the majority of domestic gardens. But in this Sinophile era people were ready to believe that China excelled in this as in every other respect, and when Father Matteo Ripa came to the Court of St James's in 1724 and told of the great imperial gardens, or rather garden-parks, of the Summer Palace at Jehol, of which he had made engravings with so much pain twelve years before, he was heard with enthusiasm; for here was direct confirmation that the Chinese garden was as Temple had imagined it to be. Further support was provided by the publication by du Halde of the Jesuit painter Jean-Denis Attiret's long account of the gardens of Ch'ien-lung's country palace, the Yüan-ming-yüan. 'Dans les maisons de plaisance,' he had written in 1743, 'on veut que presque partout il regne un beau désordre, une anti-symmétrie. Tout roule sur le principe: c'est une compagne rustique et naturel qu'on veut représenter; une solitude, non pas un palais.'

In London Father Ripa had met the Earl of Burlington, and possibly also William Kent, who was then designing the gardens of Burlington's new villa at Chiswick. Kent, who, in Horace Walpole's famous phrase, 'leaped the fence and saw all nature was a garden,' was chiefly responsible for spreading the taste for a 'judicious wildness', for the imaginative use of rocks and water, for elements of variety and surprise, into the gardens and parks of mid-eighteenth century England. The garden might be studded with classical tempietti, as at Stourhead, or varied with the occasional Gothic folly or Chinese pavilion, as at Painshill, but these were mere ornaments. Sir William Chambers, who by 1749 had visited China twice, if not three times, in the service of the Swedish East India Company, and wrote extensively on the subject, called the Chinese buildings which he had seen 'toys in architecture'. How much more so were the fragile structures, with their bird-wing roofs and tinkling bells, that adorned the parks and gardens of England, France and Sweden. They, like their Gothic cousins, were not to be taken seriously. What was revolutionary was the concept of the Chinese garden itself, and the aesthetic principles that governed it.

Chambers went further than anyone else in his admiration of the Chinese as garden designers, though much of what he said about them was the product of his own imagination. The only important example that conformed to his idea of the Chinese garden, the Yüan-ming-yüan, he never saw, and his contemporaries were justifiably sceptical when he wrote in his Dissertation on Oriental Gardening (1772): 'The Chinese rank a perfect work in that Art, with the greatest productions of the human understanding, and say, that its efficacy in moving the passions, yields to few other arts whatever. Their Gardeners are not only Botanists, but also Painters and Philosophers; having a thorough knowledge of the human mind, and of the arts by which its strongest feelings are excited.' In this respect, he might have added, they were unlike his bête noire, the upstart Capability Brown, whose parks were so natural that 'a stranger is often at a loss to know whether he be walking in a common meadow'.

C. C. Hirschfeld, in his *Theorie der Gartenkunst* (1779), rebuked Chambers for serving up his own ideas on garden design in Chinese dress in order to make them more sensational and acceptable. But Chambers, although he exaggerated, was not entirely wrong. There were a few Chinese scholars and painters who laid out irregular gardens on a very modest scale, though Chambers could hardly have known that an exact contemporary of Temple's was the gentleman painter and philosopher Shiht'ao, who designed for his friends in Yangchow gardens that embodied just those principles that both these writers attributed to the Chinese. Moreover, in China as in England, the making of gardens was looked upon as a very proper occupation for a gentleman.

Henry Hoare and Charles Hamilton studied seventeenth-century landscape paintings, chiefly those of Claude Lorrain, before creating their carefully calculated vistas at Stourhead and Painshill. But if we examine the beautiful plan of Stourhead drawn by the Swedish architect F. M. Piper, in the Art Academy, Stockholm, we might be looking at the layout of the Yüan-ming-yüan. The winding waterways and artificial islands, the pavilions and *tempietti* (albeit chiefly classical ones) on little eminences, the sudden twists in the paths to reveal new vistas such as a bridge, a grotto, a rockery – all were as had

been described by Ripa and Attiret when writing from Peking. Speaking of Stourhead, Sirèn writes:

The rustic stone material that has been used here is strikingly like that commonly found in China, and it has been exploited with the same endeavour to reproduce something of the picturesque wildness so characteristic of Chinese gardens from the Ming and Ch'ing periods. The resemblance to the Chinese 'mountains' is certainly no more a coincidence than were the grottoes at Painshill, but rather a deliberate intention, even if one cannot speak of deliberate imitation.

We may not entirely agree with Sirén in this instance – a Chinese rockery may be hard to distinguish from a ruined Italian grotto – but the consciousness was there.

The Chinese idea of the garden, however, had to compete with the ideals of the Picturesque, for they are subtly different. The Chinese garden is a microcosm; it unfolds in time, like the Chinese landscape hand-scroll which we slowly unroll as we go on an imaginary journey amid mountains and lakes. The European ideal, embodied in the Picturesque, was precisely what that word implies, a series of carefully composed pictures seen from chosen viewpoints - here a Poussin, there a Claude, next a Salvator Rosa. The Chinese concept is organic, and at least apparently natural; the European is static, and its very artificiality a virtue. While the need to pass easily from one picture to the next gave continuity to the Picturesque garden, the main experience was still of a series of framed vistas to be looked at from outside (the lowest category in the aesthetics of Chinese landscape painting), rather than of a natural world to be experienced by moving within it.

Nevertheless, Chinese ideals, misunderstood or misapplied though they may have been, did percolate some way towards the centre of eighteenth-century taste, and are indirectly reflected even in landscape painting itself. We will look in vain here for so clear an imitation of the Chinese model as Chambers advocated and Kent seems to have applied; for no European artist ever really looked at a Chinese landscape scroll with a discerning or receptive eye. Yet, tentatively in Boucher and Watteau, more wholeheartedly in Hubert Robert and the later Gainsborough, we encounter an apparently spontaneous but in reality highly sophisticated rearranging of nature on the canvas, an assymetry, a 'controlled disorder', both in composition and

62

brushwork, that owe nothing to Claude Lorrain. Salvator Rosa's romantic expressionism may have provided the pictorial techniques, but it is perhaps no exaggeration to claim that in so far as the new landscape painting had a theoretical foundation, it lay at least partly, if unwittingly, in Chinese aesthetics.

It is possible that Chinese pictorial art had a more direct influence than can actually be proved. In the 1780s le Rouge put together two magnificent volumes of engravings of gardens and ideas for gardens under the general title Le Fardin Anglois-Chinois. Some of the plates were copied from Chinese paintings which he had obtained from Stockholm. There are also several pages of engravings of rocks, some of which may have been derived from Salvator Rosa; one is taken from Vernet. But the rest le Rouge says that he drew from nature in the Forest of Fontainebleau. Yet they may have been more or less directly inspired by the rocks in Chinese painters' manuals such as The Mustard Seed Garden and The Ten Bamboo Hall. The slab-like faceting, the grouping of big rocks with little rocks clustered around their feet, and the slab in the right foreground of the engraving illustrated on page 104, all conform to the rules for painting rocks set out in these books, which were also used by Chinese garden designers. The very idea of the rock as something to be enjoyed for itself, and not merely as a component in a picturesque landscape, is entirely Chinese in its origin.

The Nineteenth Century: The Years of Estrangement

In the early decades of the nineteenth century, as chinoiserie became engulfed in the rising tide of austere neo-classicism, Europe's flirtation with the Orient – for it had been no more than that – came to an end. Japan remained a closed and virtually unknown land. Admiration for things Chinese turned to contempt as the West learned more about the true state of Chinese society. The Jesuits were gone from Peking and there were no European scholars at the Chinese court, while diplomatic missions were few, and coldly received if they were received at all. Lord Macartney's embassy in 1792 was the least unsuccessful, but it led to nothing, and now continuous contact was confined to the merchants in Canton and Macao. The Chinese themselves were becoming actively hostile to the West, and the Opium War of 1840–42 was the inevitable outcome of fifty years of growing antagonism. Meanwhile, chinoiserie went

out in a blaze of glory at the Royal Pavilion in Brighton, completed in 1832. But that extravagant fantasy was already an anachronism, coming as it did almost half a century after its nearest rivals at Potsdam and Drottningholm; for it appeared, with tremendous éclat, to an empty theatre. The comedy was over, and the audience had gone home.

Though mutual disenchantment was by now complete, decadent chinoiseries still appeared from time to time, and Europe continued to be flooded with Oriental bric-à-brac and garish 'Nankeen' porcelain. For a brief moment at mid-century it seemed that Chinese art was about to become a subject of serious study, when P. P. Thoms published a Dissertation on the Ancient Vases of the Shang Dynasty, prompted by the display at the Great Exhibition of engravings from the Sung Dynasty imperial catalogue, Po-ku t'u-lu. And in 1858 there appeared Stanislas Julien's scholarly translation of the eighteenth-century monograph on porcelain, Ching-te-chen t'ao-lu. These were translations of Chinese texts, however, not books on Chinese art. and they had no influence on current taste. But two years before Julien's work appeared there occurred - in quite another quarter - the seemingly trivial event that was to open the doors, at last, to a real understanding of Oriental art.

4 Japan: From the Meiji Restoration of 1868 to the Present Day

Art under the Meiji Emperor: Surrender and Counter-attack

By the middle of the nineteenth century the pressure for internal reform and the challenge of the Western powers were building up to a climax. In 1854 Commodore Perry returned with his 'Black Ships' to sign the treaty of Shimonoseki, which was to throw open the doors of Japan. In 1856 Townsend Harris arrived in Shimoda as American Consul General, and an Office for the Study of Barbarian Books was established. During the next four years commercial treaties and ambassadors were exchanged between Japan and the United States, and three

ports were opened to foreign trade.

The Shōgun's feudal administration was quite unfitted to deal with the flood of foreign ideas and goods that now began to pour into Japan, or with the increasing political and economic tension that resulted. In 1867 the Shōgunate was abolished and early in the following year the Emperor, surrounded by young and progressive advisers, was restored to power. Long before the Meiji Emperor died in 1912, Japan had achieved the astonishing feat of converting herself into a first-class industrial power on the Western pattern, and had defeated her two great continental neighbours, China and Russia, in war. This she accomplished by so rigorous an acceptance of Western ideas and skills that, for a time, traditional Japanese values, to say nothing of traditional art, were in danger of being totally destroyed.

In the first fifteen years of the Meiji era Western art was too little understood for any kind of synthesis or compromise with Japanese art to be possible: it was all or nothing. Resistance to Western art, at a time when acceptance of Western values and methods in all other fields was total, would simply have divorced art from society and the trend of the times. Besides, the forces of reaction, or conservatism, were thrown into disarray by the speed of the Western cultural invasion, and for a time they had no rallying point.

The alternative, as the modern Japanese scholar Kawakita Michiaki put it, was 'to let Japan be caught up in a tide of Western civilization, relying on the superior adaptation and ability of her people to make rapid adjustments and to produce, eventually, a copy of the Western system'. He makes this penetrating comment on the psychology of the Japanese in a situation which was in some ways a repetition of the crisis that had faced her under the first impact of Chinese culture in the seventh century:

The vogue for things Western in the early days of Meiji was essentially a manifestation of this - for a Japanese, instinctive - type of reaction. The movement involved what seemed an almost blindly self-effacing partiality for things Western; many different aspects of Western culture were taken over at a great rate, and copies were produced as required with astonishing speed and efficiency. It was in such a process, if the truth be told, that Western-style painting in modern Japan had its origin. The discovery of something more powerful than oneself, of something superior to oneself: the desire to adapt and adjust to it; the resulting blind partiality; and a final remodelling of the self in the new image such was the process involved in the fundamental bias towards the West that formed one aspect of Japanese culture from Meiji times on, and the same circumstances presided over the birth and development of Western-style painting in Japan as well.

Although, as we have seen, European art had been filtering slowly into Japan through the tiny funnel of Deshima for over two hundred years, a new era began in 1857 with the arrival at Yokohama of the English draughtsman and watercolourist Charles Wirgman, as staff artist for the Illustrated London News. Young Japanese, eager to learn about Western art from a real Westerner, gathered round him, and soon he had a little school in Yokohama. One of his first pupils was Takahashi Yūichi (1828-94), known as Ransen. Takahashi had already had some training in Western methods under Kawakami Tōgai (c. 1827-81), a former traditional artist and Restoration leader who with extraordinary perseverance had taught himself first Dutch then the art of painting in oils, and later became Director of the Official Painting Office, a post always held previously by a member of the Tosa or Kanō School. In 1871 he published a guide to Western-style painting, Seiga shinan, based on Robert Scott Burn's Illustrated London Drawing Book, published in 1852.

His devoted pupil Takahashi visited Shanghai with representatives of a number of associations in about 1870 'to inspect conditions', it was said, but there is no record that he made any contact with Western art or artists there. He returned to found his own school at Nihonbashi in Tōkyō in 1873. He had to make his own colours as best he could and learned oil painting largely out of books like Burn's, and far older Dutch manuals. His most influential work was probably the modest but solidly painted Salmon, whose realism caused a sensation when the picture was exhibited in 1877 in Kyōto. When in 1870 he was commissioned to paint a portrait in oils of the Meiji Emperor himself, Western oil painting had really become established. The third of this triumvirate of pioneers was Kunisawa Shinkurō, who studied in London from 1872 to 1874. On his return to Tōkyō he too opened an atelier, though this came to an end with his early death in 1877 at the age of thirty.

By now the need for proper teaching in Western art was becoming urgent, Accordingly, in 1876 the Technological Art School, Kōbu Bijutsu Gakko, was added to the College of Technology in Tōkyō. Antonio Fontanesi (1812-82), Professor of Painting in the Royal Academy at Turin and a landscape painter of the Barbizon School and admirer of Corot, was invited to head the Western painting section. He arrived before the end of the year, bringing with him Vincenzo Ragusa to teach sculpture, and G. V. Cappeletti to teach the decorative arts. Women were admitted to classes, and, for the first time, the curriculum included drawing from the nude. At first it was difficult to find models, and a ricksha coolie who was persuaded to pose complained that he had never worked so hard in his life. The three pioneers all sent their most promising pupils to Fontanesi, among them Asai Chū (1856-1907), who was to become one of the leading oil painters in the new, authentic beaux-arts manner.

The enthusiasm for Western art in Japan reached a climax in the late 1870s – precisely at the moment, in fact, when the fashion for *japonaiserie* was at its height in Paris. Regular exhibitions of oil painting and sculpture were being held in Tōkyō and Kyōto, at which Western-style artists could be sure of selling everything they showed. Tamura Shōitsu, Director of the Western painting division of the Kyōto Art School, was being paid five to seven *yen* each (about £1.25, or three dollars) for his oil portraits, while at this time even the best of the traditional painters were lucky if they could earn half a *yen*, and two great

masters, Kanō Hōgai and Hashimoto Gahō, were almost destitute. Not only were contemporary works of the traditional schools considered worthless, but the very tradition itself was in danger. Paintings by the great early Kanō masters were going begging; temples were being not merely neglected but in some cases pulled down, their treasures thrown out or sold to foreigners, and their sculptures chopped up for fuel.

In 1878 Fontanesi returned, tired and ill, to Italy. His successor, a nonentity named Feretti, so antagonised the students that after one morning's classes they rebelled and quit to form a school of their own, the Jūichi-kai, which became the focus of Western-style painting for the next decade. Ragusa continued to teach sculpture, and his influence was considerable at a time when the demand for portrait busts and heroic monuments was steadily increasing; but without Fontanesi the school sank into a decline, and was finally abolished in 1883.

The conservatives meanwhile had been watching the reckless surrender to Western art with increasing horror. It was not long before the inevitable reaction set in. For a while it lacked a focus and a leader, for in those hectic days it was a brave man who went against the tide of fashion. But by 1878 it had both, in the person of Ernest Fenollosa, who had come to Tōkyō from Boston to take up the Chair of Political Economy and Philosophy at the Imperial University.

Supremely self-assured and eloquent, the twenty-five-yearold professor lectured on Hegel and Herbert Spencer to students who were to become the leaders of Japan in the next generation. He had taken classes in painting in Boston, and soon added aesthetics to his courses. He began to collect Japanese works of art, though, since he was a beginner, his early acquisitions were inevitably poor stuff. A friend then introduced him to the collection of the Marquis Kuroda and he was overwhelmed by the splendour of the Japanese heritage. With the help of two of his students, Ariga Nagao and Okakura Kakuzō, he began to study, and to compile charts of Chinese and Japanese art. He was introduced to leading members of the orthodox Kanō and Tosa schools, whose tutoring of the eager, impressionable young scholar was to yield results momentous for the future of Japanese painting. He began to steep himself in Japan's neglected artistic legacy, spending the summers of 1881 and 1882 visiting castles and temples with Okakura. In a very short time he became convinced that the indiscriminate Westernization of Japanese art was a disaster.

In this, Fenollosa was not alone. In 1879 a group of aristocrats and conservatives had founded the Dragon Lake Society, Ryūichi-kai, an exclusive society dedicated to the study of traditional art. Fenollosa was invited to join, and on 14 May 1882 delivered a stirring address to the members, denouncing the craze for everything Western. 'Japanese art,' he declared,

is really far superior to modern cheap Western art that describes any object at hand mechanically, forgetting the most important point, expression of Idea. Despite such superiority Japanese despise their classical painting, and with adoration for Western civilization admire its artistically worthless modern paintings and imitate them for nothing. What a sad sight it is! The Japanese should return to their nature and its old racial traditions, and then take, if there are any, the good points of Western painting.

Mary Fenollosa wrote many years later that when her husband finished speaking a great gasp came from the audience. Fenollosa was heard by, among other influential men, Count Sanō, founder of the Ryūichi-kai, and by the head of the Department of Education. Such was the impact of his words that within a few weeks official orders went out to list all art treasures in the provinces, and in the autumn, at the official painting exhibition in Ueno Park, Tōkyō, for which Fenollosa was a member of the jury, a government order prohibited the display of Western-style paintings. In June of the following year (1883) the Western art division of the Technological Art School was closed. That summer the Ryūichi society sponsored the first official exhibition of Japanese art in Paris. Again, Fenollosa was on the jury, and again Western art, as well as Chinese painting in the literary style (Nanga), upon which Fenollosa heaped his scorn, was excluded.

The indefatigable young American supported his activities with expertise. He travelled busily about, generally with Okakura, discussing and listing masterpieces, their most daring and spectacular achievement being the unwrapping of the Yumedono Kannon at Hōryūji Monastery, a wooden statue of a bodhisattva that had been concealed from view for over a thousand years. They also issued certificates of authenticity. 'The priests,' Fenollosa wrote home, 'were everywhere greedy for my certificates, and I have issued more than one hundred

for things which were absolutely unidentified before.'

By now Fenollosa had become an establishment figure, a rallying point for conservatives and nationalists, the great hope and champion of the painters of the Tosa and Kanō schools, whose fortunes were at their lowest ebb. They responded by taking him to their hearts. Early in 1884 he was adopted officially into the Kanō lineage and given the name Kanō Eitan Masanobu. 'This,' he wrote proudly, 'I write in Chinese characters and have special seals. I give certificates by myself for old paintings.' The eagerness with which Fenollosa at this time was accepted by high and low, from the Imperial Household and cabinet ministers to priests and humble Kano painters. is a mark of his boundless self-confidence; it also illustrates that instinctive desire of the Japanese, from time to time, to surrender and adapt to 'something more powerful than oneself' that Kawakita described. The process was made less painful, and Fenollosa's task the easier, by the fact that he was appealing to a dormant, yet increasingly restless, nationalism.

We need not follow all the steps by which Fenollosa and his friends and pupils swept Western art aside and replaced it with a modernised version of the traditional schools, but merely note some of the main events. In 1884 Fenollosa helped to found the Kanga-kai, a society for exhibiting both ancient paintings in private collections and the work of contemporary traditional painters such as the neglected Kanō Hōgai. In the same year Fenollosa, appointed to a committee to study art education, recommended that pencil and oil paints be replaced in the schools by brush and sumi (Chinese ink). In 1886 he left the University on his appointment, with Okakura, as Imperial Commissioner charged to investigate art schools and museums throughout the world and make recommendations for Japan. They returned from their world tour in 1887. In the following year a temporary National Treasure Office was set up under Fenollosa, Okakura and the aged Kanō Hōgai.

Eighteen eighty-nine was a year of crowning achievement for Fenollosa. The art museum which he had advocated was opened, the art magazine *Kokka* was launched, and the Tōkyō Academy of Art started classes, with Fenollosa and Okakura as managers, and staffed by leading members of the Fenollosa's New Painters Group Club, Shigaku Shōkai, such as Hashimoto Gahō and Kanō Yushiō. *Nanga* and Western art were totally excluded. 'A new art is going to grow in the school,' Fenollosa declared, 'and it will dominate all Japan in the near future and will have a good influence all over the world.'

This new art, as exemplified in the work of Hashimoto himself, was in essence a reworking of the Kanō and Tosa schools, based on traditional brush techniques but incorporating a new Western realism in drawing, chiaroscuro and perspective, and sometimes the themes were contemporary. Being decorative and realistic, technically brilliant, new, and Japanese in feeling, it seemed to be an unanswerable reply to the challenge of Western art. For the next decade the Academy and its products, as Fenollosa had confidently prophesied, dominated the art world of Japan – so much so, indeed, that when in 1893 a group of leading oil painters held a large exhibition of their work in

Kyōto, not a single picture was sold.

Fenollosa would have been justified in feeling that the task he had set himself ten years earlier - no less than the restoration and rebirth of Japanese art - was accomplished. In July 1899 he received an invitation to head the department of Japanese art at the Museum of Fine Arts in Boston. For some months he hesitated. In Tōkyō he had unique status, wealth, social and political eminence, and his position in Boston would be very different. But he could not have been unaware that in Japan the tide was turning. Nationalism and anti-foreign feeling were growing, and the time would soon come when Japanese artists and intellectuals would find the dictatorship of a foreigner intolerable; indeed, the art programme which Fenollosa himself had drawn up for Japan was so nationalistic that it was obvious that no foreigner could any longer take a prominent part in it. He decided that the time had come to leave. On his departure, in July 1890, the Emperor, in an unprecedented gesture, bestowed upon him the Order of the Sacred Mirror. 'We request now,' he said at the investiture, 'that you teach the significance of Japanese art to the West as you have already taught it to the Japanese.' Fenollosa was to return several times to Japan, always as an honoured visitor, but by now the direction of the movement which he had launched was in other hands, chiefly those of his greatest disciple, Okakura Kakuzō, called Tenshin.

Sculpture

The notion of sculpture as a fine art is a new and foreign one in the Far East. The men who carved or cast the great Buddhist icons were regarded as master craftsmen rather than artists, and very few of their names are known. In nineteenth-century Japan, the tradition of Buddhist icon-carving still lingered on, to be dealt its death-blow by the Westernizing movement that followed the Meiji Restoration. Buddhism in itself was under attack, no more commissions came from the temples, and many accomplished craftsmen were reduced to carving umbrellahandles, or toys and dolls for the foreigners. Some turned to netsuke-carving and so made that craft for the first time a respectable profession.

In 1876 the Italian sculptor Vincenzo Ragusa arrived in Tōkyō to open a sculpture section in the Technological Art School. At first students were chary of signing up: modelling and carving seemed to smack too much of the workshop to have anything to do with fine art, and their friends in the painting studios asked them what they proposed to do with their plaster dolls - stand them in the tokonoma? (This is the recess in one wall of a room, in which a scroll may be hung.) But before long Ragusa had twenty pupils, some of whom became well known as sculptors and teachers. There was already a huge demand for Western-style portraits and monuments to early Meiji leaders, which they executed skilfully enough. Ragusa's best pupil, Okuma Ujihirō, became his assistant and later spent a year in Rome. His best known work is the monument to the Restoration hero, Omura Masujirō, begun in 1883 and unveiled ten years later, after the sculptor's stay in Europe. It is typical of many such monuments, completely European in all but its subject.

The anti-Western reaction of the 'Fenollosa era', which was itself an aspect of a much deeper current of resurgent nationalism, showed in sculpture as it did in painting. When Fenollosa and Okakura began to bring out from the secret recesses of the temples and expose to public view masterpiece after masterpiece of ancient Buddhist carving and bronze-casting, sculptors turned back to the Nara period for inspiration. Notable among them were Takamura Kōun and Takeuchi Kyūichi, who had acted as guide to the American when he visited Nara. But their Kannons and Shakas, full of archaic dignity and exquisitely fashioned, are no more than evocations of a dead past. Only occasionally did they break new ground, the most astonishing instance being Kōun's realistic Old Monkey, which was a highlight of the Japanese exhibit at the Chicago World's Fair in 1893.

With the founding of the Meiji Art Society in 1889 the pendulum swung back again, but not all the way. Now there 68

was room for both kinds of sculpture. Naganuma Shūkei, who had been in Italy from 1881 to 1887, came back to fill the gap left by Ragusa's departure in 1882, and gathered the latter's old pupils around him. When the Empress herself visited the Meiji Society's exhibition in 1881, sculpture in the European style had been fully rehabilitated. Most of it, of course, was a mere imitation of the salon style of the day, but in 1902 Tōkyō felt the decisive impact of Rodin. Two years earlier an impressionist painter named Kune Keiichirō had been in Paris at the time of Rodin's great retrospective exhibition, conducting a survey of art education for the Japanese government. He was enormously impressed, and in his report of 1902 he wrote the first detailed account of Rodin's work to appear in Japan. Six years later the young painter Ogiwara Morie saw The Thinker and was immediately converted to sculpture. He too wrote extensively on Rodin in Japanese journals, stressing the inner life beneath Rodin's often rough exterior surfaces. Ogiwara himself was a gifted Rodinesque sculptor, but died young in 1010, before he had established himself.

The banner of Rodinism was taken up by Takamura Kōun's son Kōtarō, whose study of the master, Rodin's Words, had a considerable impact. Rodin himself was delighted by his success in the East and sent three small pieces of his work to Tōkyō, where they were exhibited in 1912. Today the Gates of Hell stands in a prominent place outside the Museum of Western Art in Ueno Park, the symbol of Rodin's influence over three generations of Japanese sculptors. It is ironic that while this particular casting was lying in the foundry in Paris, Goering tried to buy it for his collection, and only desisted when he learned that it was destined for Germany's partner in the Berlin-Tōkyō Axis. It did not reach its final destination, however, till 1966.

The Twentieth Century: Japanese-style Painting

Okakura Tenshin rode to power on the crest of the wave that Fenollosa had set in motion. But Okakura's outlook was broader than his master's, and he was more willing to accept Western elements into the new Japanese painting, Nihonga. He had himself seen European oil painting in its proper context in his travels abroad, and realized that its revival and advance in Japan was inevitable; he even hoped at one time that Japanese

artists would make their own contribution to oil technique. But his main effort was towards the creation of a style that would be thoroughly Japanese in its materials, techniques and subject-matter, satisfied the Japanese love of fine craftsmanship, yet had absorbed enough of Western realism to make it contemporary. Though he was not a painter himself, Okakura achieved this through his teaching and the work of his pupils at the Tōkyō School. But there were dark spots in his domestic life, and he had enemies among the conservatives. In 1898 they engineered his dismissal from this key post. To their consternation, most of Okakura's staff and students resigned in protest, and together they set up the private Japan Art Academy, Nihon Bijutsu-in, which carried the message of the new Japan-

ese painting forward into the twentieth century.

In his report on the progress of the Academy in 1900 Okakura, thinking perhaps of the 'Six Principles' of the early Chinese theorist Hsieh Ho, set down his artistic ideals in six points: that whatever the painter took from tradition or from the West must be assimilated into his unconscious and become a part of him, and not just a borrowed style - not so easy for painters traditionally trained to stress style and technique above personal expression; that he must master ancient techniques; that his passion should breathe spirit into his work; that, while without perfect technique he cannot express himself, originality counts for even more; that his art must be full of dignity and nobility; and lastly that further advances must be made in historical painting and in Ukiyo-e, that is, genre painting in the traditional style. Okakura also insisted that the painter should always remain Japanese, whatever style he worked in. Caught as they were between East and West, many Japanese artists found this very difficult indeed, and it is not surprising that the great majority of them took refuge in a purely technical solution to a problem that was in essence one of personal identity.

Just as important for the growth of the Nihonga as the ideals behind it was the new concept of the rôle of art and of the artist in society that Westernization had brought with it. In the old days, painters had often worked for a single powerful patron who absorbed all their output of huge decorative screens, or of small scrolls painted in monochrome ink for the tokonoma, and most of them had belonged to hereditary guilds or families such as the Tosa and the Kanō, to which their loyalty was absolute. Now, it was every man for himself. There were large and influential art associations, but they were in a continual state

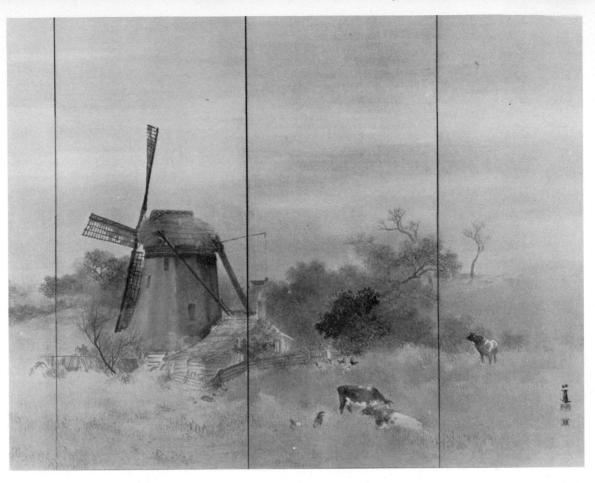

70 Takeuchi Seihō (1864–1942). Holland, Spring Colours (detail). Sumi ink on a gold ground. 1902

71~ Kōbayashi Kōkei (1883–1957). The Tale of Kiyohima: Scene III, In the Bedroom. Framed handscroll. Colour on paper. 1930

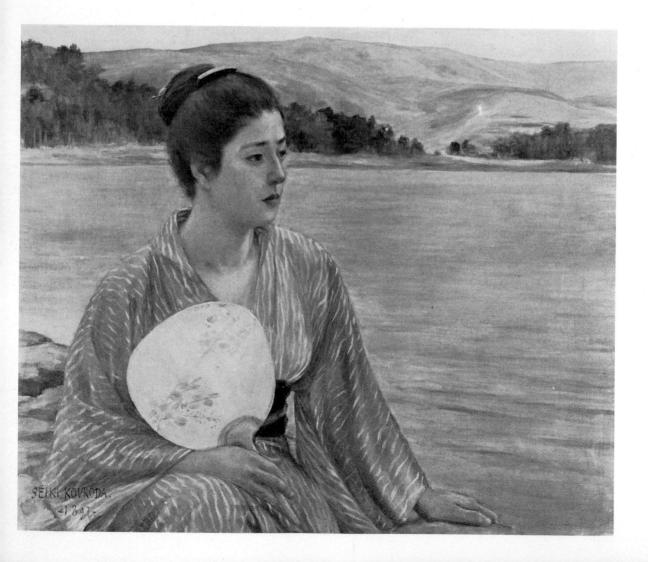

72 Nakamura Osaburō (1898— 1947). At the Piano. Four-fold screen. Colour on silk. 1926

73 Kuroda Seiki (1866–1924). At the Lakeside. Oil on canvas. 1897

74 Aoki Shigeru (1882–1911). Ladies of the Nara Court, Tempyō Era. Oil on canvas. 1904

75 Yasui Sōtarō (1888–1955). *Roses*. Oil on canvas. 1932

76 Kishida Ryūsei (1891–1929). Reikō at Five Years Old. Oil. 1918 77 Noboru Kitawaki (d. 1951). Spikenards. Oil on canvas. 1937

78 Yokoyama Taikan (1868–1958). Wheel of Life. Handscroll. Ink on silk. 1923

Opposite page, below

79 Kudō Kōjin (b. 1915). Hands and Eyes of Earth. Colour on paper. 1964

Below

80 Oyamada Jirō (b. 1914). Sketch of an Ossuary. Oil. 1964

81 Kazuki Yasuo (b. 1911). To the North, to the North-west. Oil. 1959

Overleaf

83 Kayama Matazō (b. 1928). Winter. Colour on paper. 1957

84 Inoue Yūichi (b. 1916). Chinese character shu (Japanese: shoku). Ink on paper. 1967

 $85~Domot\bar{o}~Insh\bar{o}~(b.~1891).$ Four Seasons of Garden. Ink, colour and gold on paper. 1964

86 Yoshihara Jirō (b. 1905). Circle. Oil on canvas. 1968

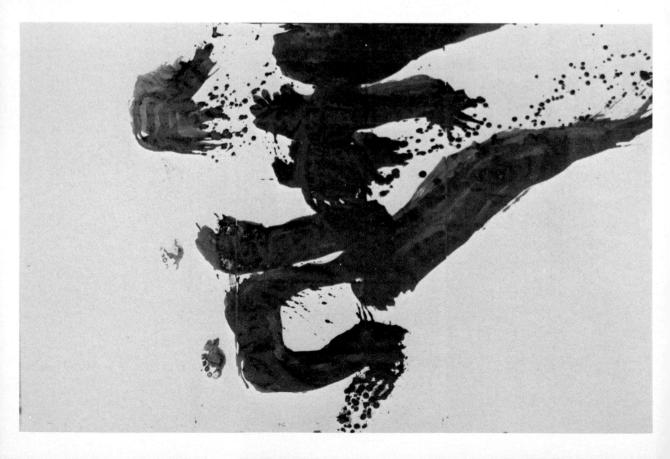

87 Yamaguchi Takeo (b. 1902). Turn. Oil. 1961

of flux, riddled with politics, and stifled as much as they were encouraged by official support. Patronage was uncertain, but public exhibitions, unheard of before the Restoration, became a permanent feature of Japanese life, stimulating individuality and introducing a new element of competition. The exhibitions, moreover, demanded a new kind of picture, one that existed in and for itself: smaller and more personal in style than the decorative screens or sliding doors, larger and more visually arresting than the quiet, sober scrolls that hung in the tokonoma. As there was no place for such pictures in the traditional Japanese house, collectors had to build special galleries to house them, and cities new Western-style museums to display them.

As early as 1890 Hashimoto Gahō (1835–1908) had achieved in his famous White Clouds and Red Trees a brilliant synthesis of decorative Kanō ink techniques and Western realism. After the turn of the century, Shimomura Kazan, Takeuchi Seihō and other followers of Okakura further refined this new synthetic style, extending its range of subject-matter, and taking their themes from Japanese history, literature, and domestic life. Some of them also made a serious study of Western art. Takeuchi Seihō, for example, went to Paris in 1900 and became a great admirer of Turner and Corot. But their rare excursions into purely Western subjects, such as Seihō's pair of screens depicting a Roman ruin and a Dutch windmill with cows, in sumi ink on a gold ground, were generally disastrous. On the whole they stuck to nature and purely Japanese themes, for which there was a steady public.

If the Nihonga developed at all, it was in the realm of purely technical experiment, in absorbing elements from the ancient courtly Tosa style, the decorative brilliance of the Sōtatsu-Kōrin school, the realism of Ōkyo, even ancient Buddhist banner- and wall-painting. A notable exponent of this synthetic style was Kōbayashi Kōkei (1883–1957). In his youth a protégé of Okakura, he acquired a thorough grounding in Chinese, Japanese and Western painting (he made a special journey to London to copy the Ku K'ai-chih scroll in the British Museum), which enabled him to produce, in addition to some semi-Western works, a series of technically brilliant scrolls on traditional themes such as the story of the Princess Kiyo's seduction of the young monk Anchin (a well known subject in the Nō and Kabuki drama), which he painted in 1930. With each conquest of another segment of the past, however, the Nihonga

became more deeply bogged down in tradition. Even Nakamura Osaburō's screen of a young lady in a kimono seated at a grand piano beneath an electric lamp, painted in 1926, which looks so 'modern', is as conservative in technique and flavour as any of the hundreds of pictures of Lord Genji or Samurai warriors that graced the Inten, the official annual exhibition in Tōkyō. Yet Nakamura's screen is a successful illustration of the marriage of East and West in modern Japanese life, contemporary in theme and intensely Japanese in style and feeling – if so calculated and needle-sharp a technique can be said to express any feeling at all.

I will spare the reader an account of the ramifications of the Nihonga between the two World Wars. Having taken what it needed from tradition and Western realism, it froze into a cold academicism, incapable of change because too often Okakura's ideals were forgotten, and style and technique became ends in themselves. The Nihonga was too rigidly disciplined, too anonymous in touch, to convey the turbulent emotions of creative men in the years leading up to Pearl Harbor; too narrowly academic to come to terms with the Western movements, notably Cubism and Surrealism, then fashionable in cosmopolitan circles. If it had not been for the Second World War, the Nihonga artists might have gone on producing these perfect, yet lifeless, pictures indefinitely. But it had not always been that way. The pioneers of the 'Okakura Era', as it came to be called, were creative and original. In fact they were too successful, and the synthesis which they achieved at a very early stage in the movement could never be improved upon. As we shall see, it took Japan's defeat in 1945, and its chaotic aftermath, to break the mould and bring the Nihonga to life once more.

The Twentieth Century: Western-style Painting

Once the anti-Western reaction of the 1880s had passed its peak, European-style painting began to advance again, and this time there was no need of a Fenollosa to check it, for conservative taste and nationalistic sentiment were amply catered for by the flourishing Nihonga movement. In 1893 Kuroda Seiki (1866–1924) returned from Paris, where he had acquired a light pleinariste style of landscape painting from Raphael Collin. To a culturally obedient public, schooled against all their better

73

instincts to regard the murky browns and heavy impasto of Fontanesi and his pupils as the latest and best in Western art, Kuroda's cheerful, lyrical palette must have come as a very welcome change. Acceptance was not by any means universal, however. A daring nude painted by Kuroda in Paris was banned by the Tōkyō police from an exhibition in 1900, and prominent writers supporting him protested in vain. The nude had appeared in Western-style painting since the 1880s, though sometimes in odd places – surely the oddest being Aoki Shigeru's Ladies of the Nara Court, Tempyō Era, painted in 1904, in which a group of very European-looking naked ladies, painted in a muddy Impressionist technique, are grouped round a pool in the manner of Albert Moore. Okakura must have had this sort of thing in mind when he exhorted painters to remain

Japanese.

In 1896 Kuroda had been appointed the first professor of Western painting at the Tōkyō School of Fine Art, and in the same year he and a number of his pupils formed the White Horse Association, Hakuba-kai, for the promotion of Western painting. Soon the movement received fresh blood with the return from Paris of a number of painters most of whom had been pupils of J. P. Laurens at the Académie Julian: Fujishima Takeji, for example, who could paint convincingly in the style of Manet, and Nakazawa Hiromitsu, Nakamura Tsune (1888-1923) and Kojima Torajirō (1881-1929), all of whom had become such devoted followers of Monet and Pissarro that without the signature their work would be indistinguishable from that of any minor, or not so minor, French Impressionist of the 1890s. In 1902 many of these painters banded together to form the Pacific Western Painting Society, which held its first highly successful exhibition in the same year.

Japanese practitioners of Impressionism seldom tried to come to terms with traditional painting, which was on the whole just as well, for in medium and technique the two styles were almost irreconcilable: the one thick, plastic and sensuous; the other smooth, clear, transparent, and without surface texture. The few painters who succeeded, such as Suzuki Shintarō and Yasui Sōtarō, who had studied in Paris from 1907 to 1914, did so chiefly by infusing into their brushwork some of the calligraphic freedom which they had acquired from the study of Chinese literary ink painting – an unlikely alliance indeed. Yasui's Roses of 1932 (Bridgestone Museum of Art, Tōkyō) would stand comparison with any European flower painting of the same

kind. Kishida Ryūsei's series of solidly painted portraits of his little daughter Reikō is completely Western in style, a slight emphasis upon the decorative texture of materials being the only concession to Japanese taste.

76

The most successful synthesis was achieved by Umehara Ryūzaburō. Born in 1888 into a prosperous merchant family in Kyōto dealing in kimonos, Umehara grew up among textile designers and printers, and said later that he knew all about the great seventeenth-century decorative painters Sōtatsu and Kōrin before he went to primary school. Umehara showed early talent as an artist and studied under Asai Tadashi, a pupil of Fontanesi, who was then teaching at the Technological School in Kyōto. His master died in 1907, and in the following year Umehara set off for Paris. The day after he arrived he saw a Renoir for the first time. 'These paintings,' he wrote, 'are exactly what I'm seeking and seeing in my dreams.'

In February 1909 the young Umehara took his courage in both hands and set off to Cagnes to pay his respects to Renoir. Later he wrote movingly of his first visit, and of the thoughts that ran through his head on the way south.

If I visit him, what should I do? Will he let me in? I've heard that when people knocked at Degas' door, he would open his narrow eyes and if it was a stranger or someone he disliked he would slam the door again. How awful it would be if the same were to happen to me! If I'm allowed in, what shall I say? There isn't much hope of engaging the master's interest if I can't even manage as well as the halting speech of my three-year-old child. Sometimes my timidity whispers to me, 'you'd better stop bothering the man you admire'. But my desire to see him is even stronger. Courage! I'm worthy of being seen by him. I like his art so much. He must know that.

They met, and Renoir was so affected by the spirit of the young painter that he agreed to give him lessons. Umehara stayed for months at Cagnes, and became Renoir's favourite pupil in his later years.

In 1913 Umehara returned to Japan, self-confident, master of a palette as hot as Renoir's, which he applied with an easy, firm touch. The pictures which he painted in the next decade may appear at first sight thoroughly European, but his upbringing was not to be denied. It may seem almost impossible that he

VI

could admit the Yamato-e, Sōtatsu or Kōrin styles to his own manner; but he succeeded, by the simple device of adding gold to his palette. Whether he was painting a nude, a still life or a landscape, he would set down his highlights in firm strokes of semi-transparent gold paint that allowed the colour to glow through it, giving the canvas extraordinary vibrancy and luminosity. In his last works, such as the landscapes he painted when, nearly eighty, he was back on the Riviera for the third and last time, blobs of gold paint take their place in a rough, vigorous pointillism. By now he had moved a long way from his early Post-Impressionism. But in spite of the seductions of his medium, he never descended to mere decoration, the bane of Japanese painting; for he drew with colour like van Gogh, and his brushwork is always expressive. Umehara's synthesis of East and West was uniquely successful because it was the expression of a powerful artistic personality.

Beside him, most of the other 'Western' artists seem mere imitators. Kanayama Heizō and Nakagawa Kazumasa, for example, carried Impressionism into the 1920s, Yamamoto Kanae and Morita Tsunetomo were faithful followers of Cézanne, Nakagawa Kigen was influenced by Matisse and Derain, Yorozu Tetsugoro was notable among many Cubists.

The Fauves and Cubists were followed, as we might expect, by the Surrealists. In 1930 Takiguchi Shūzō had translated André Breton's Le Surréalisme et la Peinture, which made a dccp impression on the art world of Tōkyō. An even deeper impression was made by the comprehensive exhibition of the work of Ernst, Masson, Miró, Tanguy and Arp shown by the Union of Rising Art in 1932. Though not many Japanese painters really understood the psychological basis of the movement, Surrealism became the dominating avant-garde art of the 1930s. culminating in Takiguchi's international 'Surrealism Overseas' exhibition in 1937. He himself believed, as he said later, that 'Surrealism should not be considered just another Western modernism, but a vital force that could revive the creative and artistic force of Japan'. Whether this would have happened is doubtful, for by then the Surrealist movement was already past its peak in Europe and Japanese painters were quick to follow trends in Europe. In any case the advent of the Second World War put an end to all avant-garde movements in Japanese art.

It would, however, be wrong to dismiss the Japanese Surrealists, any more than the Fauves and Cubists, as mere imitators.

Surrealism in Japan had a special flavour, blended with romanticism, decoration, and the irrationality of Zen; moreover it expressed a deep desire to break out of the narrow confines of Japanese tradition and to be modern and cosmopolitan. It was also an escape from the agonies of the present into a world where the spirit was free. For now the liberal climate that had developed in the 1920s was giving way to a bleak authoritarianism. In 1931 Japanese armies had occupied Manchuria; in the following year Japan was at war with China, and by 1936 she had become a military dictatorship. The flame of freedom and internationalism in the arts was smothered, and henceforward, until the end of the Second World War, only a conservative, patriotic art was tolerated. Perhaps the art of these dark years is best symbolised by the chauvinistic, muddle-headed old master Yokoyama Taikan (1868-1958). In the early decades of the twentieth century Taikan had achieved a brilliant reworking of the Yamato-e and of the ink style of Sesshū. He had made bold experiments in the use of colour, and on his visit to Italy in 1930 had made a profitable study of Leonardo da Vinci's sfumato. But now he could do nothing but produce endless pictures of his beloved Mount Fuji, symbol of the unconquerable Iapanese spirit. Not surprisingly, these latest works of Taikan's are repetitive and dull. By the 1940s true creative activity for him, as indeed for all Japanese painters, had come to a stop.

Japan after the Second World War

Exhausted by the war, occupied by a victorious army, her people half starving, her cities in ruins, Japan in the immediate post-war years hardly seemed a likely setting for an artistic rebirth. But several factors contributed to a surge of a creative activity that began when the dust of Hiroshima had barely settled. The Japanese, with that remarkable adaptability that they had shown eighty years earlier, almost overnight became enthusiastically pro-Western, while the American administration was on the whole liberal and humane, anxious to win the Japanese people over to its side. Americans were among the first patrons of the artists who had survived the war, and opened a direct channel of communication to the outside world. The waves of abstraction and action painting that radiated out from New York, the new capital of the avant garde, were very quickly

78

picked up by Japanese painters impatient to establish their credentials in the world of international modern art.

When we consider how much suffering the Japanese people had inflicted and had themselves endured during the previous decade, it is extraordinary how little of this is reflected in postwar painting. Is there a hint of it in Kudō Kōjin's surrealist landscapes of the 1960s? Hardly; his Withered Leaves (1963) and Hands and Eyes of Earth (1964) are too close to the nature of things, and too elegantly composed, to suggest any inward suffering. Oyamada Jirō's weird expressionist oil paintings, such as Sketch of an Ossuary (1964), and grimly primordial images, such as Fortunes of the Sea, a watercolour of 1956, seem to be the expression not of the agony of the war but of a very private kind of hell. Among the major artists only Kazuki Yasuo, who from 1945 to 1947 was a prisoner of the Russians in Siberia, powerfully reflected the miseries of the war and its aftermath. His typical To the North, To the North-west (1959), a haunting study of prisoners' faces, might have been painted anywhere in central Europe at about this time.

A Japanese critic has attributed this general unwillingness, or inability, of Japanese artists to express their feelings about their nation's sufferings to 'the meagreness of intellectual thought' among his countrymen. Without making such a judgment, one may say that many Japanese artists seem to be more absorbed in the craft of picture-making than they are concerned with that 'intolerable struggle with words and meanings' that alone can produce great works of art. Making beautiful pictures comes too easily to them.

Within a year of the end of the war the Japanese Ministry of Education had reorganized the official annual exhibition, renaming it Nitten. In 1947 two large exhibitions of Western art from Japanese collections were held in Tōkyō. By 1951 the lines were open to Paris, and a collection from the Salon de Mai was followed by exhibitions of the work of Picasso and Matisse. In the same year the Museum of Modern Art opened at Kamakura. In 1952 the Peace Treaty became effective, and there were signs that Japan's economic recovery was gaining momentum. The Bridgestone Gallery, with its notable collection of European painting, and the new National Museum of Modern Art, opened their doors in Tōkyō, and in the same year the capital held its first Biennale. In 1953 the Mainichi Press brought a large collection of contemporary Western art to Tōkyō, followed by a Braque retrospective exhibition. Within

eight years of Japan's catastrophic defeat Tōkyō was already becoming one of the art capitals of the world.

During these years there was an inevitable tendency for young painters to copy everything the Americans did, and the Tōkyō galleries were full of the work of almost indistinguishable young followers of Pollock and Kline. It was the 'old masters', men like Umehara and Yasui, who gave some stability to the post-war scene. For a time it looked as though the Nihonga was faced with extinction. Neither the artists nor the public wanted to see the continuation of a style that had achieved a static perfection decades earlier and had since become identified with all that post-war Japan was repudiating. But the first Tōkyō Biennale of 1952 showed that the new generation, as in the 1870s, was surrendering too hastily and too uncritically to the latest styles from abroad. If the Nihonga could somehow be made relevant to the artistic climate of the day, some critics felt, the balance might be redressed.

Deliberately, it seems, Nihonga painters such as Yamamoto Kyūjin and Yoshioka Kenji set out to modernise traditional painting, not by the obvious device used before the war of making it more realistic and depicting contemporary subjectmatter, but, on the contrary, by making their landscapes more abstract, using new colour harmonies borrowed from modern Western art, and applying pigment all over the surface in the manner of Western oil painting. Many of these painters were concerned more with means than with ends - a common failing - but there are honourable exceptions. Hashimoto Meiji, under the influence of Fernand Léger, strengthened and thickened the delicate Nihonga line till it became the dominant element in the design, and flattened his colour in the manner of Matisse. In the 1950s Kayama Matazō painted a series of winter landscapes, showing bare trees and birds, which successfully combine intensity of expression and completeness of realization in a manner that suggests Flemish painting. His Winter of 1957 is not simply a parody of Breughel; it converts Breughel into Japanese terms. Here and in his Bare Trees in Winter (1957) superbly disciplined craftsmanship does not stand in the way of deep feeling for nature.

A much older master, who in his post-war painting brought a new solidity to the Nihonga, is Tokuoka Shinsen. Born in 1896 and trained in Kyōto, Shinsen took the Nihonga a stage further towards abstraction in his *Harvested Ricefield in Rain* (1960), and *Rain* (1964), a poetic, elusive, yet solidly painted

VII

study of a garden pool with a rock in the rain, a sight so familiar in Japan. In Japanese terms it seems impressionistic, yet beside Monet's Nymphéas, which may have lain somewhere in the recesses of Shinsen's mind, it has a serene Oriental timelessness that is the very antithesis of Impressionism. In abandoning the thin, sharp line and slick graded tones of the earlier Nihonga, Shinsen has brought the style much closer to Western painting, but the somewhat melancholy beauty of the garden in the rain, so redolent of that quality the Japanese call shibui, has a very oriental flavour.

During the early 1930s Yoshihara Jirō had been a lonely, largely self-taught pioneer of the avant-garde, and one of the first Japanese painters who understood and admired Kandinsky. Twenty years later he became the rallying-point for a group of young artists stimulated by the challenge of the New York School. In 1954 fifteen of them founded the Gutai ('concrete form') Group, dedicated to the most advanced forms of Action Painting and creative happenings. Michel Tapié, visiting Japan in 1957, found them practising his art autre, and described Yoshihara as the animating spirit of the group. Tapié wrote:

He prepares unusual exhibitions (in parks, in the dockyards of Kōbe, even in honourable municipal buildings), an extremely avant-garde yet completely popular spectacle where artists create the skits, make everything, including sets, costumes, and complicated machines, and themselves act in crowded theatres, thrilling a public which is almost one hundred per cent. working class. Yoshihara produced the unique miracle of a group created as a group, which includes more than half the authentic names belonging to the avant-garde.

If some of the workmen who saw the group tearing up huge sheets of paper, or watched Shiraga Kazuo painting with his feet, were ever bewildered, they must, being Japanese, have been reassured by the knowledge that this was art, and therefore admirable; while to anyone familiar with Zen its irrationality and spontaneity had an obvious appeal. Yoshihara's own minimal art sums up the Gutai spirit at its most Japanese. 'I have been working on variations in circles. It is difficult to say what this style represents. Some say it is Zen painting. Indeed, a Zen monk once asked me what prompted me to paint in such a manner. When I replied, "Since I did not have time, this was the best I could do at the moment," he remarked, "What you have just said already contains an essence of Zen." 'To

attempt to interpret this anecdote, or even to assert that it has any meaning at all, would be to fall into the trap that followers of Zen set for the unwary.

In 1957 the American Action Painter Sam Francis was invited by the Gutai Group to exhibit in Tōkyō. While he responded to Japanese traditional painting and calligraphy, the Japanese were equally excited by his freedom and daring in the use of oil paint, by 'his regard,' as a critic put it, 'for the happy accident and his discovery of forms through the paint itself'. One of his most important works to date is the huge mural which he painted for the Sogetsu Institute, where Teshihara Sofu was teaching the art of abstract flower arrangement that he had invented.

In post-war Japan the marriage of Zen, calligraphy and Action Painting was both inevitable and irresistible, winning converts even among well-established traditional painters. 'Abstract calligraphy', an art in which the forms hover between the ideograph and pure abstraction, has had a considerable vogue; Inoue Yūichi's bold rendering of the Chinese character shu ('to belong') carries the swift 'draft script' (ts'ao shu) almost to the point of total illegibility. Perhaps the most remarkable metamorphosis took place in the work of Domotō Inshō. Born in Kyōto in 1891, Inshō by 1927 was a member of the judging panel of the Imperial Fine Art Exhibition (Teiten), and in 1944 was chosen to become one of the official artists to the Imperial Household. He executed a series of monumental screens and sliding doors for Buddhist temples in the traditional style, beginning at Tōfukuji in Kyōto in 1933. His conversion to abstraction culminated in the huge screens inspired by the Pacific Ocean and the Inland Sea painted in 1963 for Chikurinji Temple in Koji City, which a Japanese critic has called 'the first great work of abstract art in Japan'.

After this leap into the present it is surprising to find that at about the same time as Inshō was carrying out the Chikurinji Commission he was also painting the figurative Glory of Santa Maria with Japanese martyrs for the Cathedral in Ōsaka, and only a year earlier had painted a still-life in a synthetic Kōrin-Matisse manner. In his bold abstractions of the 1960s, such as Establishment and Four Seasons of Garden, Inshō overlays strong ink brushwork with colour in a manner remotely derived from that of the seventeenth-century Kanō masters. But he often surrenders to the temptation to produce somewhat self-conscious, even pretty effects by the addition of patches and dots

84

85

of gold and long trailing gold lines that wander across the composition and destroy much of its power – a device beloved of Japanese poster designers. When we consider Inshō's auvre as a whole – and he is by no means untypical – we cannot help being astonished at the ease and speed with which a Japanese painter acquires a repertoire of different, and sometimes conflicting, styles, and manages to combine them in one picture. This of course is nothing new. In the eleventh-century Tale of Genji there is a description of a landscape painting of which the top half was in the old Chinese manner, the bottom half in the new native style (Yamato-e) just then coming into fashion, and we have already seen how adept the eighteenth-century 'modernists', like Shiba Kōkan, were at this kind of synthesis.

The number of post-war Japanese painters who have succeeded in reconciling East and West in their work runs into hundreds, and we can only mention a few. Among those who were already active before the war are Saitō Yoshihige, Kumagai Morizaku, and Yamaguchi Takeo. The last-named had been associated with Zadkine in Paris in the 1920s and later became an abstract painter. Of his recent compositions in powerful flat shapes he says, 'I am little concerned with the problem of communication. In fact, I try to avoid it, because communication is needed only when something is lacking in content' - a remark which seems to put the philosophy of abstract art in a nutshell. Aso Saburō, influenced by Tobey, paints subtle abstractions in oils, less calligraphic and more decorative than those of Zao Wou-ki. Onosate Toshinobu brings to Op Art the skill and professionalism that one would expect of a Japanese. The reaction against Abstract Expressionism did not leave the Japanese unprepared; indeed, the anonymity and technical discipline of Op Art and Hard-edge Abstraction appealed to a love of sheer craftsmanship that is perhaps more deeply rooted in the Japanese than calligraphy, which is essentially a Chinese art form. More recent developments still, such as the 'body art' of Shinohara, and the reliefs of endlessly repeated ears of Miki Tomio, show that Tōkyō is not a minute behind New York and may, in the helter-skelter search for something new, even be ahead. The avant-garde artist today knows almost at once what his counterparts all over the world are up to. They have become a supra-national fraternity often communicating more readily with each other than with their own people. This has its dangers, and in Japan especially could lead to another swing of the pendulum, and a return to the chauvinism of the pre-war years.

In the complex pattern of acceptance, synthesis and surrender in Japanese art the modern woodcut stands apart with a quality entirely its own, for it is a Japanese art form that has been abandoned, then revived and revolutionized, while retaining its essential Japanese character. By the late nineteenth century the Ukiyo-e was in a sad state of decline. There was no place for it in an art world oscillating between European salon painting on the one hand and the revived Kano and Tosa schools on the other, while its function as illustration was being taken over by modern photographic reproduction processes. There were one or two attempts to modernise the woodcut during the Meiji period. Kōbayashi Kiyochika's portrait of the journalist Fukuchi Jenichirō, his very successful landscape and industrial prints of the 1880s, and the work of his pupils Ogura Ryūson and Inoue Yasuji, show what might have been achieved if they had had any following. But their efforts were premature and by the end of the nineteenth century the woodcut as an art form in Japan seemed to be dead.

The revival was largely the work of one man – Yamamoto Kanae (1882–1946), who had spent the years from 1912 to 1914 in Paris, and returned to take up a career as a Westernstyle wood-engraver. Hasegawa Kiyoshi, born in 1891, was another pioneer, but as he settled in Paris in 1918, his work is much better known in the West than in his native country. In 1920 Yamamoto produced his famous colour print Breton Girl, which made an immediate and profound impression. Though the engraving was cut in Japan, the subject was foreign enough. But the cool, flat colours, the emphasis upon the line, the simplification towards essential forms (carried a good deal further than in the Kobayashi portrait), the frank acceptance of the two-dimensional surface, all showed that Yamamoto had recovered the essentials of the Ukiyo-e. With this mild but revolutionary work the modern Japanese print was born.

In 1916 Yamamoto founded the Japanese Creative Print Society (Nihon Sōsaku Hanga Kyōkai). The emphasis was upon the word 'creative'. For what distinguishes the modern Japanese print from the Ukiyo-e is that it is no longer a popular art form, a picture translated into a print by anonymous craftsmen, but a work of art in its own right carried out entirely by the artist himself, who makes very few impressions, or a monotype only. The modern print-maker frankly engages in a

89

dialogue with his medium, exploiting its limitations and possibilities to the full.

It has often been remarked that the Japanese artist is at his best when he has to overcome the resistance of the medium – he is a carver in wood and ivory rather than a modeller in clay – and the modern Japanese print-maker shares with the carpenter and wood-worker a love and understanding of his material that is unique in the world. As Kawakita put it, 'The Japanese have always shown a special ability in those arts that involve a compromise with recalcitrant material. . . . There are certain aids and handicaps affecting the artist as he fashions his work, that function independently of his own will.' But, he goes on, 'If one looks for a fault in the contemporary print one will find it in those cases where the artist, becoming overpreoccupied with his skill at coping with physical resistance outside himself, has become bogged down in mere cleverness.'

The direct Western influence on the modern Japanese print after the initial stimulus has since become relatively unimportant, although it was Americans in Japan who first patronized the print-makers after the war, and the appreciation of foreigners that has given the movement such status as it has acquired at home. The abstract prints of the first truly modern master, Onchi Köshirö (1891-1955), were influenced by Braque and Picasso, Munakata's figurative style by Matisse. Saitō was led to the creative print by Gauguin, who in turn had been inspired by Hokusai. But the very nature and demands of the medium preclude that swift and indiscriminate surrender to successive fashions in Western art to which Japanese oil painting has been so vulnerable. Although the modern Japanese woodcut has its expressive limitations, it is the most purely Japanese, and therefore the strongest, Japanese contribution to the international movement in modern art.

Japanese Artists Living Abroad

It is rare to find a Japanese painter who comes to the West reasserting his 'Japaneseness'. Generally the acceptance of Western art is whole-hearted, for that is after all what they come for. Hasegawa Kyōshi and Ogisu Takenori were successful Post-Impressionists in Paris between the World Wars; Fujita, who settled in Paris, became in essence a French painter, and died a French citizen. Kuniyoshi, who went to America in 1906

at the age of eighteen, crowned a successful career as an American painter by being elected the first President of the Artists' Equity Association in 1947. He died in 1953 without ever having returned to his native land, and never thought of himself as a Japanese artist.

Since the Second World War a second generation of Japanese painters living abroad have made their contribution to the international modern movement, notably Inokuma Genichirō, who settled in New York in 1961, attracted thither by the complete freedom from group pressure and group loyalties – the bane of the Japanese art world – and by the businesslike relationship between artist and gallery. Kito Akira achieved a reputation in Paris, as did Sugai Kumi, whose bold abstract forms and 'abstract calligraphy' secured him a First Prize at the São Paolo Bienal in 1965; Azumi Kenjirō was long associated with Marini and became his assistant in Milan. And one could name many more. For all of them, to a greater or lesser degree, involvement with Western art and adjustment to Western society has brought a crisis of identity, most clearly and movingly articulated by Isamu Noguchi.

Born in America in 1904 of a Japanese father and an American mother (he was known as Isamu Gilmour till he grew up), educated in Japan and then again in America, apprenticed disastrously to Gutzen Borglum (who said he would never become a sculptor), trained in New York and in Paris under Brancusi, Noguchi visited Japan again in 1931 almost as a stranger. Sculpture as he then found it in Tōkyō had no message for him. Takamura Kōun was carving Buddhas in the style of the Nara period; his son Kōtarō was working in the manner of Rodin. But in the Kyōto Museum Noguchi discovered the ancient clay figurines called haniwa that had stood around the great tombs of the prehistoric period. 'They were in a sense modern,' he said later, 'they spoke to me and were closer to my feeling for earth.' He moved into a cottage and began to make terracottas and to discover the beauty of gardens and the Japanese countryside. Of this period he said, 'I have since thought of my lonely self-incarceration then, and my close embrace of the earth, as a seeking after identity with some primal matter beyond personalities and possessions. In my work I wanted something irreducible.'

Noguchi was back in New York, building a solid position for himself with sculpture and stage designing, when there came the shock of Pearl Harbor. Suddenly he realized that he was 02

93

not American but Nisei - second-generation Japanese. Yet he was not truly Japanese either. When he visited Tokyo again after the war he expected to be treated as a foreigner, and up to a point he was. But gradually he became reconciled, and more than reconciled, to his dual origin, and drew strength from it. 'Why do I continuously go back to Japan,' he wrote, 'except to renew my contact with the earth? There still remains the familiarity with earthly materials and the skill of Japanese hands. How exquisitely functional are their traditional tools. Soon these, too, will be displaced by the machine. In the meantime I go there like a beggar or a thief, seeking the last warmth of the earth.' Of his situation - one can no longer call it his predicament - he said, 'My own contradictions, enhanced perhaps by my mixed parentage, are probably shared by most artists to some degree. We all look to the past and the future to find ourselves. Here we find a hint that awakens us, there a path that someone like us once trod.'

Not all the work of this amazingly prolific and resourceful artist has been an equally successful blending of East and West. Where he has consciously attempted a synthesis, as in the UNESCO garden in Paris, of which one level is modern and formalistic, the other more purely Japanese, the symbolic meeting of the two cultures is too contrived, too intellectually conceived to be wholly satisfying. His greatest achievement, because it is most basic, is his 'garden' for the National Museum outside Jerusalem. Here, with terraces and retaining wall, he sculpted a hilltop into something spacious, inevitable, 'irreducible': nothing is imposed, and the materials, and the shapes which they are given, are natural to the site itself, as in the finest of Japanese gardens. Noguchi's own words express movingly the awareness of the garden as a common ground between man, nature and art that is one of Japan's chief contributions to civilization:

I like to think of gardens as sculpturing of space: a beginning, and a groping to another level of sculptural experience and use: a total sculpture space experience beyond individual sculptures. A man may enter such a space: it is in scale with him; it is real. An empty space has no visual dimensions or significance. Scale and meaning enter when some thoughtful object or line is introduced. This is why sculptures, or rather sculptural objects, create space. . . . What may be incomplete as sculptural entities are of significance to the whole.

The fact that Noguchi's most profoundly 'Japanese' garden does not look Japanese at all suggests that in the transmission of art from one culture to another it is not the forms and materials themselves that are important but the ideas and attitudes that lie behind them; for these, in a new setting, can be given expression through a new set of forms and different materials and yet retain much of their essential character.

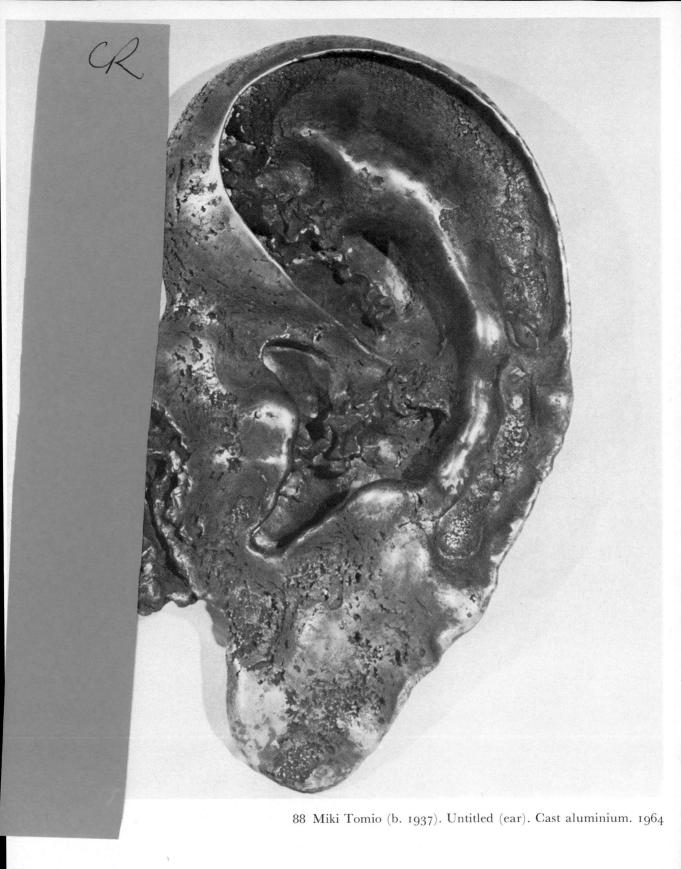

89 Yamamoto Kanae (1882–1946). Breton Girl. Woodcut print. 1920

91 Kiyoshi Saitō (b. 1907). Wall. Woodcut print

93 Isamu Noguchi (b. 1904). Black Sun. Tamba granite. 1960–63

92 Sugai Kumi (b. 1919). Snow. Copperplate engraving. 1965

94 Isamu Noguchi. Water source sculpture. Red granite. 1965

96 P'ang Hsün-ch'in (b. c. 1903). Portrait of the artist's son. Chinese ink on paper. C. 1944

95 Hsü Pei-hung (1895–1953). The Foolish Old Man removes the Mountain. Chinese ink on paper

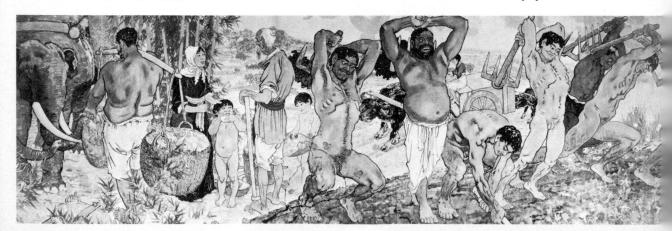

97 Kao Ch'i-feng (1899-1933). The Bridge in Drizzling Rain. Chinese ink and colour on paper. 1932

I Tani Bunchō (1763–1840). Flowers in a vase, after a painting by Willem van Royen (1654–1728) Hanging scroll. Ink and colour on paper

II Andō Hiroshige (1797–1858). *Mount Fuji from Yoshiwara*, from 'Fifty-three Stages of the Tōkaidō'. Colour print from wood-blocks. 1833–4

III Hsiang Sheng-mou (1597–1658). Bare tree. Album leaf. Ink and colour on paper. 1649

IV Lang Shih-ning. A Hundred Horses in a Landscape (detail). Handscroll. Ink and colour on silk. 1728

V Anonymous. Court lady and her attendants. Panel on silk. Eighteenth century

VI Tokuoka Shinsen (b. 1896). Rain. Colour on paper. 1964

VII Umehara Ryūzaburō. Nude with Fans. Oil. 1938

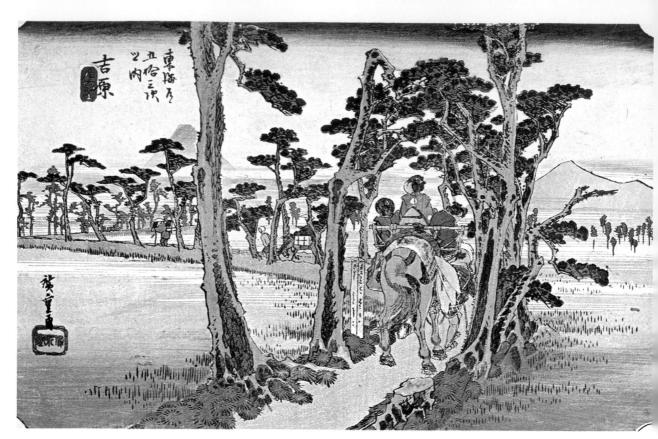

5 The Revolution in Chinese Art

We have seen how before modern times Western art was no more than a light wind blowing over the ocean of Chinese painting; it rippled the surface for a while, then it was gone, and the Chinese tradition, as represented for example by late nineteenth-century masters such as Jen Po-nien, Wu Ch'angshih and Chao Chih-ch'ien, seemed to continue its calm, slow progress through time as though it had never felt the breeze at all. Even today there are painters whose art is totally unaffected by the impact of the West - amateurs who paint delightful landscapes in the manner of Wang Hui, rendering bamboo or birds and flowers in a variety of traditional styles. There is no more incongruity in this than in a Western gentleman playing Bach or Chopin in his free time. Traditional Chinese painting, embodying as it does the arts of painting, calligraphy and frequently poetry as well, is so completely satisfying a mode of expression that it cannot significantly be enriched by the infusion of Western techniques. In fact, Western realism, because it demands an analytical approach to the subject, gets in the way both of free calligraphic expression and of the intuitive generalization from experience that gives to Chinese painting its timeless, universal quality.

The eighteenth-century gentlemen painters had regarded Western art as something of a curiosity, and they were not in the least interested in European civilization itself. But in the nineteenth century, as China suffered one humiliation after another at the hands of the European powers, she was forced to adopt more and more from the West in self-defence. Her leaders insisted that Western science and technology should only be the 'shell', while Confucius and Mencius remained the 'kernel' of Chinese culture, and there was no wholesale surrender to Western values such as caused such violent oscillations of feeling in Meiji-period Japan. In China westernization was a slow and at first almost haphazard process, and until the Revolution of 1911, and the establishment of the Republic, it was scarcely reflected in art at all. Well into the twentieth century Westernstyle art was confined largely to the Treaty Ports, and above all to the French Concession in Shanghai. What went on in these enclaves was not thought of as having much to do with China, and high Chinese officials and others in positions of power (generally warlords), unlike their Meiji counterparts, tended to be conservative and anti-Western in cultural matters. Western railways and machine-guns were one thing, Western painting – unless realistic and utilitarian – was quite another. China has no such history of alternate acceptance and rejection of foreign culture as has Japan. From time to time she has, strictly on her own terms, accepted foreign ideas and forms – Buddhism and Buddhist art being the obvious example – but slowly and inexorably she has digested them, made them part of herself, and continued on her own majestic way. Mao Tse-tung's dictum, quoted everywhere in China today, 'Make foreign things serve China'— with all that is implied in the word 'serve' – sums up a way of dealing with the culture of the Outer Barbarians that China has practised successfully for more than two thousand years.

In view of China's Olympian attitude to other civilizations, it is all the more interesting to see how she has responded to the latest and most critical of all the cultural challenges that have faced her throughout her history. I have quoted the views of Ch'ing Dynasty savants about Western art, which may be summed up by saying that while they admired its realism they could not take it seriously as painting because it showed so little skill and feeling in the use of the brush. Traditional painters continued to hold this view well into the twentieth century, and in the work of leading masters such as Ch'i Pai-shih (1863–1957) and Huang Pin-hung (1864–1955) there is not even a hint of Western influence. The Western challenge may indeed have provoked something of a revival in traditional painting.

At the turn of the century reform was in the air – too late and too little, of course, to save the Manchu Dynasty, but one of its minor effects was the opening, in 1906, of a department of Western art in the Kiangsu-Kiangsi Normal School in Nanking, followed by another in Peking in 1911. In the next three years several Chinese painters who had studied in Tōkyō returned to set up their studios in Shanghai. Chou Hsiang, who had been trained by the now re-established Jesuits at Ziccawei (l'Université Aurore), outside the city, opened a little private school in Shanghai. His star pupil Liu Hai-su later founded the Shanghai Art Academy, which became the focus of more conventional Western-style oil painting during the 1920s and 1930s. Until 1919 most of the teachers of Western art in Chinese art schools were Japanese, and the more enterprising Chinese students,

such as Liu Hai-su, went to Tōkyō for further study. At this time, even in Shanghai, there were almost no Western paintings to be seen, and aspiring young art students, as one of them, Wang Ya-ch'en later remembered, were reduced to looking for colour reproductions in periodicals in the second-hand bookstores of the Peking Road.

In 1919 Japan attempted to seize the former German Concessions in China. This aroused a violent wave of anti-Japanese feeling, and young painters, for the first time, turned their eyes away from Japan and towards Europe. Many of them were fired by the liberal ideals of Dr Ts'ai Yüan-p'ei, President of Peking University, who opened the minds of a whole generation of Chinese students to a world beyond China's frontiers, invited Bertrand Russell, Rabindranath Tagore and the American pragmatist philosopher John Dewey to lecture in Peking, and himself believed in a spiritual regeneration of China according to five principles of Education, of which aesthetic education was one. He even believed that aesthetics might take the place of religion in Chinese life.

The vernacular literature movement, launched by Hu Shih in 1917, had been another powerful stimulus, for by liberating writers from the scholarly complexities of the old literary style it enabled them to explore a whole range of feelings and emotions not previously thought of as expressible in literature at all. Much of what they produced was ephemeral and self-indulgently romantic, but this discovery of the self in literature was passionately sincere, and was not long in finding its way into art. The significance of the vernacular movement and all that it gave birth to is that while some of the forms and techniques employed in the arts, such as oil painting and the sonnet, were inevitably borrowed from abroad, it was a Chinese movement, expressing purely Chinese feelings.

To Paris the painters flocked in such numbers that one of them, Chou Ling, later founded the Association des Artistes Chinois en France. Some of them remained in France and became Post-Impressionists in all but name; some sank into poverty and obscurity; others returned to China to establish a little Quartier Latin in the French Concession of Shanghai and to set up art schools on the Beaux-arts model: Yen Wen-liang in Soochow, Hsü Pei-hung in Nanking and later Peking, Lin Feng-mien in Hangchow. Lin Feng-mien's school later became, with that in Peking, one of the two national art academies and the centre of the most progressive art movements in China.

Students returning from Europe formed little bridgeheads of cosmopolitanism, such as T'ien Han's Académie du Midi (Nan-kuo I-shu hsüeh-yüan) in Nanking, dedicated chiefly to the spread of French art and literature. In 1927 T'ien invited Hsü Pei-hung to open a Department of Fine Art, which later became the art school of National Central University. Hsü Pei-hung was at that time a thoroughly academic oil painter, having studied in Paris (where he gallicised his name as Ju Péon) and in Berlin under Kamph; among his first works on returning to China were oils of Chinese historical subjects in the manner of Meissonier and Jérome, who had also influenced an earlier generation of Japanese painters. But the pressure of his own culture was strong, and soon Hsü Pei-hung began to develop a brush technique that was both calligraphic and realistic, and is typified by the endless series of horses that he painted in the 1930s and 1940s. After 1950 this successful formula, combining realism and Chinese brushwork, seemed to be just what the People's Republic required of its painters and Hsü Pei-hung crowned a successful career by his appointment as Director of the National Academy of Art in Peking, a key post which he held till his death in 1953.

For the more imaginative painters reconciliation of East and West was not a matter of technique but of vision and feeling. To such men the sense of alienation from their own society was often a spur. When P'ang Hsün-ch'in returned in 1930 from Paris, where he had been a friend of Fujita and Matisse, and saw how incomprehensible his paintings were, even to the comparatively cosmopolitan Shanghai public, he burned them all and retired to the country for a year to consider where he stood. When he took up painting again it was not to revert to the traditional style, or to attempt some sort of technical synthesis, but to try to express himself as a Chinese in the modern idiom. Henceforward his work – except for his delightful but somewhat archaistic T'ang dancers - always remained sincere and a little tentative, as though he was not wholly sure of his identity, which indeed was the case. In the 1930s and 1940s, he and Lin Fengmien were probably the most successful artists in showing how Chinese painting could be 'modern' in form and style, and yet essentially Chinese in feeling - this indefinable quality being preserved through a somewhat generalized rendering of form, a suppression of shadows, and a fresh, sensitive handling of the brush. In the work of Lin Feng-mien the New Art Movement, established in 1929, found its clearest and most lyrical expression.

95

96

In Canton, Japanese influence was stronger. In 1916 Kao Chien-fu returned there from studying in Tōkyō, to set up an art school for the express purpose of reviving Chinese painting by using traditional techniques to depict contemporary subject-matter: industry, railway building and – much later – the realities of modern war. He and his brother Kao Ch'i-feng were strongly influenced by Okakura's Nihonga movement and by the technique of artists such as Yokoyama Taikan and Hashimoto Gahō. In surrendering to the rather slick craftsmanship of Japanese 'decorative realism', Kao Chien-fu denied himself the full calligraphic expressiveness of the Chinese brush. But his school had a wide following, especially in the south, and, as we might expect, it has taken a prominent part since 1950 in the art

programme of the People's Republic.

The second generation of Chinese painters who returned from France were more at home in Western art than their predecessors; they had greater skill at using it, and were able to adapt it more freely to their own expressive needs. In the early 1930s it seemed that a new Chinese painting, native in spirit, contemporary in theme, borrowing techniques freely from East and West, was about to take root, while a new cosmopolitanism was beginning to colour the art journals. In 1931 the sculptor, poet and critic Li Chin-fa had founded Mei-yü tsa-chih (Mi-yo Magazine), which reflected the Western leanings of his circle. It was scarcely an organ of the avant-garde. Croce and Lamartine appear in its pages, side by side with reproductions of Bouguereau and Bourdelle. More ephemeral, though more progressive, were such journals as I-shu hsün-k'an and I-shu, in which we find discussions of Surrealism and a study of Herbert Read's The Meaning of Art by the scholar and critic T'eng Ku. However, the response to European art at this time could not help but be confused. Many painters and critics had a hazy notion of the origins and characteristics of art movements since Cézanne, tending to label them all 'Futurism'. The modernists, moreover, stopped well short of the Western avant-garde. What China needed, they felt, was to master Western realism in order to bring art closer to life. It was, perhaps not surprisingly, a handful of traditional painters and critics who understood the message of Kandinsky, and particularly his stress upon the 'inner necessity' and spontaneity of expression, although it is hard to discern any direct influence of Western Expressionism in the work of the traditional masters. What really stimulated a revival of traditional painting was a resurgent nationalism.

In 1928 P'ang Hsün-ch'in and a group of his friends had founded the Société des Deux Mondes to keep open the lifeline to Paris. In the stormy wilderness of Shanghai they felt an acute sense of isolation, for the rich merchants (almost their only patrons) only wanted flattering portraits and the odd piece of ornamental sculpture. Unlike their Japanese counterparts, the Chinese middle class in the coastal cities felt no obligation to welcome Western art; they had not been schooled to regard what was foreign and up-to-date – however little understood – as in itself desirable and good. There were, moreover, no collections of European art in China, and it was natural that the gentry condemned what little they saw as inferior to their own.

Meanwhile China was in crisis. Caught between their Kuomintang rulers on the right and the Communists on the left, oppressed by the growing menace of Japan, the internationally minded artists and intellectuals felt that the attitude of mind represented by the Société des Deux Mondes and other cosmopolitan groups in Shanghai was becoming more and more untenable. Already in 1926 the archaeologist Kuo Mo-jo had quit his ivory tower and launched an attack on all the foreign 'isms' in modern Chinese literature. In 1932 some of the modern painters formed the Storm Society, dedicated to bringing art closer to the people. But what art? And to which people? 'The people' were the urban proletariat and the illiterate peasantry, and their cause was best served not by the followers of Matisse and Picasso but by the wood-engravers, led by the writer Lu Hsün, who were creating out of an ancient Chinese medium a truly popular art that rapidly developed into a powerful weapon of left-wing propaganda. During the first years after the forming of the woodcut movement in 1929 the engravers had been inspired by Russian socialist realism, but soon their work began to take on a national character.

The dilemma of liberal artists and writers in the 'modern movement' was abruptly resolved by the Japanese attack on Peking in July 1937. There followed eight years of war during which all the centres of modern art were occupied by the enemy, ties with Europe were severed, and painters, deprived of canvas and oil paints, became refugees and moved far into the interior where they rearranged their lives in a new and strange pattern. For the Japanese people the war was the culmination of a decade of increasingly oppressive militarism; and as they moved inexorably towards defeat creative art in any form became impossible. For the Chinese, in spite of the hardships, govern-

ment censorship and isolation from foreign contacts, the early war years were a period of unity, expansion, even exhilaration, as painters discovered a new world in the western provinces, Central Asia and Tibet. They responded with passionate sincerity to their wartime experience, and in so doing created new styles in which Western realism was at last successfully absorbed. The styles practised in China since the People's Republic took power in 1949 are very largely those created by such artists as Chang An-chih, Hsaio Ting and Hsü Pei-hung's pupil Wu Tso-jen in West China between 1937 and 1945.

Meantime the painters dreamed of returning to the coastal cities and of a new, free life after the war when contacts with the outside world would be renewed. For a brief time in 1945 and 1046 it seemed as if the modern movement might get under way again, and even that China might, like Japan, feel the impact of the New York school and give birth to an Abstract Expressionist movement. But the Kuomintang regime was fast disintegrating, inflation out of control, Shanghai a sink of corruption, and painters were filled with a despair so deep as to make the renewal of artistic ties with Europe and America for most of them an impossible dream. One of the fortunate exceptions was Chao Wu-chi, a gifted young pupil of Lin Feng-mien and P'ang Hsün-ch'in in Hangchow, who left in 1947 for Paris, where he is known as Zao Wou-ki. I shall have more to say about him presently. When in the autumn of 1949 the Communist armies arrived in Shanghai they were welcomed, by the vast majority of intellectuals and artists, with open arms.

Art in China since 1949

98

We might expect that a Marxist China would have rejected out of hand her poetic, conventionalized traditional art and embraced an uncompromising socialist realism. There is indeed a good deal of socialist-realist art that is entirely Western in style; innumerable portraits of Chairman Mao, for instance, and huge paintings and posters celebrating China's achievements in industry and self-defence. But these are not the whole story. Certain crucial elements of traditional art have proved indestructible, though their traditional nature may seem to be obscured by their radical content.

For a short time after 1949 the old beaux-arts training continued in the art schools. By 1953, however, Hu Chiao-mu

was describing a new regimen in the National Academy in Hangchow - how Lin Feng-mien and other 'followers of Matisse' were going with their students to farms and factories to paint what they saw instead of basing their work only on Greek sculpture and the nude. 'The first-year and second-year students,' Hu Chiao-mu reported, 'have to draw portraits of the "living men" besides studies of Greek sculptures. Likewise the third-year and fourth-year students have to draw "models in clothes" in addition to studies of nudes.' This does not sound very revolutionary; indeed, in matters of style and technique the Chinese academies remained a good deal more conservative than many Western art schools. Nor was the difficulty in persuading students to draw what was before their eyes in itself anything new. In the early 1930s students in Peking, set to draw a street scene, had asked their teacher for photographs of figures that they could copy into their pictures. They were helpless without a ready-made formula. But now it was not a question of how they drew, but of what they drew, and, as we shall see, the problem of dependence upon a ready-made schema has not been solved by substituting heroic peasants for Greek casts.

Soon the authorities were intensifying their efforts to force students to abandon their traditional habits. The influence of Russian realism was some help in the 1950s, but after the decisive break with Russia, and the drift away from her East European satellites, China had no fruitful cultural contact with the advanced Western countries, and she was on her own. It is no accident that, while Western-style oil painting continued to have its place, it has become increasingly regarded as a foreign style – like Christianity, something alien to the Chinese temperament – and in recent years the main emphasis has been upon experiments in extending the scope of traditional painting (kuo-hua) to include the expression of revolutionary content.

In the early post-Liberation years the work of Kaethe Kollwitz and Picasso was considered ideologically acceptable, and the latter's *Peace Dove* was cunningly adapted in scrolls by numerous orthodox Chinese painters. By the late 1950s the government felt confident enough to open the doors to a wider range of expression in the arts, and in 1957 launched the Hundred Flowers Movement in the sincere belief that it could control and exploit the creative energies which a more liberal policy would generate. But the government was not prepared for the flood of individualism and protest that followed. The

IOI

Hundred Flowers Movement came to an abrupt end, some painters who had demanded too much freedom were disciplined,

and there was a general tightening of controls.

But even this was not enough. When the Cultural Revolution exploded in the summer of 1966 one feature of the campaign was a violent attack upon everything Western on the part of thousands of half-educated young people who felt that they were 'out in the cold', with no hope of a future in the élite of the party, the universities or the professions. People owning Western books and pictures and thought to have Western connections were stripped of their possessions by roving bands of teenagers, and although the reports of actual destruction of works of art were greatly exaggerated, the movement, which continued with slowly diminishing energy for more than two years, severed all China's remaining cultural contacts with the Western world. Universities and museums were closed, and remained closed for nearly five years. Art journals such as Mei-shu, which up to 1966 had been steadily increasing their attacks on the degenerate art of the capitalistic countries, abruptly ceased publication. In every department of China's cultural life the board was swept clean for a complete re-evaluation of the arts and their rôle in society.

Since 1966 writing on art has concentrated on two things: attacks on former President Liu Shao-ch'i and on his revisionist party theorist on art, Chou Yang, who was accused of having advocated wholesale surrender to bourgeois formalism; and analysis of certain key works in modern drama and opera in which the new aesthetic is being worked out with great thoroughness. The kind of synthesis of traditional and Western techniques in opera and ballet, and of stylization and realism, which has been established for productions such as *The White-haired Girl* and *The Red Detachment of Women*, is likely also to provide the programme for the visual arts in the years to come, unless

there is a radical change of policy.

While by no means avant-garde in the Western sense – they communicate their meaning much too readily – these dramatic works are daring in the confidence with which they take what they want from East and West, and they pulsate with energy. The scene in *The White-haired Girl* in which the heroine, lost in the mountains, defies the elements while her streaming hair and tattered clothes turn white, is one of the most exhilarating and beautiful moments in the modern dance-drama. It is impossible to dismiss such achievements as mere propaganda.

China's leaders have recognized that aesthetic problems cannot simply be ignored, and that it would be impossible to impose a crude socialist realism on the Russian model. For one thing, such a course would not be Chinese; for another, the Chinese are far too intelligent to wish to avoid theoretical and philosophical issues, and their pride in their nation's cultural heritage is strong and deep. Chairman Mao has made it clear that traditional forms need not be abandoned; what must change is the attitude of social and intellectual exclusiveness that was characteristic, for example, of the ink painting of the Ming and Ch'ing literati, and survived in their twentiethcentury successors. 'We do not refuse,' he said, in one of the famous Yenan Talks on Literature and Art in 1942, 'to use the literary and artistic forms of the past, but in our hands these old forms, remodelled and infused with new content, also become something revolutionary in the service of the people.' The attitude to Western art is equally unambiguous. 'Making foreign things serve China' means that, in theory, any Western art form may be adopted, or adapted, to meet China's needs; while the use of the word 'serve' shows that the foreign element, however important, will always be considered as the offering of a subordinate, just as the gifts brought by foreign ambassadors have always been regarded as 'tribute'.

When we consider how great an emphasis has been put upon 'realism' in Chinese critical writing since 1950 it is important to understand what is meant by the term. Russian academic realism still has its place, but to a post-Liberation theorist such as Hsia Chou or Tsung Pai-hua (formerly a 'bourgeois' critic), realism consists in finding in nature, and capturing, not the outward visible form of a particular thing, but its essence. To Hsia Chou, Shih-t'ao was a realist because he was inspired by nature rather than by the art of the past. Tsung Pai-hua even quotes Blake - 'to see a world in a grain of sand' - and compares the economy and suggestiveness of one of Pa-ta Shan-jen's sketches to the actor's opening of a non-existent door. To take the essential form and give it universal significance, says this critic, is 'the essence of the realistic method of the classical tradition'. If we might object that the great individualists of the past, such as Pa-ta Shan-jen and Shih-t'ao, belonged to an élite, were out of touch with the masses, and painted pictures that only a handful of like-minded men could understand, the modern theorist would reply by saying that their very individualism was the mark of their refusal to co-operate in a corrupt,

feudal society, and that their unorthodox style of painting was a form of political protest. There is in fact some truth in this.

But even in her search for models for a more literal kind of realism modern China has not had to look beyond her own frontiers. I referred earlier (page 64) to the mastery of perspective in the Sung Dynasty and its subsequent rejection, and to the astonishing grasp of shading and foreshortening employed in the Ch'ing-ming Festival scroll, painted at the end of the Northern Sung period. Except for strong chiaroscuro, cast shadows and a dynamic use of colour in the design, every device at the command of the traditional Western artist has been known in China since the twelfth century, although the literati, for reasons which I have discussed, deliberately rejected most of them.

After 1950 there was a reaction against the landscape painting of the literati in favour of the far older tradition of figure painting, which has its roots in the didactic wall-paintings in the palaces of the Han emperors. Here, too, what is wanted is not objective 'realism', but something of a much loftier kind: heroic figures depicted, as Mao Tse-tung put it, 'on a higher plane, more intense, more concentrated, more typical, nearer the ideal, and therefore more universal than actual everyday life'. Sir Joshua Reynolds, writing on the sublime in art, could not have expressed himself more succinctly. 'Revolutionary idealism' is the name given to this kind of art in China today. But not all of it carries so obvious a message. Ch'eng Shih-fa, formerly an individualistic painter of traditional scenes of bamboos and rocks, has since 1950 painted a series of lyrical pictures, chiefly of the peoples of China's Tibetan borderlands, which use the Chinese medium and brush line in an entirely new way, expressing the idea of peaceful abundance with great charm and originality.

The most striking example of realism in modern Chinese art is the *Rent Collector's Courtyard*, a sculpture group modelled in 1965. Before Liberation, the province of Szechwan had been notorious for the wealth and rapacity of its landlords; tenant farmers had often mortgaged their crops for sixty years in advance to pay their rent, and many peasant families were born and died in debt. In the courtyard of a former landlord's mansion in Ta-yi County a group of local sculptors and artisans recreated, in full-size figures in clay, the misery of the annual rent collection, the greedy landlord and his henchmen, the

102

poor peasants bringing in their rice and selling their daughters, the weeping children and old women. The work is intensely affecting as a reminder of the past, and the treatment might at first glance seem a thoroughly Western example of socialist realism.

But China has a long and vigorous tradition of clay sculpture at the artisan level, which survives in the masterly tomb figurines of the T'ang Dynasty and in temple sculpture, notably at Maichishan. Gentlemen never - after the fourth century, at any rate - dirtied their hands with clay modelling, still less with stone carving; nevertheless, sculpture was influenced by the aesthetics of painting. In this dramatic panorama, which runs round the four sides of the courtyard, a story unfolds in space and time precisely as it does in the long narrative scroll paintings. Not only this, but the sense of space in the groupings is thoroughly 'painterly' in the Chinese way. The figures are united, not organically as they would be in any traditional Western sculptural group, but pictorially, the intervals between them being pregnant with meaning, as cruel, sardonic glances and agonized or defiant glares shoot across empty space, drawing together the participants in the drama by the same kind of psychological or dramatic bonds that unite the separate figures in a traditional scroll, such as Chou Fang's Tuning the Lute and Drinking Tea, or the anonymous Sung painting, Breaking the Balustrade, in the National Palace Museum collection.

More than any other of the great civilizations today, the Chinese know what they want. They are not riven, like Japan, by the contrary pulls of national and international culture and art, or undermined by the crisis of confidence in capitalist society. They have a programme which covers every department of human activity and which the people as a whole support. There is no place for abstract art, although an official told Sir Herbert Read on his visit to China in 1959 that there was no reason why it might not one day be one of the 'hundred flowers'; abstract painting is not only regarded as an extreme instance of bourgeois formalism, but is rejected on the subtler ground that in calligraphy China already has an abstract art of her own and so has no need to borrow from abroad. A Western observer, knowing how highly calligraphy is still regarded, and remembering that Chairman Mao's handwriting is universally admired. might conclude that this admiration involved accepting an aesthetic of pure form, which would be contrary to current

ideology. In fact, however, the problem does not arise, or rather, as often happens in China, what to a Western critic would be a theoretical inconsistency is not seen as a problem at all. For the present approach to calligraphy is precisely that of the Sung Dynasty literati, who measured both painting and calligraphy by the quality of the personality and temperament that they revealed. Given the writer's sincerity, it is what is admirable in him as a man that, in great measure, makes his handwriting admirable. In an article on 'The Problem of Formal Beauty in Recent Discussion in China' (1964), Chu Kuang-tsien puts what was at that time clearly the officially favoured view:

A piece of handwriting by Yen Chen-ch'ing (T'ang Dynasty) strikes one at once with its strength and firmness, whereas a different one by Chao Meng-fu (Yüan Dynasty) strikes one with its grace and suavity. Each is beautiful in its own way. But the effect is different: we feel uplifted and invigorated in one case, but enchanted and somewhat relaxed in the other. The difference in effect reveals the difference of the two great artists in character. It is their character-revealing factor which moulds the form of the strokes and gives life and meaning to the whole piece of work. Shall we say that it has nothing to do with calligraphic beauty? It would be just as absurd to say that a girl's shyness and modesty have nothing to do with the beauty of her blush!

The writer goes on to emphasize that the inseparable relationship between form and content was well understood by ancient Chinese critics. This leaves the way open for the adoption of any form, Chinese or Western, if it is infused with the right kind of content. There may yet be room for nonfigurative painting, since abstract forms may carry a symbolic message.

Meantime the most immediate problem has been the adaptation of the traditional language of art to modern needs. The vocabulary and grammar of traditional painting, the method of training whereby the student acquired through study and practice a repertory of conventional forms and rules for composition, had by the nineteenth century congealed into a beautiful but almost dead language. The elements of that language are chiefly the individual brush strokes, ts'un, by which the artist expresses the character and texture of his

landscape forms. In the years before Liberation modern painters such as Lin Feng-mien and Chao Wu-chi rejected this vocabulary in favour of a very personal kind of naturalism. Today a new vocabulary is taking shape. We read of Li K'ojan visiting the T'ai-hang Mountains or Chairman Mao's birthplace, not only to relive momentous events in Revolutionary history, but also to 'check his ts'un' against the forms and textures of real rocks and mountains. Once having done this, having revised and brought up to date his vocabulary, and much more difficult - having created new 'words' for things never considered before as suitable matter for art, the painter is equipped with a new conventional language. He need, in theory, never leave his studio again. But he will, because he recognizes that only a direct experience of nature can put life into his formal vocabulary and because he has been taught not to cut himself off from his fellow men. Nevertheless, the later work of Li K'o-jan, Ya Ming and their many pupils shows the crystallization of a new set of conventions, a new orthodoxy, such as we find in the seventeenth-century followers of Tung Ch'i-ch'ang and Wang Shih-min. This is not imposed from above; still less is it influenced by the West. It is simply a return to the natural Chinese way of painting.

103

Chinese Painters on the International Scene since the Second World War

The Western reader might ask why Oriental painters who live or lived in Paris and New York, and paint in oils, should find a place in this book. At first glance their work may appear entirely Western, though a longer look often reveals subtly Oriental features. But this is not the only reason for including them. Men like Zao Wou-ki in Paris and Cheong Soo-pieng in Singapore, whatever manner they paint in, have never ceased to think of themselves as Chinese. This awareness of their origin may reveal itself, if at all, only in a particular kind of sensibility in the use of the line, a tendency to give colour a subordinate rôle, or a subtly poetic feeling for space and depth, recognizable only to someone familiar with Oriental art. But, however imperceptible, the consciousness is there in the artist himself, and in a variety of ways, direct and indirect, he cannot help but express himself as a Chinese, and in so doing make a Chinese contribution to the East-West dialogue. One would not, on the other hand, include, simply because he is of Chinese race, a

04

105, 106

painter such as Dong Kingman, whose work and outlook have never been anything but American.

There is another reason for including Chinese painters living abroad and working in advanced Western styles. The establishment of a new artistic orthodoxy in China has left no place for the individualists and eccentrics who traditionally flourished, or at least eked out an existence, on the fringes of Confucian society. The fact that today they are active in Hong Kong and Taiwan, and to a lesser extent in Europe, America and Southeast Asia, makes them none the less Chinese.

As long as the differences between Chinese and Western art were clear-cut the Western public tended to be not merely critical but often positively hostile towards Chinese artists who painted in the Western idiom, and judged their works particularly harshly. If the Chinese painter continued to work in the traditional style they dismissed him as of no international significance, while if they detected in his work the influence of Picasso or Klee they accused him of 'copying', although they would take for granted the same influences on a Western painter. For Zao Wou-ki to be stimulated by Jackson Pollock showed how derivative he was; for Mark Tobey to be influenced by Chinese calligraphy, on the other hand, showed how receptive he was.

Faced with this sort of prejudice, some Chinese painters abroad have retreated into a professional traditionalism, for there is always a living to be made by teaching ink painting or designing calendars and greeting cards. Others – P'an Yü-liang and Liao Hsin-hsüeh, for example – became solid Post-Impressionists in Paris, though both preserved something of their heritage; Liao Hsin-hsüeh was also a competent bamboo painter in Chinese ink, while, even at her most Cézannesque, P'an Yü-liang reveals a Chinese expressiveness in her brush line, and her signature is placed unerringly in the Chinese fashion.

Abstract Expressionism and Action Painting put the Oriental painter in a totally new relationship with Western art. Now suddenly calligraphic abstraction became respectable, and no serious critic would accuse Domoto Inshō, Zao Wou-ki or Liu Kuo-sung of merely 'copying' Pollock or Kline, although these painters would in most cases admit that it was the impact of the New York school after the war that drove them to discover, or rather to rediscover, the Abstract Expressionist roots of their own tradition. Art since 1945 has in any case become

international, and today the stimulus is as likely to go from East to West as in the other direction. The complaint that the work of some Oriental painters is no longer really Oriental has ceased to have any meaning.

The successive stages in the evolution of Zao Wou-ki's painting offer a striking illustration of the flowering of the new abstract movement in Far Eastern art. His early work in Hangchow, chiefly portraits in oils and very sensitive and original small landscapes in the Chinese manner, shows an imaginative young painter making a series of tentative explorations in a new direction while remaining essentially Chinese. On his arrival in Paris in 1947 he felt the full impact of modern Western art for the first time. For a while his work was strongly influenced by Paul Klee, whose 'landscapes of the mind' have appealed to many modern Oriental artists. Meantime Zao Wou-ki was moving towards abstraction. He began to work in oils on a much larger scale, sometimes incorporating archaic ideographs, or suggestions of ideographs, taken from Shang bronzes and oracle-bone inscriptions. In so doing he was paying homage to the ancient Chinese belief that the arts of painting and writing came into existence together and are of divine origin. This idea has a strong appeal to all educated Chinese painters, and other abstractionists have followed Zao Wou-ki, finding that incorporating the ideograph gives their painting a richness of symbolic content and association that Western abstract painting so conspicuously lacks. Such is the beauty and power of the characters themselves that many a lesser painter than Zao Wou-ki has been tempted into using them in a purely decorative way. Others, particularly in Japan, have taken the ideograph as a spring-board for 'abstract calligraphy', in which the form may suggest an idea or call up an association without itself being legible as a character.

Zao Wou-ki's contribution to non-objective art went still further, however. Some of his large abstract oil paintings of the 1960s combine calligraphic élan with an atmospheric depth that owes nothing to Pollock or Kline, but is the expression of his instinctively Chinese feeling for three-dimensional space. The Chinese artist is never concerned with the surface of things. He is always aware of what lies behind it, and the misty distances that fill so many traditional paintings are intended to hint at a reality that exists beyond what the eye can see. Zao Wou-ki is delighted if we can 'read' his abstractions as landscapes, for that is what they are. It only needs a touch here and there –

VIII Chang Dai Chien (b. 1899). Ten Thousand Miles of the Yangtze River. Chinese ink and colour on paper. 1968

IX Liu Kuo-sung (b. 1932). Abstraction. Ink and colour on paper. 1966

X Tseng Yu-ho (b. 1923). At Second Sight. Ink and collage on gold paper. 1962

XI Vincent van Gogh. The Artist's Bedroom at Arles. Oil on canvas. 1888

XII Henri de Toulouse-Lautrec. Miss Loie Fuller. Lithograph

98 Ku Yüan (b. c. 1910). Denouncing the Landlord. Woodcut print. C. 1950

99 Wu Tso-jen (b. 1908). Yaks. Chinese ink on paper. 1963

100 Wei Tzu-hsi. Wind and Rain can't stop them. Chinese ink and colour on paper. 1956

101 Ch'eng Shih-fa (b. c. 1905). *Under the Pipal*. Chinese ink and colour on paper. 1960

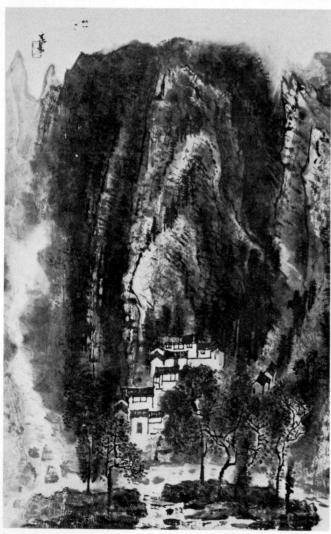

102 Anonymous sculptors, Szechwan. Rent Collectors' Courtyard: Scene 3, 'Measuring the Grain'. Life-size clay sculpture. 1965

103 Li K'o-jan (b. 1907). Mountain Village. Chinese ink and colour on paper

104 P'an Yu-liang (b. 1905). Still life. Oil, C. 1945

105 Zao Wou-ki (b. 1920). Buds and Lotus. Watercolour. Exhibited in 1948

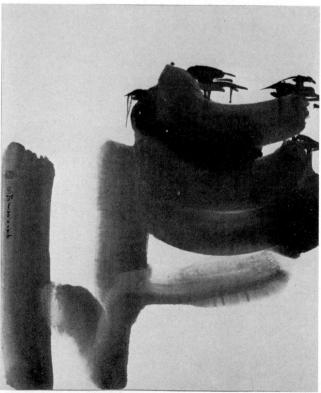

108 Hung Hsien (b. 1933). Composition. Ink and colour on paper. Exhibited in 1971

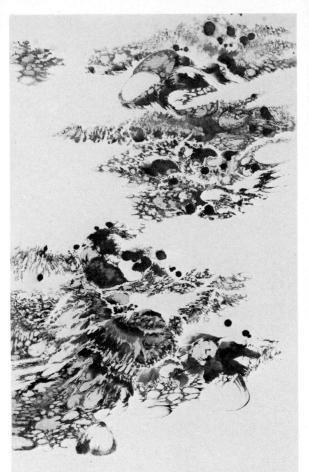

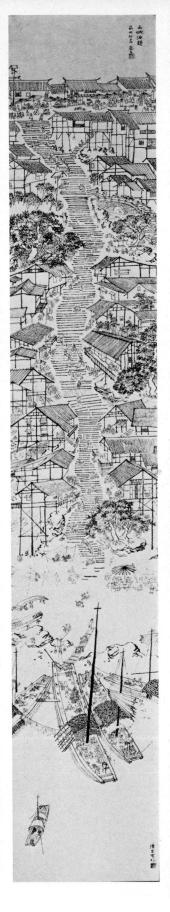

109, 110 Ch'en Ch'i-k'uan (b. 1921). *The Ganal* and (right) *Chungking Steps*. Ink on paper. *C*. 1954

111 Ch'en T'ing-shih (b. 1919). Abstraction. Print from banana-leaf fibre board. 1967

112 Tseng Yu-ho. Tree Roots. Ink on paper

a few trees, a cottage, a fisherman – and we have come full circle to the landscapes of the late T'ang 'action painters' and the Zen ink-flingers of the thirteenth century.

This step has in fact been taken by a number of Chinese painters in the last ten years, for example by Lui Show Kwan (Lü Shou-k'un) in Hong Kong, whose swirls with the brush the fact that they are more transparent and luminous than those of Soulages is only partly due to the medium employed are transformed into suggestions of landscapes by the addition of a few rocks, or trees, or a fishing boat. The most surprising convert to this way of painting was the noted painter Chang Dai Chien (Chang Ta-ch'ien). Although in appearance and manner the very embodiment of traditional painting, this bearded, long-robed master, who once spent two years copying Buddhist frescoes at Tunhuang, has responded with tremendous energy and verve to the march of events. In 1953, at a famous meeting in Antibes, he exchanged paintings with Picasso, a personality with whom he had much in common. In 1968 he painted a long hand-scroll of the Yangtse River in which ink washes and strong mineral colours are allowed to mix, to confront or repel each other in a daring and apparently accidental fashion, after which, by the addition of telling accents and precisely drawn details, the composition is turned into a stupendous panorama that sends us on an imaginary journey down the river from its source in Tibet to where it loses itself in the China Sea.

The modern movements, such as the Circle Group in Hong Kong and the Fifth Moon Group in Taipei in 1965, have sprung from the happy marriage of Abstract Expressionism and Action Painting on the one hand and the Chinese calligraphic tradition, sense of space, and intuitive feeling for the life of nature on the other. They have also been united in their aim of breaking free both from Western art and from dependence on the traditional formal vocabulary. Liu Kuo-sung and Chuang Che, for example, rejected the tien (dots) and ts'un (texture strokes) altogether. More recently still, some followers of Lui Show Kwan in the In Tao (Yüan Tao, or 'Original Way') Group in Hong Kong have gone a step further, reacting against calligraphic gesture painting, and have begun to create a new formal vocabulary. The possibilities of these new explorations seem inexhaustible. They are certainly producing a wide range of work, from the free, sweeping forms of Lui Show Kwan and the earlier Kline-like gestures of Chuang Che to the elegant,

VIII

es ne 108 on er

carefully controlled semi-abstract landscapes and cloudscapes of Hung Hsien. Liu Kuo-sung has varied what can become a too uniformly beautiful style by using collage, working on the back of the paper, or pulling out the coarsest fibres after painting. Some of his more recent paintings, inspired by the exploration of space, verge on the spectacular, but in his best work there is a perfect balance between calligraphic vitality and poetic depth, and his colour harmony is profoundly lyrical.

In the late 1960s Op Art, Pop Art and Kinetic Art appeared as the inevitable reaction against the expressive limitations of pure abstraction. Their exponents are not content simply to copy the styles and methods of Vasarely or Lichtenstein, but are deeply concerned with what relevance these movements may have to the Chinese tradition, for only when this has been established can the style have any meaning for them. This heartsearching, conscientiously undertaken, has prevented the uncritical surrender that took place in post-war Japan. In Hong Kong I have heard the dynamic confrontation of areas of pure colour in Hard-edge painting interpreted as an expression of the interaction of opposites enshrined in the Yang-vin concept, and Kinetic Art as an expression of the state of eternal flux that both Buddhists and Taoists see in the natural world: while for painters like Chuang Che in Taiwan, who came to feel that the lyrical abstractions of Liu Kuo-sung and others in the Fifth Moon Group were too élitist, too remote from the feelings of a society in ferment, there is Pop Art. Most Chinese artists shrink from this as vulgar and as a denial of the calligraphic basis of their tradition, but in a rigidly censored society such as that of Taiwan, Pop Art is about as close as a painter can approach to an art of social protest.

These artists, and other independent painters such as Cheong Soo-pieng in Singapore and Ch'en Ch'i-k'uan in Taiwan, are making an important and unquestionably Chinese contribution to the international modern movement. They are profoundly serious. Poised between East and West, they are searching not only for a style but for their own identity, and they are finding their identity in their painting. This is not to say that their work, in terms of the international modern movement, is always entirely original. There may be precedents for Liu Kuo-sung's 'Which is Earth' series of the late 1960s, for example, in Adolph Gottlieb's *Blast* (1957); for some of Lui Show Kwan's abstractions in Mark Tobey's series of calligraphic abstractions of 1956—

109, 110

57; for Hung Hsien's techniques in those of Pavel Tchelichew; for Ch'en T'ing-shih's prints in the compositions of Yoshihige Saitō; for the abstractions of Li Tzu-yüan in the screens of Mori Manabu. In no case, of course, can we prove that the one was derived from or suggested by the other. But with the extraordinary speed of the movement of art today, and the infinity of choices open to the artist, such derivations are much less meaningful than they used to be. The effort to be original has in any case become the pursuit of an illusion, as Jackson Pollock showed when he hurled a book of Picasso reproductions across the room and shouted, 'God damn it, that guy thinks of everything!'

Occasionally the homage of the modern Chinese painter to tradition reveals itself in a more direct yet still very subtle way. Tseng Yu-ho as a girl in Peking studied what we might call the 'academic literary style' under P'u Hsüeh-chai, a cousin of the last Manchu emperor. With this thoroughly traditional equipment, she was flung by her marriage to Gustav Ecke, and her subsequent removal to America, into the mainstream of modern Western art. The results were startling. Between 1955 and 1965 she produced a series of paintings in which she managed to convey with an astonishing freshness of vision the form and texture of the Hawaiian landscape in the language of the Chinese scholar painters, notably that of the morose seventeenth-century eccentric Kung Hsien, whose stippling technique is well suited to depicting the strange geology of Honolulu. The ominous atmosphere and dense textures of Max Ernst, who visited Honolulu in 1952 and gave a series of lectures on modern art at the University of Hawaii, was another rather more elusive influence upon her.

In more recent years Tseng Yu-ho has painted a series of 'Sung' and 'Yüan' landscapes in which she pays homage to the great classical masters such as Li Ch'eng and Huang Kungwang, suggesting their characteristic compositions and even their brush techniques while working in a completely modern idiom – a striking instance of the power, and indeed the obligation, of a scholarly Chinese painter to keep the tradition alive by a creative reinterpretation of it. The tendency toward abstraction in her recent paintings, the temptation to use gold or silver foil as a background in the manner of Japanese screen painters, and to play with collages of paper, tapa cloth and seaweed as a substitute for the calligraphic line, have brought this highly talented painter perilously close to pure surface

decoration. From these she has moved on again, to Chinese motifs such as the 'TLV' mirror design of the Han Dynasty. Though based on Chinese tradition, these elegantly fashioned works display a cool detachment far removed from the spontaneous language of the brush.

6 Europe and America: from 1850 to the Present Day

Japan and the Impressionists

One day in 1856 – the exact date is forgotten – the French designer and etcher Félix Bracquemond, taking one of his plates to be printed by Delâtre, noticed in the printer's studio a little book of woodcuts in red covers which aroused his curiosity. Delâtre would not part with it, and Bracquemond eventually obtained it from someone else, after which he carried it around with him wherever he went, showing it enthusiastically to his many artist friends, among whom were Manet, Degas, Fantin-Latour and Whistler. This famous little volume, one of Hokusai's sketchbooks (Manga), has become to art historians the symbol of the birth of the Japanese cult in Paris, and the precursor of the flood of Japanese prints that in the next three decades was to have so decisive an influence on the direction taken by French painting. Félix Bracquemond himself returned again and again to Hokusai for inspiration, chiefly for his porcelain decorations. Meantime, in about 1857, Claude Monet, a sixteen-year-old pupil of Boudin, was buying his first Japanese prints for a few sous in the junk-shops of Le Havre.

The main events in this rising tide of japonisme are well known. In 1862 Mme Desoye (or de Soye) and her husband, recently returned from the Orient, opened their shop, La Porte Chinoise, on the Rue de Rivoli, where they dealt in Far Eastern arts and crafts of all kinds. Their establishment became the Mecca for artists, collectors and the beau monde in general. Manet, Fantin-Latour, Tissot, Whistler, Baudelaire, the Goncourts and many others could be seen there rummaging for fans, textiles, colour-prints, blue-and-white porcelain. Soon every studio and up-to-date salon had its pile of kimonos, its fans and woodcuts pinned to the wall. All the Impressionists owned Japanese fans or prints, or both, some many hundreds, and they often appear as accessories in their portraits and interiors. Whistler, studying in Paris between 1855 and 1859, was one of the first painters to fall under the spell of Oriental art. Not only did he collect prints, but he had a passion for Chinese and Japanese blue-and-white porcelain, which he later carried with him to London.

113, 114

The French hunger for things Japanese was whetted by the Japanese exhibits at the Exposition Universelle in 1867. It was more literally assuaged by the founding in the same year of the Société Japonaise du Jing-lar, whose members, chiefly painters, collectors and critics, held monthly dinners with sake and chopsticks, at which each had his own menu-card designed by Bracquemond in a pseudo-Japanese manner. England had already seen Japanese art at the Great Exhibition of 1851, but the vogue did not really catch on till Whistler settled in London.

Although other dealers soon began to exploit the craze for japonnerie – notably Samuel Bing, with whom van Gogh and his brother had some dealings years later – Mme Desoye's La Porte Chinoise remained for many years the centre of the cult. In 1875 the Goncourts in their Diary described la grasse Mme Desoye, enthroned in her 'bijouterie de l'idole japonaise. Une figure presque historique de ce temps, car ce magasin a été l'endroit, l'école, pour ainsi dire, où c'est élaboré ce grand mouvement japonais, qui s'étend aujourd'hui de la peinture à la mode.' Mme Desoye's shop has long since disappeared, but the reverberations of what a critic called cette grande explosion japonaise could still be heard in the first decades of the twentieth century.

The Goncourts claimed in their Diary (1868) that they had 'discovered' Japan as early as 1860, but the fashion can be traced to no single source. Zacharie Astruc's articles on 'The Empire of the Rising Sun' in the same year probably made a wider impression than the Goncourts' advocacy, and exhibitions helped a good deal. There were Japanese paintings again in the Exposition Universelle of 1872, and in Vienna in 1873. Fenollosa's Ryūchi Society, founded in Tōkyō in 1879, sent a representative and paintings for exhibitions in Paris in 1883 and 1884; Samuel Bing was appointed local representative of the society, and augmented its shows with paintings from his own huge collection.

In his defence of Manet, published as early as 1867, Emile Zola had cited the élégance étrange and the taches magnifiques of Japanese woodcuts. Meier-Graefe thought that this was the first occasion in the history of European art on which the influence of Japan was mentioned, but this seems doubtful. The main flood of literature on Japan, however, came in the 1880s and 1890s with, for example, Théodore Duret's L'art japonais (1882), and Samuel Bing's influential periodical Le Japon artistique, launched in 1890. Edmond de Goncourt's

sympathetic study of Utamaro appeared in 1891, his much less successful book on Hokusai six years later. Many of van Gogh's ideas about Japan, true and false, were derived from Pierre Loti's Madame Chrysanthème, which he read in 1888. The writings of men who had lived in Japan, such as Lafcadio Hearn, Whistler's pupil Mortimer Menpes, Ernest Fenollosa and his pupil Okakura Kakuzō, all helped to reveal a new world one that was exotic and remote, yet growing in power and importance, gratifyingly pro-Western, and an inspiration in all aesthetic matters. By contrast, China at this time was seen as weak and corrupt, helpless under the heel of the Western powers, anti-foreign and, according to the missionaries, inhumane. It is little wonder that, while Europeans were drawn to Japanese culture and art, and felt that they understood them, they were repelled, through sheer ignorance, by those of China. As Le Blanc de Vernet picturesquely put it in 1880, 'chez les Japonais, une allure absolument libre, vive, riant et fantaste comme leur caractère', while 'chez les Chinois, l'art est froidement méthodique et correctement formaliste', a preposterous verdict that was not revised until well into the twentieth century.

The attitude towards Japanese art on the part of its nine-teenth-century devotees was equivocal. On the one hand the Ukiyo-e, the art of the 'floating world', which was, until the late 1880s, all that they knew, was felt to be exotic, alluring, exquisitely unreal; on the other, it was recognized as a vigorous, democratic tradition that drew its strength from the newly emerging masses, its subject-matter from the streets, teashops and brothels of rapidly expanding Edo, as Tōkyō was then called. Both views are half-truths. There is a formal and technical discipline in Japanese art that makes a total descent into self-indulgent aestheticism impossible; while, as for the almost photographic realism of the Japanese print, which Edmond de Goncourt stressed in his book on Utamaro, that realism lies rather in the choice of earthy subject-matter than in the handling of it, which is both stylised and decorative.

When in 1890 Maurice Denis uttered his famous dictum that 'whether it is a nude or anything else . . . any painting is essentially a flat surface covered with colours assembled in a certain order', the Japanese colour woodcut had for thirty years been undermining the foundations of the art of the salons. In the Japanese print – Hokusai and Hiroshige in their landscapes are but partial exceptions – there is no atmosphere, the colour has no texture, there are no shadows. Flat areas of pure colour

are separated by clear, sharp, rhythmic lines, and the picture area is frankly accepted for what it is, a flat surface. The focal point of the composition may be far off centre; objects and figures may be cut off by the edge of the print, in the interest not of visual realism but of effective pattern-making. Subject-matter counts for little. In these respects the Japanese print is the complete antithesis of all that was taught in the nineteenthcentury European art school. For the painters banded in revolt against the French Academy, the Ukiyo-e seemed at this critical moment to provide not only a vindication of their theories but a practical means of realizing them on canvas. 'Damn it all,' wrote Pissarro to his son Lucien in 1893, after seeing an exhibition of Japanese prints, 'if this show doesn't justify us! There are grey sunsets there that are the most striking instances of impressionism.' And again, in his next letter: 'These Japanese artists confirm my belief in our vision.'

Japanese art must have been a frequent topic of discussion at the Café Guerbois in the Rue des Batignolles, in the 1860s the meeting-place for all the leading figures in the Impressionist movement from Bracquemond and Manet to Gauguin and Cézanne, and of writers and critics such as Astruc, Zola and Duranty. The unquestioned leader of the Batignolles Group, as it came to be called, was Manet. Just when he first encountered Japanese art is uncertain, but he was a close friend of Bracquemond and a frequent visitor to La Porte Chinoise from 1862, the year in which he executed the large Musique aux Tuileries. In this richly painted work some writers have detected the first hint of Japanese influence, in the tendency to create a pattern of patches of colour, in the effective use of black in the design, and in the rather flat, schematic drawing of the faces which has been attributed to Manet's admiration of Hokusai's shorthand figure drawing. If indeed Japanese influence is detectable, it is overwhelmed, as nearly always in Manet's work, by his sheer joy in the medium of oil paint. We would not expect the pupil of Couture and the admirer of Velazquez to surrender without a struggle to so alien an aesthetic.

By the end of 1863, in La Chanteuse des Rues, Manet had gone a step further. The model, Victorine Murend, has just emerged from the half-open doorway and seems to hesitate in her forward movement, her voluminous dress swirling about her. Her face is a white blank with the features drawn upon it. The long lines of shadow and dark braid sweep up to her head, both articulating the movement within the figure and giving it

unity. The exact counterparts of all these devices can be found in Kaigetsudō's arresting paintings and prints of the beauties of the Yoshiwara, the red light district of Tōkyō. Thus Manet, when the Ukiyo-e first began to exercise its influence, embraced and reconciled its two apparently conflicting features – social realism, and an aesthetic based on the expressive power of line and colour alone. Of all his contemporaries only Jacques-Emile Blanche understood that Manet, without resorting to obvious *japonaiseries*, had absorbed and turned to his own use the essential message of Japanese art.

The same almost pure, flat colours, simple forms enclosed by an emphatic line, and absence of shadows, define other pictures which Manet painted at this time, notably the *Dead Toreador* of 1864. The *Olympia* of 1863, which caused such a furore when it was unaccountably accepted for the Salon, is often cited as the apogee of Manet's 'Japanese' period, but it has no Oriental features which are not present in other paintings of the mid-1860s, though they are here brought together with superb

assurance in a composition of monumental daring.

Manet's visit to Spain in 1865 helped to renew his old passion for Velazquez. That he did not at once or wholly forget the lesson of Japanese art is shown by the Fifer, painted in the following year, an almost shadowless figure poised in space, which one outraged critic called 'a costume dealer's signboard'. But in The Execution of the Emperor Maximilian there is the beginning of a return to solid, three-dimensional forms, while the landscape detail in the background reveals that sensuous handling of oil paint that Manet could not suppress for long. Henceforward the Japanese elements recur from time to time. We see them in the flatness and tendency to design in patches of colour in the Zola portrait of 1868 (in which the much discussed Japanese print and screen in the background are of more documentary than pictorial importance), and in the telling use of black as a colour in Luncheon in the Studio (1868), the grouping of On the Balcony (1869); while later still Manet reverts from time to time to a daringly 'Japanese' assymmetry of composition - in On the Beach (1873) for instance - or to odd angles and cutoff figures, as in La Place de la Concorde (c. 1875) and Nana (1877). By this time the lesson of the Japanese print had been totally absorbed - as it never was by Whistler - and had become a natural part of Manet's vision.

Only in one respect did Manet deliberately copy Oriental methods. Some of the plants and animals in his illustrations to

Mallarmé's 'L'Après-midi d'un faune' are adapted from woodcuts in Hokusai's Manga. For a time he seems to have studied Japanese brush painting, and in his swift ink sketches, such as The Bistro (1877) and L'Espagnol, he shows some understanding of sumi technique. For a time he liked to write letters on paper on which he had already made a sketch in Chinese ink. The lovely page brushed with sprays of bindweed must have been inspired by the letter papers used by Far Eastern poets and calligraphers. But Manet's line is seldom as Oriental as theirs; as a European, he is generally too interested in the form which the line encloses to allow it the full calligraphic freedom of Far Eastern ink painting. In the whole of Western art perhaps only Rembrandt, in his pen drawings, achieved a perfect synthesis of the expressive and descriptive functions of the line.

Edgar Degas was twenty-eight when, in 1862, he first met Manet, and first visited Mme Desoye's Porte Chinoise. Over the years he amassed a huge art collection which included important prints of Utamaro, Hokusai and Hiroshige, bought initially under the guidance of Bracquemond. Everything he did, he did with a cold deliberation. He was a poet, and his sonnets, perfect in form and phrasing, are without human tenderness or passion. The effects in all his pictures are equally calculated and controlled. 'No art,' he said, 'was ever less spontaneous than mine.' The beauty is in the poetry of pure form, with no thought for what lies behind it, and in this he is closer to the Japanese than to his own master Ingres. The idea of painting the low life of Paris was Japanese also, and he depicted the brothels of Montmartre with the same detachment as the masters of the Ukivo-e had recorded the squalors and delights of the Yoshiwara, transforming them, as they had, through the medium of an exquisitely refined sensibility into harmonies of pure line. colour and tone.

On a few occasions Degas was deliberately, obviously Japanese. He liked to paint Japanese fans for his own amusement, and showed five of them at the Impressionist Exhibition in 1870. The composition of his etching of Mary Cassatt in the Louvre (1880) is taken straight from the tall, narrow 'column prints' (hashira-e) of Kiyonaga. His exquisite painting of Mme Camus (1870), wife of the collector of Oriental ceramics, posed holding a fan against a glowing rose-pink wall, is perhaps the nearest that he ever came in his oil painting to the kind of japonaiserie that Whistler indulged in, and it is saved from vulgarity by Degas' fundamental concern with colour and tone as ends in themselves

118

- a concern which Whistler rarely felt. We have only to compare the portrait of Mme Camus with the cluttered, garish whimsicality of Whistler's *The Golden Screen: Caprice in Purple and Gold* (in the Freer Gallery, Washington) to see what a gulf separated the two artists. Indeed, Degas deplored the rampant *japonaiserie* of his day. 'Hélas!' he exclaimed to Bartholomé in 1890, 'Le goût partout!' As George Moore aptly put it, 'Degas thinks as little of Japanese screens . . . as of newspaper applause . . . he puts his aesthetics on his canvas.'

Some recent writers have attributed Degas' objective vision as much to the influence of photography as to that of the Japanese print. The invention of the hand-held 'detective camera' in the 1880s has been called in to explain his apparently accidental compositions, and the odd angles and cut-off figures that we see in so many of the ballet pictures - notably in Le Rideau - and in Aux Courses en Provence and Place de la Concorde. Some of these pictures were painted in the 1870s, before the invention of this particular type of camera, but already in the 1860s there was a vogue for stereoscopic street scenes which showed moving figures. some cut off by the edge of the plate, in instantaneous exposures as fast as a fiftieth of a second. These could have given ideas to Degas and to Manet, as they certainly did to the amateur Impressionist Caillebotte. After Degas' death a large quantity of photographs, about which he had been very secretive, was found in his studio. They must share with the Japanese print the honour of having influenced his attitude toward composition, while they probably helped him also to establish that subtle unity within a restricted range of tonal values that is unique to his paintings.

If the Olympia represents Manet's most successful translation of the Japanese message into French terms, the Bains de Mer of c. 1866-7 is undoubtedly Degas' – and for the same reason. For in each work the artist has for the moment completely subordinated texture, depth and atmosphere to a flat arrangement of pure colour and line. Having achieved this, Degas returned to his master, Ingres, as Manet did to Velazquez. Thereafter Degas' colour becomes richer and more brilliant, but his later oils and pastels, however solidly painted, are often held together by principles of composition that he learned in the 1860s from the study of Japanese prints.

On the whole, the Impressionists were concerned chiefly with the rendering of form in terms of the colour of the light reflected from it, and in this particular aspect of their researches they did not feel that they were helped in any way by the Japanese woodcut, although they might point to it as a confirmation of their theories. Renoir took a rather different view. He felt that a people had no right to appropriate an art that belonged to another race. The Japanese cult disgusted him, as it did Degas, and he remarked once to Vuillard that 'perhaps it's having seen so much *japonaiserie* that has given me this horror of Japanese art'. There is a rather touching irony in the fact that the pupil to whom Renoir was most devoted in his last years was the Japanese Impressionist Umehara Ryūzaburō, discussed on pages 140–41.

Monet, although probably one of the first of the Impressionists to buy Japanese prints, and a life-long collector of them, seems to have derived little from the study of them; they were not what he needed in his high Impressionist years. His most ambitious Oriental exercise – La Japonaise (1876), in the Museum of Fine Arts, Boston – representing his wife Camille in a theatrical pose, holding a fan against a background of fans, and swathed in a preposterous monster-encrusted robe, is a brilliantly vulgar pastiche of the sort that would have horrified the fastidious Degas. Monet himself later regretted it and called it 'trash' (une saleté).

During a brief stay in Holland in 1871, Monet bought Japanese prints and painted a few landscapes in bright, flat, pure colours, such as The Blue House at Zaandam, but he quickly abandoned this style on returning to Paris. In his later work Japanese elements of design persist, although his rich impasto makes them almost unrecognizable, and they come to final fruition in the great series of paintings of lilies to which he devoted himself in his last years. From about 1892 until he died in 1926 he painted almost nothing but the lily pond and Japanese bridge which he had created at Giverny, culminating in the vast 'Nymphéas' series, for which a special oval salon was built in the Musée de l'Orangerie, Paris, after his death. The texture of these huge, coarsely painted canvases of water lilies, wisteria and weeping willow is anything but Japanese; but the conception, although perhaps suggested to him by a friend, puts us in mind of the vast decorative screens and sliding doors of some palatial Japanese halls, while the realization of the scheme in terms of colour alone, and the very choice of colours - predominantly green, purple, white and gold - remind us of Korin. In spite of the obvious roughness of execution, Monet in these panels seems to achieve the impossible: the reconciliation of the

121

conflicting aims of Impressionism and of decorative art. So he too, strictly on his own terms, finally drew Japanese art into the mainstream of the French tradition.

Whistler was one of the first Western painters to fall under the spell of Japanese art, and his surrender was the most complete. He came almost straight from West Point to Paris, the more defenceless against the exotic fashion because he had not been schooled in the Salon tradition. Soon he was buying prints with great discernment — not the crude, aniline-coloured midnineteenth century sheets that everywhere passed for the best in Japanese art, but the earlier, subtler work of Kiyonaga and his contemporaries. When, after the rejection of At the Piano by the Salon of 1859, he moved to London, he took the craze with him, and soon had infected the Rossettis, with whom he competed for years in friendly rivalry in buying prints and Oriental porcelain. The walls and even the ceiling of his house in Chelsea were covered with fans; he slept in a Chinese bed and ate off blue-and-white.

The Rossettis were apt pupils, and William Michael Rossetti's description of a volume of Hokusai's Manga, published in The Reader in 1863, is full of admiration. He admits that some of the subjects are unedifying. 'The devil in man and the doll in woman seem to be the designer's idea of the radical distinction between the sexes.' But, for the rest, he is all praise for 'Hoxai's' work. 'It assuredly belongs,' he writes, 'in various respects to the greatest order of art practised in our day in any country in the world. It has a daringness of conception, an almost fiercely tenacious grasp of its subject, a majesty of designing power and sweep of line, and a clenching hold upon the imagination.' And he hopes that people who see these books 'may come to recognize their superiority, in some respects, to anything which contemporary European art has to show us'. Here Rossetti shows an even clearer grasp of the essential merits of the prints than does Whistler himself.

Unlike the Impressionists, Whistler never lost his enthusiasm for things Japanese. As late as 1885, in the celebrated 'Ten o'Clock Lecture', he was putting Japanese art on a par with that of classical Greece. Were another artistic genius, he declared, never to appear again, 'the story of the beautiful is already complete – hewn in the marbles of the Parthenon – and broidered, with the birds, upon the fan of Hokusai – at the foot of Fusiyama'. This was too much for Swinburne. 'The audience,' was his waspish comment, 'must have remembered

that they were not in a serious world; that they were in the fairyland of fans, in the paradise of pipkins, in the limbo of blue china, pots, plates, jars, joss-houses, and all the fortuitous frippery of Fusiyama.'

Whistler's japanophilia led him inevitably into the kind of pictorial extravagances that Monet indulged in once and always regretted. A series of his most popular paintings depicts European models dressed up in Oriental clothes and surrounded by the sort of bric-à-brac that Lazenby Liberty was now supplying to his London customers by the ton: Die Lange Leizen (1864), La Princesse du Pays de la Porcelaine (1864), The Golden Screen: Caprice in Purple and Gold (1861), The Balcony: Variations in Flesh Colour and Green (1867-8) - the very artificiality of the titles is revealing. The climax, and Whistler's most spectacular excursion into japonaiserie, was the Peacock Room (1876; now in the Freer Gallery, Washington), in which the artist, without the owner's permission, covered F. R. Leyland's priceless Spanish leather hangings with peacocks in blue and gold. This was a tour-de-force of decorative art, however, and has very little to do with nineteenth-century painting.

In the same years that Whistler was paying these extravagant tributes to popular fashion he was painting a series of pictures, entirely unoriental in theme, which show a deeper understanding of the Japanese aesthetic than any other painter except Degas had achieved. In The Music Room (1860) black is daringly dominant in a composition indirectly inspired by Kiyonaga; in The Little White Girl (1864), a picture that impressed Monet, Whistler's chief concern is with the subtlest harmonies of grey and white; in portraits of his mother (1872) and of Carlyle (1874) Japanese principles of design are applied with serene dignity, while little Cicely Alexander (1874) is portrayed in an exquisite harmony of colour and line, a delicate counterpoint between figure and background, in which even the obviously Japanese elements, such as the butterflies and butterfly signature, seem entirely appropriate to the charm of the subject.

Yet even in this lovely work Whistler was not so much painting what nature presented to him as making the outward reality conform to a pre-conceived attitude to what a picture should be. Such an approach is both romantic and academic, and Whistler, in rebellion against the Salon, has simply substituted one set of aesthetic principles for another. 'Whistler,' wrote George Moore, 'of all artists, is the least impressionist . . . he thinks of nature but he does not see nature; he is guided by

123

his mind, and not by his eyes.' The Impressionists, guided solely by their eyes, all, sooner or later, rejected Japanese art; but not Whistler, who once said that nature 'put him out'.

The most Japanese of Whistler's later paintings are the many 'Nocturnes', painted from 1875 onwards. Here the sources of his inspiration are very obvious. It is not that the composition of Old Battersea Bridge, and the idea for The Falling Rocket, are taken from Japanese prints - van Gogh borrowed as freely - but that when Whistler saw the Thames wrapped in the fog of a winter evening he could not help relying upon the exquisite pictorial formula that he had evolved, and Hiroshige hung like a transparent veil between himself and the real world. He lacked the passion of a Monet or a Cézanne, or rather his passion was partly misdirected. In London he had a rôle to play which the more rigorous artistic standards of Paris would not have demanded or allowed. In London, Hiroshige and Utamaro stood him in good stead, for only by translating Impressionism into pseudo-Japanese terms could he make it palatable to the philistine English public.

Japan and the Post-Impressionists

Just when van Gogh first encountered Japanese art is not certain. Pissarro wrote to his son that van Gogh had seen prints in his parent's home in Nuenen. Writing from The Hague to his friend Anton von Rappard in July 1883, when he was thirtyone, van Gogh mentions a print by Régamey and comments, 'beautiful Japanese motifs'. And he had been in Antwerp but a few days when, late in 1885, he exclaimed to his brother Theo, quoting the Goncourts, 'Japonaiserie for ever!' and described the docks as 'a famous japonaiserie, fantastic, peculiar, unheard of'. 'My studio is not bad,' he goes on, 'especially as I have pinned a lot of little Japanese prints on the wall, which amuse me very much. You know those little women's figures in gardens, or on the beach, horsemen, flowers, knotty thorn branches.'

By March 1886 van Gogh was in Paris, collecting prints, and in the following year had acquired enough – some probably borrowed from Samuel Bing – to mount a little exhibition in Le Tambourin, a café in the Boulevard de Clichy frequented by the Impressionists. He spent long hours in Bing's huge establishment rummaging for prints, and took a number hopefully to sell on commission. He suggested to Theo that, after a visit to the south

of France, they should go into the print-selling business together. He saw enormous profits, but his object was not primarily commercial. 'Japanese art,' he wrote to Theo in July 1888 from Arles, 'decadent in its own country, takes root again among the French Impressionist artists. It is its practical value for artists that naturally interests me more than the trade in Japanese things. All the same, the trade is interesting, all the more so because of the direction French art tends to take.' And to the painter Henri Bernard he wrote, 'Even if the Japanese are not developing in their own country, it is certain that their art is finding its development in France.' Although there was still not much profit in Japanese prints, at least in the kind that van Gogh could afford, he foresaw the time when even these would become rare. 'Wind up our connection with Bing?' he wrote to Theo, 'Oh, never!'

Nothing came of this project, of course, at least commercially. But the prints had a profound effect on van Gogh as a painter. Together with his reading, especially of Pierre Loti's Madame Chrysanthème, they created in his mind a fanciful picture of Japan as a country of clear, simple forms and brilliant colours. No doubt he had also read Duranty's widely quoted declaration that 'the instinct of the people of Asia, who live in the perpetual dazzling light of the sun, has led them to reproduce the constant sensation by which they have been impressed, that is to say, of clear, flat colours'. Confusing the Far East with India is remarkable in a late nineteenth-century critic. But this popular view convinced van Gogh that he would find Japan in the south of France.

Van Gogh left Paris in February 1888, and by September was writing to Theo from Arles, 'Here my life will become more and more like a Japanese painter's, living close to nature like a petty tradesman.' And again, 'If the weather were always fine like this, it would be better than the painter's paradise; it would be absolute Japan.' But winter came, and it was not Japan, and van Gogh knew by now that Provence was very different from what he had imagined. 'There is still present in my memory,' he wrote to Bernard, 'the emotion produced by my own journey last winter from Paris to Arles. How I watched to see if it wasn't like Japan! Childish, wasn't it?' By now the collapse of his dream no longer bothered him, for he was totally absorbed in painting the world around him, and to this end he began to study the methods of the Japanese print-makers and draughtsmen with much closer attention.

113 Katsushita Hokusai (1760–1849): Insects. Page from sketchbook (*Manga*; 1814–15). Coloured print from wood-blocks, made from original ink drawings with colour wash

114 Katsushita Hokusai. Wrestlers. Page from sketchbook (*Manga*; 1814–15). Coloured print from wood-blocks, made from original ink drawings with colour wash

□ 115 Edouard Manet (1832–83). La Chanteuse des Rues. Oil on canvas. 1863

116 Kaigetsudō Anchi. *A Beauty of the Day*. Woodcut print

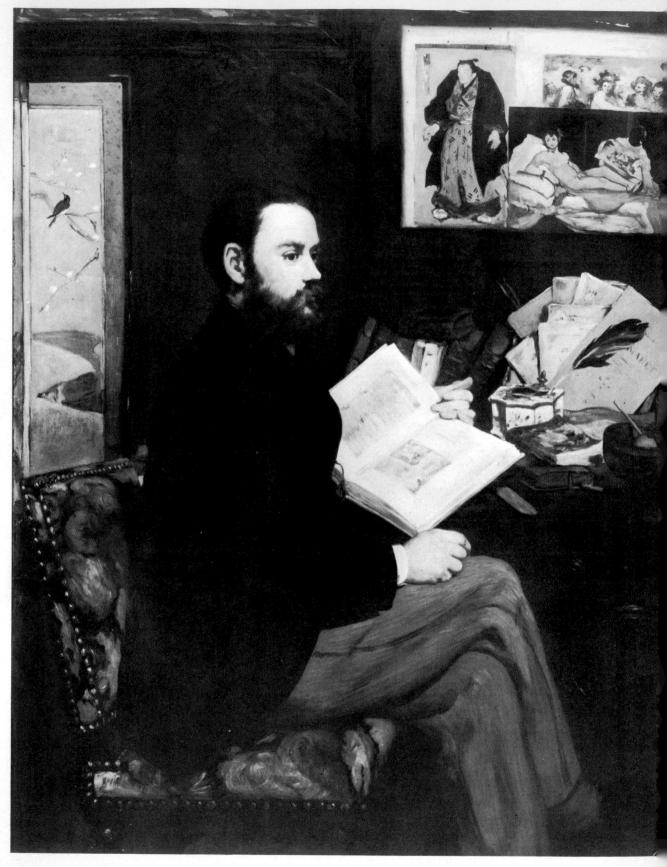

117 Edouard Manet. Portrait of Emile Zola. Oil on canvas. 1868

118 Edouard Manet. Page of letter with sprays of bindweed. Watercolour

119 Edgar Degas (1834–1917). Au Louvre. Pastel. 1880

120 Edgar Degas. Bains de Mer, Petite Fille Peignée par sa Bonne. Paper mounted on canvas. C. 1866–7

121 Claude Monet (1840–1926). La Japonaise. Oil on canvas. 1876

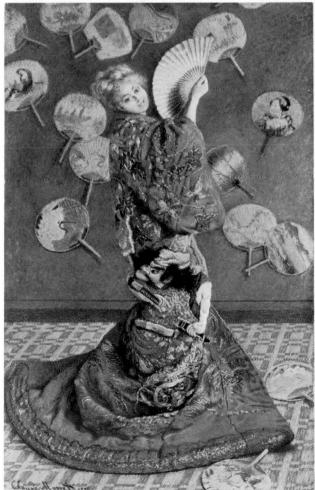

122 Claude Monet. 'Nymphéas' series (detail). Oil on canvas. C. 1916–23

123 James Abbott McNeill Whistler (1834–1903). The Golden Screen: Caprice in Purple and Gold. Oil on canvas. 1861

124 James Abbott McNeill Whistler. Miss Cicely Alexander: Harmony in Grey and Green. Oil on canvas. 1874

125 James Abbott McNeill Whistler. Old Battersea Bridge: Nocturne in Blue and Gold. Oil on canvas. C. 1885

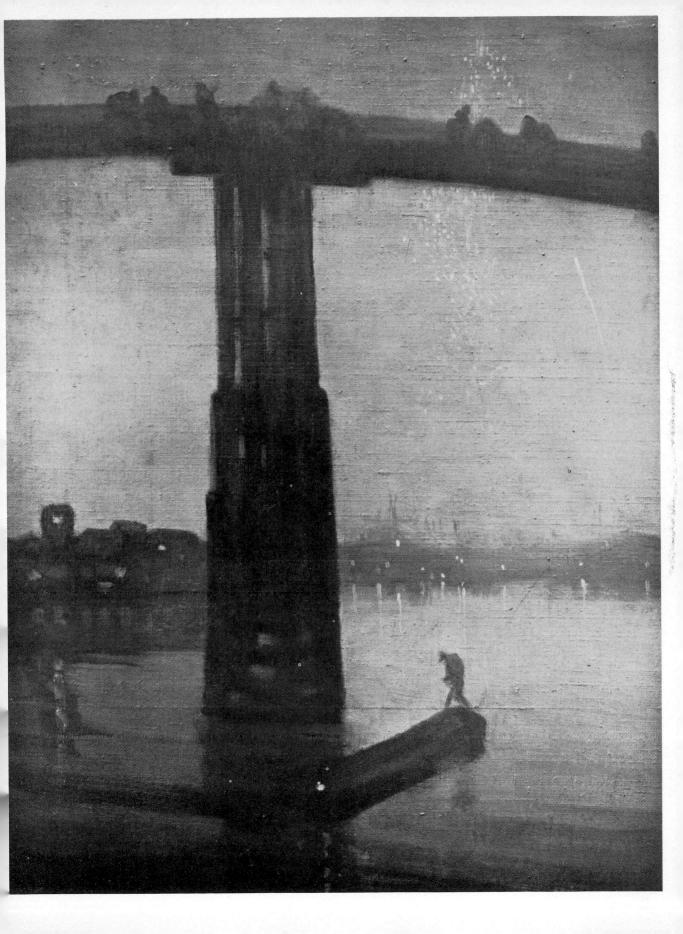

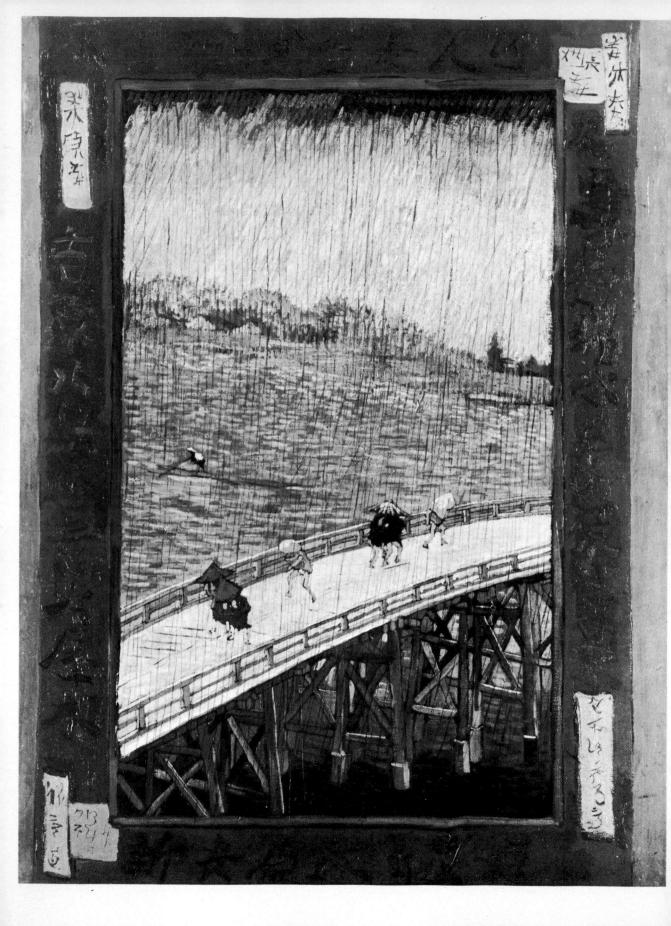

127 Vincent van Gogh. Le Père Tanguy. Oil on canvas. 1887

□ 126 Vincent van Gogh (1853–90). Copy of Hiroshige, Sudden Shower at Ohashi. Oil on canvas. 1888

128 Vincent van Gogh. Harvest: the plain of La Crau, Arles, June 1888. Pen and sepia ink. 1888

129 Andō Hiroshige (1797–1858). Cherry Blossoms at Koganei. Wood-block print in four colours. Late 1830s

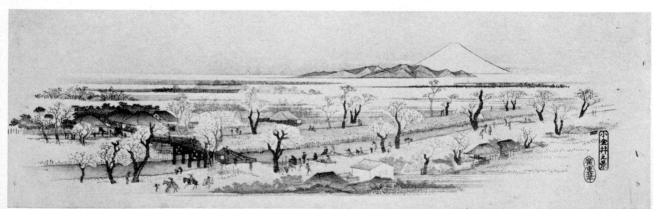

130 Anonymous. Prince Siddharta cuts his hair, signifying his retreat from the world. Relief panel from Borobudur. Stone. Ninth century

131 Paul Gauguin (1848-1903). Where do we Come from? What are we? Where are we Going? Oil on canvas. 1897

132 Henri de Toulouse-Lautrec (1864–1901). Jane Avril au Jardin de Paris. Coloured poster. 1893

133 Pierre Bonnard (1867–1947). 'Japanese' screen in four panels, depicting carriages, women and children with hoops. Lithograph. 1897

134 Maurice Denis (1870–1943). Procession under the Trees. Oil on canvas. 1892

135 Vasily Kandinsky (1866–1944). Light Picture, no. 188. Oil on canvas. 1913

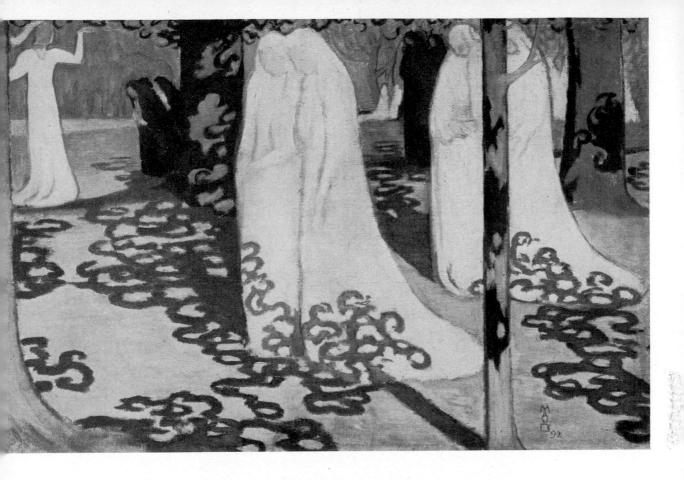

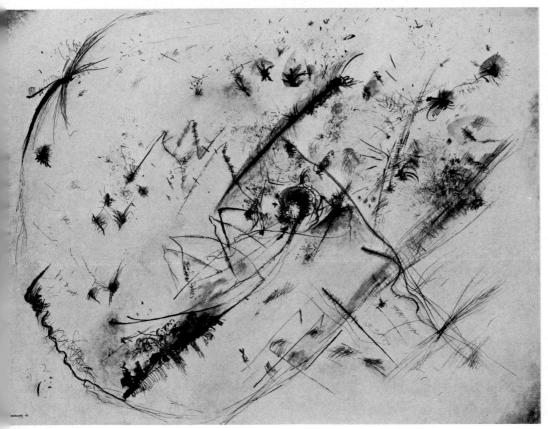

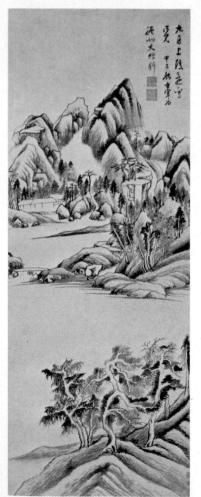

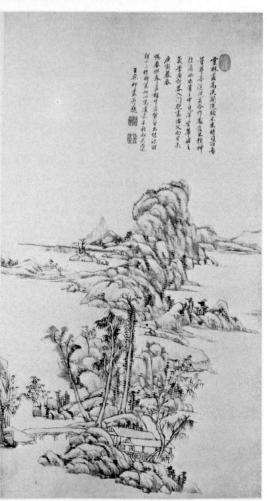

136 Naum Gabo (b. 1890). Construction in Space with Balane on Two Points. Plastic, glass, metal and wood. 1925

137 Tung Ch'i-ch'ang (1555–1636). Mountain landscape for Sheng-pei. Ink on paper 1624

138 Wang Yüan-ch'i (1642–1715). Landscape in the style of Tung Ch'i-ch'ang. Ink and slight colour on paper. 1710

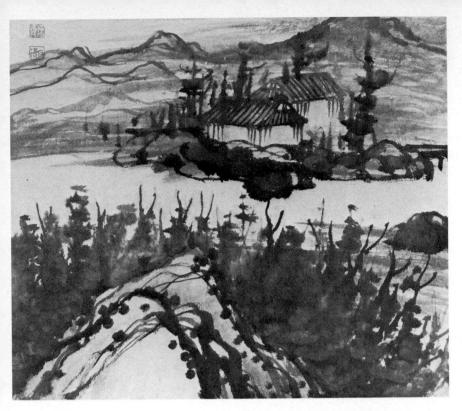

139 Shih-t'ao (1641–c. 1717). Landscape for Taoist Yu. Album leaf. Ink and colour on paper

140 Attributed to Ying Yü-chien (Southern Sung, thirteenth century). Mountain Village in Clearing Mist. Ink on paper

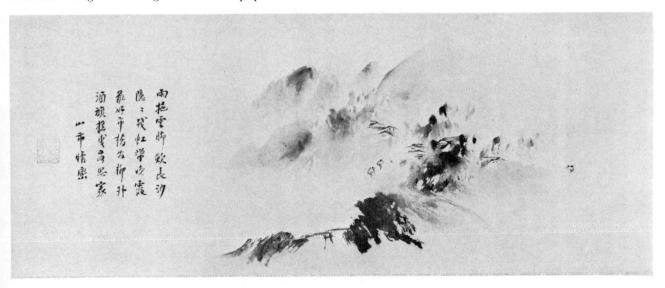

初出号崇守金子有知知的母家中自守及的在皇兄

141 Pa-ta Shan-jen (c. 1625–c. 1705). Small fish. Album leaf. Seventeenth century

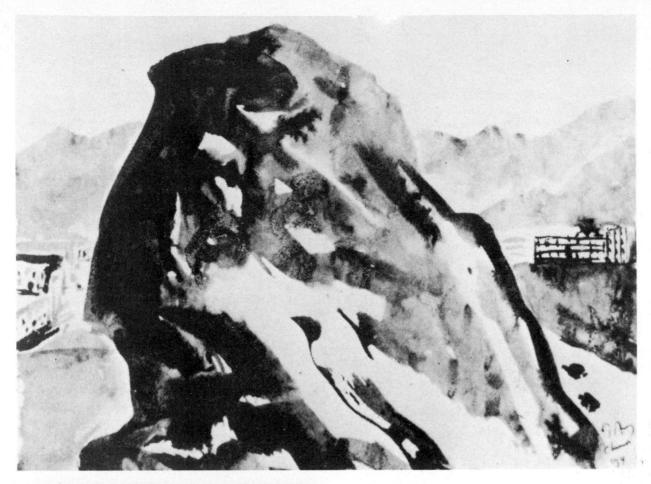

142 Mark Tobey (b. 1890). Soochow. Chinese ink on paper. 1934

143 Mark Tobey. Centre Agité Dominé. Gouache and pencil. 1960

146 Pa-ta Shan-jen. Small birds. Album leaf. Chinese ink. Seventeenth century

44 Mark Tobey. Composition. Sumi ink. 1957

45 Henri Michaux (b. 1899). Painting. Chinese ink. 1960-67

147 Morris Graves (b. 1910). Wounded Gull. Gouache on rice paper. 1943

While in Paris, van Gogh had made three careful copies in oils of Japanese prints: a tea-house waitress by Eisen Kesai, and Hiroshige's Plum-tree and Sudden Shower at Ohashi from the 'Hundred Famous Views of Edo' (1857). Like Monet and Whistler, at that time he was chiefly interested in Japanese prints as exotic accessories in the backgrounds to his canvases. The Eisen, for example, appears with other prints on the wall, behind the sitter, in one of the two versions of his portrait of the rapacious artists' colourman, Père Tanguy. But, once in Arles, van Gogh left the cult of japonaiserie far behind. He still hung prints in his bedroom and studio, and refers several times in his letters to the aims of the print-makers, which he now began to understand much better than he had in Paris. Their absolute clarity of form and colour cleansed away the rather fuzzy texture that his canvases had acquired in Paris under Impressionist influence. 'I wish you could spend some time here,' he wrote to Theo, 'you would feel it after a while, one's sight changes; you see things with an eye more Japanese, you feel colour differently. The Japanese draw quickly, very quickly, like a lightning flash, because their nerves are finer, their feeling simpler.' So perfectly is the Oriental influence now integrated into his work that it is only through his letters that we can be sure that van Gogh is still thinking about Japanese methods at all. Writing to his brother in October 1888, he described in detail the colours in the painting of his bedroom in Arles and commented, 'Here colour is to do everything . . . the shadows and shadows cast are suppressed: it is painted in free, flat tints like Japanese prints.'

126

But it was not only through clear, flat colour that Japanese art spoke to van Gogh. In mid-June he wrote to Bernard, 'The Japanese . . . express marvellously well the contrast between the dull pale complexion of some girl and the vivid blackness of her hair, with nothing but a sheet of white paper and four strokes of the pen. Not to mention their spiky black bushes dotted with a thousand little white flowers.' During the summer of 1888 van Gogh was particularly absorbed in Japanese drawing and woodcut techniques. He wrote to Theo that he wanted 'to make some drawings in the manner of Japanese prints' and sketched for him one of the grasshoppers that swarm over the olive trees, noting that they were 'like those you see in Japanese sketchbooks'. Another drawing of grasshoppers is strongly suggestive of Hokusai's Manga, though probably done from life.

In May and June 1888 van Gogh executed some of his most

important landscape drawings, of the Crau and the banks of the Rhône. He described one of them to Bernard, adding, 'It doesn't look Japanese, yet actually it is the most Japanese thing I have done.' Writing to Theo, he was only slightly less emphatic about these drawings, 'which do not look Japanese, but which really are, perhaps more so than some others'.

We accept so readily the Japanese influence on paintings of van Gogh's Arles period, such as The Bedroom, La Berçeuse, Les Alyscamps and The Fishing Boats, that it is a little difficult at first to see in what way the drawings are also Japanese. But we have only to glance at some of the long, horizontal prints of Hiroshige to see where van Gogh found his inspiration. The flat landscape, stretching back in horizontal planes lined with trees, the fences, reeds and grasses drawn with delicately repeated vertical strokes of the pen (replacing his earlier hatching technique), the use of dots to suggest leaves, the 'spiky black bushes dotted with a thousand little white flowers', can all be found in Hiroshige's long, horizontal sheets. To make his drawing still more Japanese, van Gogh now uses a slightly absorbent paper and reed pens of varying thickness which suggest something of the calligraphic elasticity of the Oriental brush. The notion, put forward by so many writers, that he used 'Japanese reed pens,' is absurd. There is no such thing as a 'Japanese reed pen'. Van Gogh never seems to have experimented, as Manet did, with sumi techniques. His new method of painting with short, firm strokes of the brush now gives his oils an even more clearly articulated structure, which we see above all in the landscape with the blue cart called Fardin de Maraichers, of June 1888, which is very clearly related to the drawings, and so, indirectly, to Hiroshige. Henri Dorra has suggested that the dotting and stippling technique, taken up almost simultaneously by Seurat, Signac and Pissarro, was inspired by the exhibition of Japanese art at the Galerie George Petit in 1883. He does not mention van Gogh in this connection, but in his case the influence seems to be even more clearly established by his own letters.

For van Gogh, the northern linear artist thrust into the colourful south, Japanese art was the catalyst. For it was the example of the Japanese print that showed him how the apparently conflicting aims of expression through the dynamic line, and expression through composition in colour, could be reconciled. The tension between line and colour that runs through his later work is the same as that which gives such

visual excitement to the best prints of Hokusai and Hiroshige; yet – and herein lies his genius – the Japanese influence is

completely transcended.

Like van Gogh, Gauguin had his own vision of Japan. He had a small collection of Japanese prints; he included prints in the background of several of his portraits; and among the reproductions which he took with him to Tahiti in 1898 were Japanese sketches and works of Hokusai. In Avant et Après, the outpouring of notes, reminiscences and anecdotes which he sent back from the Marquesas in 1902 shortly before he died, he included a long and fanciful description, inspired by Loti, of a Japanese peasant family making a cloisonné vase. But the idea

of Japan never excited him as it did van Gogh.

For a while Gauguin had thought of going to Java, and he was the first European painter of any importance to admire Buddhist art. At the Exposition Universelle of 1889 he was enchanted by the Indonesian village and the Javanese dancing. He bought photographs of the reliefs on the great ninth-century stupa of Borobudur, which provided him with motifs for figure paintings for the rest of his life, beginning with the now lost Eve painted in Paris in 1890. Several of the standing figures in his Tahiti paintings, Groupe avec un Ange, Faa Iheihe, Et l'Or de leur Corps, are copied from those of worshippers in the Borobudur reliefs, while the girl that holds the centre of his Contes Barbares (1002) is seated, rather artificially, in a vogic pose taken from one of the Dhyani Buddhas on the stupa. The composition of Gauguin's last and greatest work, Where do we Come from? What are we? Where are we Going?, may also have been inspired by one of the long narrative panels on Borobudur, and indeed his study of those reliefs, with their heavy, graceful and voluptuous figures, often seated or reclining in languid poses, the anatomy reduced to essentials, the smooth contours harmoniously simplified, provided him with a vocabulary of ready-made images, with which the women he saw in the Marquesas must have seemed miraculously to accord.

Nowhere more successfully than in Buddhist Mahāyāna art have abstract ideas been given visible form. For Gauguin the crypto-Symbolist, the idea generally preceded the form; indeed, he said that he sought forms to match his ideas. The gravely beautiful figures of his Tahitian women have about them an air of mystery, as if the secrets of that dying civilization could only be suggested in terms of the silent, remote, yet sensuously lovely images which Gauguin took from Borobudur. To suggest

the mystery, as Mallarmé said, is the dream – 'to choose an object and extract a mood from it by a series of decipherings.' No matter that Gauguin could have had only the smallest notion of the theological complexities of the Borobudur reliefs: the aim of Symbolist art was to evoke ideas which could never be, and need never be, put into words.

The road to pure Symbolist art as it was understood in late nineteenth-century Paris, however, was a road to disaster. Indeed, it is a blind alley in any epoch. Three pears on a cloth by Paul Cézanne are moving and sometimes mystical, whereas, wrote Félix Fénéon caustically, 'the entire Wagnerian Valhalla' - when painted by the Symbolists - 'is as uninteresting as the Chamber of Deputies'. Gauguin was too good a painter to fall into the Symbolist trap. He did not need the example of Japanese art to save him, but it certainly helped to refine and intensify his concern with line and colour. At the time when Japanese influence on him was at its height, in about 1888. Gauguin began to speak of abstraction, meaning a synthesis of form and colour, and freedom from the object. 'In Japanese art,' he said, 'there are no values,' meaning no gradation of tone. And in a letter to Bernard he cited the Japanese for the virtues of painting without shadows: 'I shall get away as much as possible from anything that gives the illusion of an object, and shadows being the trompe-l'ail of the sun, I am inclined to eliminate them. But if a shadow enters your composition as a necessary form that is an altogether different thing.'

Occasionally, as in Jacob Wrestling with the Angel and The Three Puppies (both 1888), Gauguin took a motif straight out of Hokusai or Kuniyoshi – and incidentally aroused Pissarro's wrath for stealing from another culture. Gauguin's cloisonnisme, in which areas of colour flatter and purer even than van Gogh's are bonded by firm dark lines, was inspired by Japanese prints and enamel work. Japanese colour harmonies and principles of design are obvious in On the Beach (1902), while the tall, gloriously rich panel, The White Horse (1898), has in it more than a hint of Kōrin.

Gauguin thus achieved in his own art a fusion of Post-Impressionism with the decorative ideals of Japan and something of the metaphysical formalism of Hindu-Javanese art. Had this been a conscious process, an end in itself, it would have been of little significance. But Gauguin's synthesis was produced unconsciously, in the realization in painting of his own passionate attachment to the world of his senses, the exotic world of

Tahiti and the Marquesas. It is this synthesis unconsciously arrived at that makes him a key figure in the confrontation of Eastern and Western art.

Many of the Japanese prints that the Impressionists admired depict the twilight world of the Yoshiwara. But Utamaro and Kiyonaga transmuted the sordid existence of the prostitutes and teahouse waitresses into scenes of quiet and decorous beauty, drained of their poignancy by the abstraction imposed by the woodcut medium. Toulouse-Lautrec found his subjects, his home, in the Yoshiwara of Montmartre. He had a strong feeling for Japan, collected fans, dolls and prints, had himself photographed dressed up as a samurai. He even dreamed of sailing in a yacht to Japan, where he would be less conscious of his shrunken legs. But Lautrec's revelation of the dark side of city life, unlike Utamaro's, is pitiless in its realism. The very harshness of his handling of oil paint ensures that no veil of textural beauty hangs between the subject and the viewer, and so obscures the truth. In this his aims are the very opposite of those of the print-makers.

It was not in Lautrec's paintings, however, that his fundamentally decorative talent fulfilled itself, but in his posters and lithographs; for these exacting media presented a challenge and a discipline. They forced him to face the same problems that the Japanese print-makers had to solve, to give full expression to the idea in terms of line and flat colour, to suggest volume without shadows, pictorial depth without atmosphere. The simplification of his design is typical of the Ukiyo-e. The use of black masses and sweeping lines, in his posters for Aristide Bruant and for the Divan Japonais, for example, recalls the Japanese primitives and Kaigetsudō; the harmonies of yellow and green in *The Englishman at the Moulin Rouge* and *Reine de Joie* derive from his study of Harunobu; his very signature becomes a Japanese sword-guard.

But there is a difference. The faces in Japanese prints are always formalised, depersonalised; they are not individuals but types; however electrifying in pictorial effect, Sharaku's huge actors' faces are but masks. Lautrec's attitude to his subjects might be psychologically neutral, but he was incapable of generalizing, and even when he is at his most abstract and decorative the eye is arrested by some incisive detail. The faces in the posters are not masks, not even types; they are Jane Avril, La Goulue, the lecherous English nobleman caricatured.

In Lautrec's household account for January 1893, when he

was twenty-nine and living with Dr Bourges in the Rue Fontaine, there is the item 'Kakemonos, fr. 37.50'. We do not know what these Japanese hanging scrolls were, but they were not the first that Lautrec bought. In his portraits of the doctor and of the photographer Paul Sescau, painted in 1891, he had posed his friends in his studio before a Japanese scroll depicting what appear to be birds and flowers. What he thought of these he does not tell us; his correspondence, unlike van Gogh's, is remarkably unrevealing about such matters. But he seems to have been one of the first European artists to enjoy Oriental paintings, as opposed to prints, for their own sake.

The hanging scrolls that reached Paris in the 1880s and 1890s were chiefly orthodox works of the Kanō school. They would hardly have affected Lautrec's use of colour, but they may have stimulated his line to a greater freedom, while in some of his hand-coloured lithographs, such as the extraordinary vision of Loie Fuller dancing amid a cloud of veils, Lautrec combines with his sweeping calligraphic line a subtle harmony of graded tones, from blue through grey to violet, that suggests Japanese ink-wash painting, and reminds us of Whistler's 'Nocturnes', while by spraying the sheet with gold he gives a final, and almost excessively Japanese, touch. But the lithograph of Loie Fuller is perhaps an extreme example, much closer in spirit to art nouveau than to Utamaro or Hiroshige.

Oriental Art, the Symbolists and the Nabis

At the turn of the century French art still reverberated under the impact of Japan, but by now the ripples had spread outward and downward into decorative art, and particularly into the spidery tendrils and sweeping 'whiplash' rhythms of art nouveau. Like chinoiserie, art nouveau is in itself an episode in the history of European taste, a compound of earlier japonismes and the aesthetics of the arts and crafts movement, and, like chinoiserie, it lies outside the scope of this book. Yet it was in the decorative art of the 1890s that there came the first indirect hint of an altogether new awareness of the aesthetic ideals of the East.

In 1890 Maurice Denis had made his declaration, quoted above, that 'any painting is essentially a flat surface covered with colours assembled in a certain order' – a point of view that Sōtatsu and Kōrin would have perfectly understood. In the previous year a group of young Symbolist painters who called

VII

themselves Nabis ('prophets', in Hebrew) had come together at the Académie Julian, dedicated, like the Pre-Raphaelites, to the regeneration of art. Their leaders were Denis, Bonnard, Serusier and Vuillard. They did not deliberately invoke the example of Japan; nevertheless, 'the painter's work,' wrote Denis' friend, the monk and artist Verkade, 'begins at that point where the architect considers his finished. . . . Down with perspective. . . . The wall must remain a surface. . . . There are no pictures, there is only decoration.' Of the group, Bonnard went furthest, in his playful three- and four-panel screens of 1889-92 which earned him the title le Nabi très japonard. He took his themes from daily life, made much of empty space and flat textile patterns, used oblique views and slanting planes to suggest depth. But, as with so many French painters, his love of the texture of oil paint soon weaned him away from Japan towards a more plastic and sensuous handling of colour.

With Bonnard's return to the fold the direct influence of Japan on French painting - 'that leaven,' as Maurice Denis put it, 'which little by little permeated the whole mixture' - comes to an end. The indirect, and eventually far more profound, influence of Oriental art, on the other hand, was just beginning. The Symbolists - and the Nabis were all Symbolists - having taken art out of the Academy, having condemned the Impressionists for their concern with mere appearance, sought to invest form once more with meaning, or rather to create visual 'equivalents', as they put it, for emotional and psychical experience. 'The supreme art,' declared their most articulate spokesman, G. Albert Aurier, 'cannot but be ideistic' - he reserved the word 'idealistic' for classical and neo-academic art - 'art by definition (as we know intuitively) being the representative materialization of what is highest and most divine in the world, of what is, in the last analysis, the only existent thing - the idea.' Painting, he went on, aims to express ideas, by 'translating them into a special language'.

But what ideas? Aurier was aware of traditional Asian art, and refers admiringly to Buddhist sculpture. But the symbolic languages of Asian art had developed during thousands of years, in company with the ideas which they expressed, and within the framework of their own cultures the visible symbols were always intelligible. The French Symbolist painters, unless, like Denis, they borrowed their language from Catholicism or Theosophy, sought to express states of feeling too subjective to be translatable. No wonder Verkade said, 'There is only decoration.'

And yet, if the Symbolists failed to create a genuinely symbolic art, they were nevertheless the prophets they claimed to be. For their manifestos, far more than their paintings, which are often rather dull, hint at an altogether new attitude to the function of art. In 1909 Maurice Denis, looking back over the achievement of the Nabis, said that in their hands 'art, instead of being representation, became the subjective deformation of nature'. Years earlier, he had written that art 'is first and foremost a means of expression, a creation of our minds for which nature merely supplies the pretext'. Even Gauguin never went quite as far as that.

Denis' insistence on the primacy of the artist's inner vision, and on art as expression rather than representation, carried implications for the twentieth century that he could not have foreseen. For they led on the one hand straight to abstract art and Abstract Expressionism, and on the other to a view of the nature of artistic creation which at last made possible a true meeting of Eastern and Western art. Illumination came with dramatic suddenness in the first two decades of the twentieth century, not as a result of a deeper study of Oriental art, but through what now seems an inevitable further step in the trend towards the dissociation of the artist from the object which had begun with Gauguin and the Symbolists.

Oriental Art and Twentieth-century Painting in the West

So striking seems the accord, in aims and methods, between Oriental painting and certain key movements in modern art that it is natural to assume that these revolutionary Western developments have been to some extent at least inspired by Far Eastern art and thought. The parallels between the free existentialist gestures of Pollock, Kline or Soulages on the one hand, and Zen ink painting on the other, seem too close to be due to mere chance. After all, it might be argued, if Far Eastern influence had been decisive upon the Impressionists in the limited area of the solution of purely visual and formal problems, how much more so must it be on the movements in contemporary art of which not only the methods but the very philosophical basis often seem to be thoroughly Oriental.

Between 1909 and 1920 there was launched upon the European public a barrage of manifestoes aimed at the destruction of traditional Western beliefs about the nature and purposes of art.

The attack came from many directions, chiefly from Munich. The keynote was struck by Kandinsky in 1909 with his famous dictum, 'Alles is erlaubt' ('Everything is permitted'). All forms of imitation, declared the *Futurist Manifesto* of the following year, should be held in contempt. What should inspire the artist, Kandinsky maintained, was not representation of the visible, but 'the inner spiritual side of nature'. In Paris, Matisse was insisting that there is an 'inherent truth' which must be disengaged from the outward appearance of the object to be represented: 'Exactitude n'est pas la vérité.'

What is this truth? It is not the form, though it is expressed through the form. 'The absolute is not to be sought in the form,' wrote Kandinsky. 'The form is always bound in time, it is relative since it is nothing more than the means necessary today in which today's revelation manifests itself, resounds. The resonance is then the soul of the form which can only come alive through the resonance, and which works from within to without.

The form is the outer expression of the inner content.'

How is this inner content revealed? By absolute spontaneity first of all. The second of Kandinsky's three types of creative art, which he called Improvisation, he defined as 'a largely unconscious, spontaneous expression of inner character, of non-material (i.e. spiritual) nature.' André Breton called it Automatism, and said it was 'the only mode of expression which gives entire satisfaction . . . by achieving a *rhythmic unity*'. And Klee described how 'the creative impulse suddenly springs to life, like a flame, passes through the hand onto the canvas, where it spreads further until, like a spark that closes an electric circuit, it returns to the source, the eye and the mind'. Creation, he said, 'must of necessity be accompanied by distortion of the natural form; only in that way can nature be reborn and the symbols of art revitalised'.

When representation of the object was no longer the chief aim of painting the Western artist could abandon the traditional view that space in a painting could only be made real through the objects that occupy it. This was forcefully expressed by Naum Gabo in the *Realist Manifesto* of 1920: 'We renounce volume as a pictorial and plastic form of space; one cannot measure space in volumes as one cannot measure liquid in yards. . . . What is it (i.e. space) if not one continuous depth?' And, to emphasize this fundamental point, he repeated, 'We cannot measure or define space with solid masses, we can only define space by space.' Gabo also proclaimed the idea, which

was revolutionary in the West, that the plastic arts could embody, through movement, a synthesis of space and time, when he wrote, 'We affirm in these arts a new element, the kinetic rhythms, as the basic forms of our perception of real time.' Such pronouncements, which seemed in their day destructive of all artistic values, are now, so profound has been the change in our thinking in the West, taken for granted. To a Far Eastern painter, each of them would have seemed a statement of the obvious.

The creative impulse described by Klee had been the theme of a remarkable long poem, the Wen fu ('Prose-poem on Literature'), written in AD 300 by Lu Chi, who analyses with passionate insight the joys and frustrations of literary composition. Here he describes the sudden coming of pure inspiration and its equally sudden vanishing:

Such moments when Mind and Matter hold perfect communion,

And wide vistas open to regions hitherto entirely barred, Will come with irresistible force,

And go, their departure none can hinder.

Hidden, they vanish like a flash of light:

Manifest, they are like sounds rising in mid-air.

So acute is the mind in such instants of divine comprehension,

What chaos is there that it cannot marshal in miraculous order?

Kandinsky's dualism of outer form and inner content had been stressed in the fourth century by the Chinese Buddhist and mystic Tsung Ping, who opened his brief 'Preface on Landscape Painting' (Hua shan-shui hsü) with these words: 'The sages cherish the Tao within them, while they respond to the objective world; the virtuous purify their minds, while they appreciate represented forms. As to landscape paintings, they both have material existence, and reach into the realms of the spirit.' And again, 'The divine spirit is infinite; yet dwells in forms and inspires likeness; and thus truth enters into forms and signs.' Forty years later a scholar and musician named Wang Wei (not the famous T'ang painter-poet) wrote a short 'Preface on Painting' (Hsü hua) in which he clearly distinguished between representation, which was the 'discipline' of painting, and the animating spirit, which was its 'essence'.

The concept of the 'inner resonance' of the object, which

Kandinsky said constituted the 'material of art', and the 'rhythmic unity', which André Breton in What is Surrealism saw as the aim of painting, have much in common with the first of the six principles of painting set down by Hsieh Ho between AD 530 and AD 550. This principle, ch'i-yun sheng-tung (literally, 'spirit-resonance, life-movement'), has become the cornerstone of Chinese aesthetic theory down the centuries. It means, in essence, that the painted forms, which in Far Eastern art are always to some degree conventionalized, must be brought to life by the animating spirit (ch'i). Early Chinese painters felt that this 'spirit' was a cosmic force, external to the artist, with which he must intuitively identify himself through the contemplation of the natural world. Later writers held that the ch'i was something awaiting release from within the psyche of the individual painter. They would have agreed absolutely with Kandinsky that 'form harmony must rest only on the purposive vibrations of the human soul'. As Will Grohmann has observed, 'the Far East is better equipped to understand Kandinsky than we are'.

Revolutionary ideas put forward by the Symbolists also have their far older Oriental counterparts. The belief expressed in Aurier's statement quoted on page 239, that the painted forms can in some sense stand for ideas, is central to Symbolist theory. The Chinese summed up the theory in two words – hsieh i (literally, 'write ideas') – a purpose which gentlemen painters had held up since the Sung Dynasty as the true aim of painting; accurate representation could be left to the court painters and professionals. The aesthetics of scholarly painting in China raise pictorial symbolism to a level of subtlety undreamed of by

Gauguin and Aurier.

Maurice Denis' belief that nature merely provided the pretext for expression, and that form is no more than a vehicle for feeling, has also been central to the aesthetic of the Chinese literati since the Sung Dynasty, when the poet-painter Su Tung-p'o (1036–1101) said that the gentleman painter is not attached to material objects; when he paints he merely 'borrows' the form of things in which, for the moment, to 'lodge his feelings'. But he does not leave them there, and so form attachments that would burden him. The catalogue (which appeared a few years later) of the Emperor Hui-tsung's collection, contains, in an entry on the bamboo painter Wen T'ung (d. 1079), the statement that he 'availed himself of things in order to give lodging to his exhilaration'. Dissociation from the object has a long history in Chinese art.

Even the aims and techniques of the Cubists were, to some extent, anticipated by the Chinese landscape painter Wang Yüan-ch'i (1642–1715), whose method of, as it were, pulling his rocks and mountains apart and reassembling them into a tightly organized mass, with a semi-abstract organic unity of its own, has been likened, in its laborious intensity, to Cézanne's method of realizing his 'little sensation'. Wang Yüan-ch'i's particular method of painting was indeed unique in Chinese art, but the distortion of natural forms has been common with Chinese gentleman painters since the Yüan Dynasty.

Two centuries after Wang Yüan-ch'i, Paul Klee spoke of the expressive distortion of form as the only way in which 'nature can be reborn and the symbols of art revitalised'. We are forcibly reminded of the great Ming Dynasty critic and theorist Tung Ch'i-ch'ang (1555-1636), whose painting and writing illustrate the concepts of distortion and revitalisation to a remarkable degree. In Tung Ch'i-ch'ang's landscapes the rocks and mountains are twisted and contorted, flat receding planes rise up to confront us, forms interlock and interpenetrate with teasing ambiguity. In later scholarly painting in general, and in Tung's work in particular, these are not merely distortions of natural forms; they are, even more, distortions of the forms created by the great early masters in the amateur tradition, such as Tung Yüan and Huang Kung-wang, upon whom Tung Ch'i-ch'ang modelled his style. He acknowledged that no landscape painter could avoid using the schema inherited from his predecessors, but he insisted that the repertoire must be creatively reinterpreted by each successive generation of painters, and that this revitalisation of the symbolic language inevitably involved distortion of both inherited and natural forms.

In January 1949 Jackson Pollock described his method of painting in a few now famous sentences. 'When I am in my painting,' he said, 'I am not aware of what I'm doing. It is only after a sort of "get acquainted" period that I see what I have been about. I have no fears about making changes, destroying the image, etc., because the painting has a life of its own. I try to let it come through. It is only when I lose contact with the painting that the result is a mess. Otherwise there is pure harmony, an easy give and take, and the painting comes out well.' This might be any Chinese or Japanese calligrapher or Zen painter speaking. Here again is Wen T'ung, by no means a special devotee of Zen, discussing his own bamboo painting:

138

'At the beginning, I saw the bamboo and delighted in it; now I delight in it and lose consciousness of myself. Suddenly I forget that the brush is in my hand, the paper in front of me; all at once I am exhilarated, and the tall bamboo appears, thick and luxuriant.'

Perhaps even closer to Pollock is the seventeenth-century individualist Shih-t'ao, who in his essay on painting, Hua yü lu, enunciated the concept of the i hua (literally, 'one line'), whereby the artist's exhilaration carries him through the painting on an unbroken surge of creative power. Shih-t'ao devotes a short chapter to the free movement of the hand holding the brush, fundamental to both painting and calligraphy, and ends, 'If the painter's wrist is animated by the spirit, it produces miracles, and mountains and rivers reveal their soul.' His section on yin-yün, a phrase that in the Book of Changes refers to the fundamental unity of Heaven and Earth, concerns precisely that ecstatic losing of oneself in the creative act that Jackson

Pollock so vividly described.

We may carry the parallel still further. As long ago as the T'ang Dynasty (AD 618-906) there were artists in South China (in the Nanking-Hangchow region) who practised techniques as advanced as those of any modern Action Painter. 'Ink Wang', according to contemporary accounts - none of his work, alas, survives - would get drunk, then spatter and splash ink onto silk (presumably laid out on the floor), then, laughing and singing, stamp on it and smear it with his hands as well as with the brush. He also dipped his hair into the ink and slopped it onto the silk. A certain Mr Ku from Kiangsu would cover the floor with silk, then run round and round, emptying ink all over the floor and sprinkling colours over it. Not content with that, he would then have someone sit on a sheet and drag it round, creating swirls of ink and colour. This must have been a public performance, like Georges Mathieu's spectacular antics before an audience. The work of these men has all disappeared, but something of its extraordinary quality survives in a scroll attributed to an obscure thirteenth-century Zen master named (Ying?) Yü-chien. The essential difference between the late T'ang eccentrics and the modern Action Painters is that, while the latter left their gestures and splashes as complete statements, their Chinese predecessors of a thousand years ago, by a few deft touches of the brush here and there, proceeded to turn theirs into landscapes. But Action Painting and Zen art belong to no period. They are moments in time and space that are not linked in any kind of historical continuity; they simply occur, and occur again, in an eternal present.

For the synthesis of space and time which Naum Gabo proclaimed in his *Manifesto* of 1920, and which the exponents of Kinetic Art later realized in practice, there is in the Chinese landscape hand-scroll a precedent already two thousand years old. The hand-scroll, which is unrolled a little at a time, presents, by means of a continually shifting perspective, a journey in space which, like music, can only be experienced in time. And just as the panoramic scroll is a world in miniature, so may the time taken to view it represent, in miniature, the time which such a journey would take in a real landscape.

Chinese painting has never lost the sense of space, which is as old as pictorial art itself, and has no need of a receding ground line, solid objects, or a landscape to suggest it. In Neolithic art, in Han wall painting, sometimes in European mediaeval art, space is just 'there', whether there are objects in it or not. We are often told by Western writers that the Oriental painter 'invites us to fill up the blank spaces in our imagination'. But there are no blank spaces in a Chinese painting. 'Emptiness' is a purely metaphysical concept.

A Chinese painting is first and foremost a picture of space; it defines space, as Gabo put it, by space, not by objects. A miraculous example of this is a sketch of a little fish alone in the middle of an album leaf, by the seventeenth-century eccentric Pa-ta Shan-jen. Only the fish is painted; only the fish tells us that the 'blank' part of the paper is water and not air. The unpainted water fills the picture space, indeed goes far beyond it. It will still be there when, with a flick of its tail, the little fish has darted out of sight.

We could go on matching the theories and methods of revolutionary twentieth-century Western artists against those of the traditional Orient, but there is no need to labour the point that what has happened in modern Western art has brought it suddenly, in certain fundamental aspects, into total accord with that of the Far East. It is as though the inhabitants of one country, with immense imaginative effort, had succeeded in creating what they thought was a new language, only to discover that it was the native tongue of another land on the other side of the world.

There are differences, of course. Some movements in modern Western art, such as Surrealism, Dada and Pop Art, have no recognizable counterparts outside the West, only imitations of

them. Few Western avant-garde painters have shared Matisse's cosy and very Chinese ideal of 'an art of balance, of purity and serenity devoid of troubling or depressing subject-matter, an art which might be for every mental worker, be he businessman or writer, like an appeasing influence, like a mental soother'. Western Expressionism, rooted in the restless, anti-classical psyche of northern Europe, is too full of conflict and anxiety to achieve, except rarely, the inner serenity of even the wildest Zen art. Notable exceptions are the early abstractions of Kandinsky, who was at least partly Asiatic and who, thanks to his Russian temperament, felt, as Herbert Read happily put it, 'at ease in an atmosphere of chaos and intimations of immortality'. Kandinsky may have been stimulated by Madame Blavatsky's theosophy, but mysticism does not lead inevitably towards abstraction in art. On the contrary, it usually inspires a feeble and insipid symbolic art. Kandinsky's discovery of abstraction, apart from the famous encounter with the painting turned on its side in his studio, owes far more to Wilhelm Worringer's very influential thesis of 1908, Abstraktion und Einfühlung ('Abstraction and Empathy'), in which for the first time the 'will to abstraction' is defined as a recurrent impulse in the history of art, than it does to the influence of Oriental art.

Yet it is difficult to convince ourselves that Oriental influences were not at work, here and there, in the first decades of the present century. In one or two cases they certainly were. Mark Tobey's moment of truth (discussed further on page 252) came one autumn evening in 1935 at Dartington Hall, in the year following his fruitful visit to the Far East, and though his first exercise in 'white writing' looked to him like Broadway, it was unconsciously inspired by his experience of studying calligraphy in Japan. Henri Michaux is another example of direct influence in the 1930s, Morris Graves in the 1940s and 1950s, Sam Francis in the 1960s; but these instances are not of critical importance for the development of modern art, for, as Herbert Read wrote in 1959, 'Klee and Kandinsky, in the course of their experimentation, had anticipated all the possibilities that lay ahead: every type of Abstract Expressionism that was to be developed between 1914 and the present day has somewhere its prototype in the immense oeuvre of these two masters.'

An important exhibition of Far Eastern art was held in Munich in 1909. Kandinsky wrote an appreciative account of it, which appeared in the same year, for the Moscow art magazine *Apollon*. Yet there is nothing in his own theoretical

writings to suggest that he was ever influenced by the Japanese paintings in that exhibition, which included works by the sixteenth-century landscapist Sesson and several Zen masters. If he was affected at all he seems not to have been aware of it himself.

Worringer in Abstraction and Empathy refers but once to Japanese art. His comment is a perceptive one. 'Japonisme in Europe,' he writes, 'constitutes one of the most important steps in the history of the gradual rehabilitation of art as pure forms . . . and on the other hand it has saved us from the immediate danger of seeing the possibilities of pure form only within the classical canon.' This is excellent as far as it goes, but it represents rather a verdict upon the completed Japanese phase than the beginning of a new understanding of Oriental art. Indeed it would be very surprising if Worringer or any of the pioneers of the modern movement - Kandinsky, Matisse, Klee and Gabo - had shown any awareness of the kind of ideals that are expressed in the early Chinese writings on art from which I have quoted. Critical interest in the era of Cubism was focused almost entirely upon the art of Africa and Oceania. Very few of these Chinese texts were translated before the 1930s in any case, and even today some of them, particularly those that concern the detachment of the gentleman painter from the object, perspective, and the methods of the T'ang 'action painters', are known only to specialists in Chinese painting.

The change in Western art in the twentieth century, which has brought it in certain fundamental respects into harmony with that of the Orient, was not due to the influence of Oriental art, nor was Oriental art held up as an example; never did Kandinsky or Klee echo Pissarro's remark about an exhibition of Japanese prints which I quoted earlier: 'Damn it all, if this show doesn't justify us!' It was due rather to a profound change in Western thinking about the nature of the physical world, most clearly expressed in the physical sciences. No longer do we believe in a finite world, or in the permanence of matter. The physicist may describe it in terms of waves, particles, or energy, according to the aspect of nature which he is investigating, and he speaks no longer of objects, but of events. 'Physical concepts,' Einstein said, 'are free creations of the human mind, and are not, however it may seem, uniquely determined by the external world.' Space and time, we have come to feel, are infinite, and our knowledge of them can be but partial and relative. Solid matter has dissolved into an accre-

143, 144

tion of particles in an eternal state of agitation. Such a view would seem the natural one to any thinker in the Hindu-Buddhist world. For the basic ambiguity of our concept of matter, and particularly for the illusory nature of sense data, the Buddhist philosopher would use the term $M\bar{a}y\bar{a}$ ('illusion'); while, when referring to the idea of continuous change, he would speak of $S\bar{u}nyat\bar{a}$ ('the Void'), or $S\bar{a}ms\bar{a}ra$, the chain of existence in which all things are for ever coming together, dissolving, and coalescing again into new transient patterns. To the Eastern mind, Taoist or Buddhist, the Void is a positive force.

From ancient times [wrote a Japanese critic] Being or the Existent, in other words that which makes the appearance of Things as They Are, has been thought of as Mu [an approximate term is 'nothingness']. And by Mu we do not at all mean a state of absolute Zero, but the mysterious core of Being filled with a dynamic, creative energy of infinite scope.

If the light of intelligence is directed from this Mu, everything from Man to Nature takes on the same transcendental dimension. Not that Man and Nature thereby come to face each other in an impassive confrontation, but that there occurs a persuasive, mutual interchange of energies between the pair and which contributes to the development and growth of both. . . . From the Japanese point of view, it is not Man who draws, but rather the Existent brings forth its own shape.

Or, as Klee put it, 'art does not render the visible, rather it makes visible.'

As Western science has been liberated from bondage to visible matter, so has Western art been set free from the necessity of depicting it. What the eye sees at one moment in time is ephemeral, and so illusory. Their awareness of the limiting character of scientific one-point perspective led the Chinese, centuries ago, to reject it. That Chinese painters had a grasp of its principles is shown by the way in which the T'ang Dynasty fresco-painters of the Paradise compositions in the caves at Tunhuang handled their complex celestial palaces. The tenth-century landscapist Li Ch'eng was severely taken to task by the Sung critic Shen Kua for his very skill in this craft. Why look at a building, said Shen Kua, from only one point of view? Li Ch'eng's 'angles and corners of buildings', and his 'eaves seen from below', are all very well, but only a continually shifting perspective enables us to grasp the whole. Chang

Tse-tuan's remarkable long panorama of life outside the Northern Sung capital, Going up River at Ch'ing-ming Festival Time, painted in about AD 1120, represents both the climax and the swansong of pictorial realism in the upper levels of Chinese landscape painting. Southern Sung academicians such as Ma Yüan drifted into a dream world of their own, almost into a poetic surrealism, while the gentlemen painters from the succeeding Yüan Dynasty onwards showed no interest in realism whatsoever. Today many Western painters have rejected perspective, chiaroscuro, the very picture-frame itself, because they have come to realize, like their Chinese predecessors of the Sung Dynasty, that pictorial realism, far from making possible the representation of the Real, actually hinders it. The same liberating process has taken place in Western poetry, music, drama and film, and all these arts are open as never before to influences from the Orient.

So it is that today, for the first time, Eastern and Western artists, instead of borrowing from each other for their own immediate ends, as Chinese court painters in the eighteenth century borrowed from the Jesuits, and the Impressionists from the Japanese, have found common ground in a view of reality that reaches beyond the bounds of art itself. Sometimes in the West we hear painters such as Liu Kuo-sung or Yoshihige Saitō - to take two names at random - criticised for 'copying' Pollock, Kline or Soulages. But this is quite wrong. On the contrary, the Far Eastern painters, after a brief and on the whole disastrous flirtation with Western realism, are now firmly back on their own ground. That they have to some extent been inspired by the New York School, and all that led up to it from Kandinsky onwards, to achieve a rediscovery of the Abstract Expressionist roots of their own tradition, cannot be doubted; but for this very reason it may be that their involvement in it is deeper and more lasting than that of the Western painters, many of whom have already moved on, before they have even begun to explore the expressive possibilities of calligraphic abstraction. We should speak not of Western influence on Liu Kuo-sung and Saitō but rather of stimulus, or even of provocation.

The American Response to Oriental Art

For Europe to accept the Oriental aesthetic was to deny her own heritage. Modern America has not found it so difficult, for her culture derives part of its strength from its very rejection of Europe. The popularity of Oriental art and thought in America has been partly due to the calibre of the men who propagated it – Fenollosa and Okakura, Coomaraswamy and Suzuki, to name but a few; but their success was also due to the American willingness to look beyond Europe. The American mind may be a little gullible at times but it is open and generous, and America suffers not at all from the intellectual complacency of Britain and France. America, moreover, looks westward across the Pacific as well as eastward, and her enthusiasm for things Chinese and Japanese has not been tainted by a sense of cultural

superiority to the East.

For twenty years before the New York Armory Show in 1913 opened American eyes to modern art, Arthur Dow, Fenollosa's close friend and travelling companion in Japan, had been promoting a system of art education that stressed not the realism of the salons, but essentials of pictorial form, rhythm and construction. 'I confess,' he wrote with great insight, 'to sympathy with all who reject traditional academicism in art. . . . Japanese art had done much towards breaking the hold of this tyranny, the incoming Chinese art will do more, but it may remain for modernist art to set us free.' Some critics have seen the Oriental aesthetic at work in Dow's most distinguished pupil, Georgia O'Keefe, but after early experiments in sumi she developed a style that owes little or nothing to the Orient. Ever since she abandoned those experiments, her inspiration has been Texas - 'my country,' as she said, 'terrible winds and a wonderful emptiness'. Nothing could be further from the Oriental ideal of a paintable landscape than the plains of Texas.

'I have often thought,' wrote Mark Tobey in 1957, 'that if the West Coast had been as open to aesthetic influences from Asia, as the East Coast was to Europe, what a rich nation we would be.' Though America continued through force of habit to look to Europe, it was in the Pacific north-west, and notably in the work of Tobey himself, that Oriental art first struck a responsive chord in an American painter. On Tobey the influences were cumulative. First, his conversion, in about 1918, to the syncretic faith Báhá-í; then, in 1923, his encounter with Japanese prints in Seattle, and his meeting with the Chinese painter and critic Teng K'uei, who gave him his first lessons in handling the Chinese brush. Ten years later he stayed with Teng K'uei in Shanghai, then moved on to Japan, where he spent a month in a Zen monastery, painting and practising calligraphy, and trying

to meditate. Like the fourth-century Chinese landscape painter Tsung Ping, he found that he was not very good at meditating, but, like Tsung Ping, he felt that the act of handling the brush gave him the same feeling of spiritual release.

Tobey's experience in Japan left him feeling very much an occidental – or so he thought. But after he had returned to England in 1935, one autumn evening in his studio in Dartington Hall he began to weave on paper an endless web of white lines on a brown ground. When he had finished the result did not look to him in the least Oriental; it looked like Broadway. But, as he later remembered this climactic experience, of its own accord, he said, 'the calligraphic impulse I had received in China enabled me to convey, without being bound by forms, the notion of the people and the cars and the whole vitality of the scene'. The scales fell away. In a sudden flash, without being aware of what was happening, he had broken through the Western conventions of pictorial space into a new world.

It is often said that what is Oriental about Tobey's famous 'white writing' pictures is their calligraphic quality. But his line, endlessly moving or agitated in jerky rhythms though it may be, is never in these paintings really calligraphic; unlike the line in Oriental calligraphy, it cannot be pulled out of the picture to stand as an expressive form on its own. Rather is it a means to an end - namely, the evocation of a feeling of continuous space, which became for Tobey 'a kind of living thing - like a sixth sense'. The line, as he put it, brings about 'the dematerialization of form by space penetration'; it is, in other words, descriptive rather than expressive. Much later, in 1957, Tobey experimented briefly with pure calligraphic ink gestures, but while these pictures are obviously Oriental in appearance, they are less deeply Oriental in feeling than those miraculous hints of a world beyond time and space revealed in the most lyrically abstract of his 'white writing' pictures. In the 1950s a number of artists, such as Pollock, Dubuffet, Michaux and Cuppa, arrived at a similar type of all-over composition composed of endlessly moving lines, or dots, or agitated vermicular forms, that seem to extend beyond the picture space; but only in Tobey's is there a direct link with Oriental art.

Yet even in Tobey's case we are no longer on firm ground, and such terms as 'Oriental in appearance' tell us more about our own ignorance than about the picture itself. For Tobey's declared aim was to express an essentially American experience

- 'the frenetic rhythms of the modern city, the interweaving of streams of lights and streams of people who are entangled in the meshes of this net' – something utterly remote from the kind of visual experience that the calligraphic rhythms of Oriental art had been called into being to evoke. Tobey indeed seems to be a classic illustration of one of the main themes of this book, discussed in the last chapter – namely, that artistic influence is really fruitful only when the artist, or indeed the culture, that absorbs it feels a conscious or unconscious need for what it offers and can at once put it to use.

There is not enough space in this book to do full justice to the Oriental influence on contemporary American painting, but I should at least mention William Barker, whose *I-ching* series of oil paintings was inspired by the Shang oracle bones (as was Zao Wou-ki in one phase of his career), and Ulfert Wilke, an exponent of abstract calligraphy who spent a year in Japan, part of it in a Zen temple. Both Stanton MacDonald-Wright and Ad Reinhardt have made a serious study of Chinese painting – the former has been a Professor of Oriental Art – but no Oriental influence can be seen in their own painting.

The work of Morris Graves, another Seattle painter, may seem at first sight more Oriental than Tobey's. For not only did he borrow Tobey's 'white writing', but the subjects of some of his most striking pictures are taken from the Chinese ritual bronzes in the Seattle Art Museum. He is a profound admirer of Tobey and a student of Zen, has visited the Orient, and creates around himself a thoroughly Japanese ambience. But his work is very different. While in Tobey's paintings forms dissolve into space, Graves' archaic bronzes and wounded gulls loom out of the night, bathed in an unearthly luminosity, as if possessed by some magic, animating force. Space is not the subject of his pictures, but only the matrix out of which the forms become manifest with a dream-like clarity. A parallel has been drawn between his birds and those painted by the Chinese seventeenthcentury eccentric Pa-ta Shan-jen, which have something of the same compelling power. But while Graves' birds dwell in a twilight world, Pa-ta's birds belong to the day. They may sometimes look bad-tempered, but never are they, like Graves', threatening, wounded, blind, or dead. Such a view of nature would be unthinkable to a Chinese painter.

Morris Graves said of his Wounded Gull that 'the dying image will soon be one with the vast, infinite forms of the ocean and the sky around it', and felt that this was a Zen idea. But in Zen the

-11

union of the spirit with Eternity is attained not by the dissolution of the physical body but by the conscious mind. It is an ecstatic thing, and Zen art above all is an art of release and joy. An American critic wrote of Graves' tortured Owl of the Inner Eye, 'Vainly [my italics] it attempts, through its outer calm and inner intensity, to unite itself with the void and attain Satori.' No Zen painter would depict the spiritual agony and loneliness of a being unable to find union with God. In spite of his Oriental themes and occasional Oriental techniques, Graves' mysticism seems somewhat Western in character.

a said fragment and butting in a bad the agree

7 Some Reflections on the East-West Dialogue

We have come to a point in our enquiry into the East-West confrontation where we may legitimately ask whether one can discern any pattern or principle at work governing the process of artistic influence between cultures, and what is the significance of this interaction for the future of art. Let it be said at once that there are no complete or satisfying answers to either of these questions: we know very little about the psychology of artistic stimulus in the individual, still less about how it operates between cultures: nor can we see into the future. Nevertheless it may be of some use to set down, if only in the form of notes, some of the factors that seem to be involved in this process, and are beginning, even now, to reshape the art of the major civilizations. If these comments seem disconnected and inconclusive, that is because this is a theme that too easily inspires highsounding generalisations, and the temptation to indulge in them must be resisted.

Let us consider first the conditions under which artistic influences operate. Styles in art may travel under their own colours, so to speak, or be carried by forces or events that in themselves have nothing to do with art. Japanese influence on the Impressionists was a case of direct transmission from one group of artists to another through the neutral medium of commerce; Western art, on the other hand, was adopted by Meiji-period painters under pressure from the Japanese government, who deliberately promoted it as an instrument of modernization and nation-building.

Religious art carries style on its wings, and unlike court art takes no account of class, while its appeal goes beyond art itself. More specifically, the power that resides in a religious image may depend precisely upon what it looks like – upon its style. The more closely the image resembles the particularly potent icon from which it derives, the more of the original's power will seem to emanate from it. The history of Buddhist art is full of instances of copying of famous images, the best known being the statue of Sākyamuni reputedly made by King Udyāna in the Buddha's lifetime, which has sired a vast family of closely similar images throughout Buddhist Asia for over a thousand years. Such an icon is recognized at once by the devotee, who

feels its potency through its style. Even in religious art the medium is, to a great extent, the message.

So potent a vehicle is style, indeed, that the archaeologist and art historian may be tempted to interpret the appearance of similar forms in different places as evidence of deeper or more direct contact than actually occurred. In primitive communities a type of image may be shared by two tribal groups that have nothing else in common, and may even be traditional enemies, or separated by hostile tribes. Techniques and skills, moreover, can travel great distances, leaving no trace of their passage. The painted pottery of Neolithic China, for example, may have been influenced by that of Mesopotamia, for it employs decorative motifs that appeared much earlier in the Near East; but the two cultures were not only unaware of each other's existence, they were also separated by nomadic peoples who apparently did not make painted pottery themselves. There is no need to infer direct contact between prehistoric Mesopotamia and China, or the vast, slow Völkerwanderung that was once taken as the only possible explanation of the similarity. It seems that a culture may, like an organism, act as a 'carrier' without itself being affected.

In many cases, artistic transmission occurs as a response to a conscious, and quite specific, need. The need may be deep-seated, such as that fulfilled by Buddhist art in East Asia; or it may take rather trivial forms, such as sheer boredom and the hunger for something new, but is nonetheless real for that. 'Sick of Grecian elegance and symmetry, or Gothic grandeur and magnificence,' wrote Lady Mary Wortley Montagu in 1740, 'we must all seek the barbarous gaudy gout of the Chinese.' In T'ang China, fashion had a good deal to do with the wholesale borrowing of Western art. Fashion may be the vehicle in an even more literal sense. Father Bouvet, like Athanasius Kircher before him, published his copies of Chinese figure paintings in L'Estat présent de la Chine chiefly as an example to the court of how to dress with more dignity and modesty. Any artistic message that they carried was merely accidental.

While foreign forms and techniques might be borrowed to fulfil a particular rôle, there was, at least in China, a tendency for them to be kept firmly in their place. The 'foreign realism' in the art of the Ch'ing dynasty was confined largely to the Nanking painters and professional artists. Buddhist art brought with it to China a number of foreign techniques such as shading, chiaroscuro, 'relief painting', and some peculiar drapery con-

ventions, which were assiduously applied by Chinese painters to the figures in Buddhist banner and wall-painting; but these techniques and conventions were not, as far as we know, used at all in secular figure painting of purely Chinese subjects by scholarly masters such as Yen Li-pen. The Chinese evidently felt that foreign techniques were only appropriate to foreign subject-matter. In fact, these techniques were gradually forgotten as Buddhism lost its hold over China. The Japanese, as we would expect, have not taken so uncompromising a view. It would be interesting to enquire whether the principle of reserving foreign techniques for foreign, or 'second class', subject-matter has been applied in any art that was not Chinese.

Yet the work of art, while outwardly the product or illustration of a cultural situation, is in the final analysis the creation of an individual. Where East and West meet is in the mind of the artist himself, and the processes of acceptance and transformation depend ultimately upon the choices that he makes. What governs these choices? The answer is partly historical, for the fact of his encountering a particular style or object can usually be accounted for. At the same time his choices are governed partly by the way in which he 'sees', and this is the product of tradition and training which, too, are historical facts. As Gombrich pointed out in *Art and Illusion*, he sees and paints what he has learned to see and paint. Beyond that point again, the choices that the artist makes are determined by the pressures upon him, as a creative individual, from personal circumstances and human relations.

As with a civilization, whether or not an artist responds voluntarily to the challenge of an alien form, style or technique depends ultimately upon whether it fulfils a need for him. Where no specific need exists it can be created artificially by confrontation with the new object, as experts in advertising well know. The effect then is likely to be transient. Sasanian art had appealed to T'ang China through its richness and novelty, and rapidly went out of fashion when China became culturally isolationist after the middle of the dynasty; so with *chinoiserie*, which found its natural place in Rococo ornament, to disappear entirely with the next turn of the wheel of fashion. Very different was the impact of European art on certain Chinese painters in the seventeenth century, for when they encountered it they recognized not simply a new style of painting, but a new kind of vision. Until they saw the engravings brought by the Jesuits

they had, so to speak, no idea what they were missing. The realism of Northern Sung painting was by then long forgotten, and the Western pictures stirred anew in certain painters of the Nanking school a desire for greater realism that had lain dormant, or perhaps had survived only at the level of popular art. The difference here is that the 'need' which *chinoiserie* fulfilled was hardly felt by creative artists at all, while that met by Western realism in late Ming and early Ch'ing painting was a genuine, if unconscious, one.

The most fruitful responses seem to have occurred when the alien art has helped to fulfil a need of which the artists at the 'receiving end' were already fully aware. The influence of the Japanese print on the Impressionists is the clearest example of this. The Impressionists were groping towards something, and the Ukiyo-e, by showing them in part at least what it was they were groping for, helped them to articulate their aims both pictorially and verbally, and they freely acknowledged their debts. Contrary to popular belief, this is not true of the relationship between Cubism and African tribal sculpture. Cubism was a natural development beyond Cézanne; and only when that point had been reached did the solutions to formal problems arrived at by the carvers of African masks suddenly become interesting and meaningful to Cubist painters and stimulate their further development. It was Cubism, moreover, that opened the eyes of the public to the aesthetic merits of African sculpture, and not the other way about. It is, however, quite unnecessary for the aims and meaning of the original art to be understood for it to be influential. The Cubists were interested only in the purely formal qualities of African sculpture, the Impressionists only in those aspects of the Ukiyo-e. Also, the imported style might be put to quite different uses, or given a different interpretation. Japanese artists, for instance, have employed Surrealism not so much to reveal the subconscious as to express the idea of spiritual freedom and, indirectly, as a form of political protest.

The view that influence operates in response to a conscious or unconscious need is supported by the truth of its opposite: namely, that where no need is felt, no influence is transmitted. Cultures, like neighbours, can live next door to each other and never exchange a word. China and India have felt from time to time that they ought to understand each other, but in things of the mind they are worlds apart. Rabindranath Tagore's visit to Peking in 1924 was a failure; Bertrand Russell and

John Dewey, on the other hand, were a tremendous success. They brought to China precisely what she needed; while Tagore preached a transcendental aestheticism that was no help at all in her painful progress into the modern world. Chinese paintings have been known and enjoyed (I use the word deliberately) in Europe since the seventeenth century, yet Chinese painting had no direct influence on Europe before the last generation. This can only be explained by the fact that until very recent times it met no need felt by Western artists at any level of consciousness.

How is this need felt? We would give much to know what thoughts - I mean, in the first place, purely professional thoughts about composition, form, line and colour - passed through the mind of Tung Ch'i-ch'ang when, as seems very probable, he thumbed through the exquisite engravings in Nadal's Evangelicae Historiae Imagines and other books brought by the Jesuits. And what did Boucher feel when he took in his hands the Chinese albums in the collection of his engraver friend Jacques-Gabriel Huquier? Did these pictures say nothing to him? If so, then that can only be because he did not really see them; because he was prevented from giving them his full critical attention by the feeling that, while they were exotic and enjoyable - and all the more enjoyable for being exotic they could not be taken seriously as art, for they could not be profited from. As the Chinese court painter Tsou I-kuei put it, speaking of Western artists, 'These painters have no brush manner whatsoever; although they possess skill, they are simply artisans and cannot consequently be classified as painters.' Some such feeling too may have prevented the ardent Catholic convert and landscape painter Wu Li from making any attempt to paint in the Western manner. The practice of Western art, whatever its merits, was for artisans; it could have no message for him and make no claim on him as a scholar and a gentleman. If this was indeed the case, the influence of European engravings on the Nanking painters requires some explanation. It may be that their concern with brush methods, which produced that famous handbook for art students, the Painting Manual of the Mustard Seed Garden, made them particularly predisposed to examine techniques from any source.

The response, when it does occur, does not involve the wholesale adaptation of a foreign art or style. That is simply copying. The artist's response is a process of ingestion and transformation, often of distortion. All the major examples that I have given in this book involve this process, ranging from the careful effort to concoct pictures in the European manner shown by Shiba Kōkan's Barrel Makers to the complete transformation of Japanese techniques and principles of design that we find in van Gogh. The translation of a form or style from one medium to another is also of crucial importance. Western realism becomes something subtly different when expressed in the ink and washes of a Nihonga painter such as Kaihō Yūshō; the aesthetic of the Ukiyo-e undergoes an astonishing transformation when translated into oil paint or Lautrec's lithographs. Just how this transformation comes about is a mystery. It takes place in the course of the artist's dialogue with his medium, an intense and private thing which the artist himself does not understand, and which is still beyond the skill of the psychologist to describe.

We cannot leave the subject of the confrontation of Eastern and Western art without giving some thought to just what it is that is confronting what. I approach this with some misgivings. Comparisons of this sort involve making generalizations about beliefs and attitudes which must at best be very superficial. But it is worth the attempt because East and West have traditionally felt very differently about the world and have expressed their feelings in very different ways. Only when we realize how great these differences are can we fully appreciate the achievement of the creative artists who have borne the brunt of the confrontation and, in some cases, achieved without deliberate intent a triumphant resolution of them.

A number of attempts have been made to describe the fundamental differences between Eastern and Western concepts and modes of expression, of which one of the most thoughtful was F. S. C. Northrop's The Meeting of East and West. The East, as Northrop put it, dwells in an 'undifferentiated aesthetic continuum'; the West in a 'differentiated logical continuum'; in the East the 'aesthetic' component predominates, in the West the 'theoretic'. We can think of many aspects of which this is not true: the West has her poets and mystics, China her pragmatists. But the differences are sufficiently striking for a comparison such as this to be more helpful than otherwise. I should like in the few remaining pages to see if this contrast holds good in the world of art, fully aware that the canvas is being painted in very crude colours, and that Japan is a special case. Although aspects of the Far Eastern tradition are ex-

pressed particularly vividly in Japanese art, they are by no means all native to Japan. She has a special rôle in the confrontation of Eastern and Western art of which I shall speak in a minute. In the meantime my comparisons will be drawn between China on the one hand and Europe on the other, and will stress traditional concepts rather than the increasingly similar attitudes of modern times.

If such statements have any validity at all, it may be said that the Western outlook is traditionally theistic, the Eastern atheistic. The West sees God as the centre; to the East there is no centre. To the West, man is God's supreme creation; to the East he is but part of a total, if not clearly defined, pattern. Western man conceives of God from below, as it were, working upwards from experience of the human father towards the transcendental, and makes his God in his own image. The East, having never seen the need for a personal God, does not attempt to describe the Divine except in the vaguest metaphysical terms. The West sees the working out of God's purposes in finite time; the East has no eschatology. Western man, in attempting to explain God's purposes, creates formidable philosophical problems for himself (such as the existence of evil), which are meaningless to the Eastern mind. Working outwards from the directly observed and experienced, the Western mind searches for meaning through the cumulative understanding of separate parts; the Eastern mind, less strenuously, seeks through intuition a grasp of the whole pattern.

It follows from this that the 'typical' traditional Western work of art, if there is such a thing, is likely to be a record of a particular experience or form, while the typical Eastern painting is a generalisation from experience, the distillation of an essential form. Exceptions at once leap to mind: Christian art before 1200, for example, shares with Buddhist art a hieratic formalisation utterly different from the realism of Western Classical, late Medieval, Renaissance and post-Renaissance art. But the kind of art that is the product of particularised experience is typically Western, the general statement typically Eastern. When Cézanne spoke of his 'little sensation', he meant a reaction to a quite specific stimulus at a particular time and place; when the Sung master Fan K'uan spoke of observing the effect of moonlight upon the snow he was speaking of the cumulative storing up of experience that he could draw upon whenever he wanted to paint a winter landscape. Even the titles of paintings illustrate this difference: compare, for instance,

the precision of Mont Saint Victoire, La Maison du Pendu, and Dr Tulp's Anatomy Lesson, on the one hand, with the deliberately generalised Travelling amid Mountains and Streams, Early Spring, and Scholars Collating the Classics on the other.

Thus while the West approaches Reality through the particular instance, the East sees the instance as an aspect and hence as a symbol of the Whole. The processes are complementary, and each has its potential limitation. Western art – a good deal of Dutch painting, for example – can cling so close to the object as never to take wing at all; Oriental art, by the continual restatement of general truths, can become wearisome unless the statement is enlivened by a feeling of the artist's spiritual excitement communicated through the brushwork.

The Western work of art, like the Western body of knowledge itself, is the product of a careful process of analysis and building up. The composition of the picture is the solution of a problem that the painter posed for himself, and recognition of the problem and of the artist's triumphant solution of it is an important part of our pleasure in his achievement. When the Eastern painter first puts brush to paper he knows what he must do, and the act of painting is a kind of performance in which he is no more concerned with overcoming technical problems than is the concert pianist. The composition may be familiar, and our appreciation of it rests, as with music, upon the quality of his performance and upon the depth and subtlety of his interpretation, rather than upon the novelty of it. Originality in itself has never counted for very much in Chinese art.

The traditional art of China and Japan, far more than that of Europe, depended upon a set of pictorial conventions that were eventually codified in painters' manuals such as the Mustard Seed Garden, referred to on page 97. There were no words in this vocabulary for foreign and unfamiliar things or for things not considered suitable for painting. We can see the difficulty that this still presents today when a contemporary 'realist' in China attempts to paint what is before his eyes, when Lo Ming, for example, puts a row of beetle-like lorries on his Highway to Tibet, or when a traditional Chinese painter visiting Switzerland tries to depict a mountain village. Either the lorries and the chalets are drawn correctly, in which case they are out of key with the conventional language of the rest of the picture, or they are translated into Chinese conventions and the landscape becomes so generalized as to lack any

interest. The solution to this problem is either to do away with conventions altogether, and hence to abandon the fundamental basis of Chinese pictorial art, or to create a new vocabulary of 'type forms'. That the latter course, apparently being taken today by Li K'o-jan and others of his school, is in direct contravention of one of the basic tenets of Socialist Realism is one of the more intriguing aspects of art in China since 1949.

Because the Western viewer derives so much of his pleasure from the artist's mastery of purely formal problems, he can enjoy a work of art of which the subject-matter may be in itself unedifying, if not positively repulsive. Asians, and particularly educated Chinese, are often appalled at the slaughter, martyrdoms and rapes which fill our galleries and upon which we gaze with such admiration: they see our separation of form and content as evidence of a deplorable lack of spiritual and moral wholeness. They have no sympathy for a point of view that sees form as content – this is also the fundamental objection of the new China to abstract art – and can ignore the sadism and violence about which it is so often composed. Japan here, as elsewhere, is a special case, and much closer to the West: the dramatic cruelty of some of the narrative scrolls is a source of added excitement to the viewer and intensifies their impact.

Because the East sees Reality as indivisible, it holds out for many people in the West – in particular for more and more of our youth – the promise of a view of the world that is more profound and all-embracing than the one they were born to. At the same time, the East is acquiring the disciplines of logic and science that the West has developed. This reversal of rôles may be temporary and is certainly partial; there are whole areas, notably in social behaviour and the more intangible realms of thought and feeling, that remain unchanged on both sides; but it constitutes a revolution in both Eastern and Western civilization more far-reaching than either has experienced in the whole course of world history. Modern art, in which China discovers realism and particularisation, while the West moves towards abstraction and the general statement, is only one aspect of this revolution.

The effect of this upheaval is of course more apparent on the East than on the West, for it is Western technology that still sets the pace. It is flattering for the Westerner to see the rest of the world modelling itself in his image. We take it for granted that the Chinese and Japanese wear European clothes and are accomplished violinists, while we consider an expert Western

performer on an Oriental instrument a phenomenon, a European in Oriental garb an eccentric. It is the East, we think, that must adapt to our ways, not we to hers. In the short term this may be inevitable, but, if we take a much longer view, the opposite may turn out to be the case. Western youth – or at least a growing segment of it – is in revolt against the values that the West is imposing on the world. Not only revolutionary ideas such as Maoism, but traditional Oriental values, social modes and artistic techniques are finding expression in the West, often in the most unexpected places, and are beginning to work a subtle change in Western culture. If this fact is not more widely acknowledged it is because Occidentals, so much less well informed about the East than the East is about them, do not realize where these ideas and forms originated.

And what of Japan? What is the Japanese world view; and where does she stand today? By now it must be clear that the Japanese artistic tradition is not something that can be broadly defined and compared with that of the West, as can that of China. Japan is a restless, dynamic blend of conflicting cultural forces, her native temperament and religion, Shintō, her love of nature, and her reverence for craftsmanship combining with and sometimes reacting violently against the overwhelming pressure of successive waves of cultural influence from abroad. She has developed a remarkable expertise in dealing with these pressures, which has not been impeded or slowed down by a coherent philosophical system of her own against which they had to be measured. Japanese writers have noted how readily. for example, Japanese artists have accepted abstraction, partly because in their architecture and crafts they are already surrounded by abstract art of great variety and subtlety, but partly also because they have seen no need to understand abstract art intellectually. For them there has not been so intense an internal struggle as has challenged the Chinese painter. The Japanese critic Kawakita Michiaki has spoken of the 'mannerism of superficial abstract painting' after the Second World War and observes, 'It is true that while Japanese painters have often displayed an unusual facility for sensibility, their intellectual base has often been deficient.' As I have suggested in an earlier chapter (page 116), the adaptation of an alien style or technique - and this applies to all periods of Japanese art - often occurs too quickly and easily to permit, or demand, that imaginative reworking which is the only means whereby China and the West can come to terms with each other's art.

There is yet another reason for Japan's rapid and wholesale adoption of Western culture. Since the late nineteenth century, many progressive Japanese have believed, with Fukuzawa Yukichi, that Japan's salvation, meaning her development into a modern power, lay in 'getting out of Asia' and attaching herself to the technological West, thereby so strengthening herself that she could show the rest of Asia the way into the modern world. The swift, skilful adoption of every development in Western culture as soon as it appeared was an essential part of this process. It even became a patriotic duty. Japan's success in fulfilling this self-appointed rôle can be seen from the fact that it was Japanese painters who first taught Western techniques in China before 1920, and Japanese Abstract Expressionists in the decade after the Second World War who translated the idiom of the New York School into a style for the whole of the Far East, not by means of a philosophical reinterpretation of its basic theory but purely in terms of style and technique.

As I have suggested, almost every style practised by Chinese avant-garde painters in Hong Kong and Taiwan since the 1960s has had its antecedents in post-war Japan. When, in Hong Kong in 1972, I put this to a group of modern painters which included Lui Show Kwan, Liu Kuo-sung, Hon Chi-fun and Lawrence Tam, they strenuously denied it. At first I put this down to the artists' natural vanity. But on reflection I realized that so confidently were they rooted in their own tradition that they were incapable of copying a foreign style. It had to establish its credentials in Chinese terms before they could make use of it. If we find the works of Liu Kuo-sung ultimately more satisfying than those of Inshō Domotō, it is because they seem to be less decorative, less on the surface, and more deeply thought through.

Modern Japanese art, nevertheless, has an important historical part to play as a catalyst for the cultures of East and West. That indeed is the rôle in which Japan has cast herself in other realms than art. The great Meiji-period liberal and innovator Ōkuma Shigenobu believed that 'Japan had the ability and duty to arbitrate between East and West, erasing barriers between races and cultures. . . . Japan had the unique capacity to graft the scientific civilization of the West, having its origin in Greek knowledge and analysis, onto the substratum of ancient civilization of China and India, based on intuition and sentiment'. By fulfilling this task, Ōkuma felt, Japan would also be able to repay her ancient cultural debt to China. Such was his belief in Japan's future in the world that he could confidently claim that

'on the Japanese alone devolves the mission of harmonizing the civilizations of East and West'.

In proposing their country primarily as an intermediary, these writers are doing Japan less than justice. In one area at least, that of garden design, Japan's contribution is unique. While the art of the garden was created in China, the Chinese never used it to express their highest philosophical concepts; that office they reserved for poetry and landscape painting. But for the Japanese the garden has become the most subtle and eloquent statement of the relationship between man, nature and art. Today, as Western man begins to revolt against the machine society he has created, and artists seek tangible ways – chiefly through Environmental Art – of expressing their rediscovery of their relationship with nature, they must look to the Japanese example if they hope to advance beyond the present somewhat crude or merely infantile forms that this movement seems to be taking.

Meanwhile, the interaction between East and West becomes ever closer and more intense, and there is no turning back. A number of writers have envisaged an eventual synthesis. Fenollosa as early as 1808 was foreseeing a new, loftier world culture born out of the fusion of Far Eastern spirituality and Western science, a view echoed in Northrop's vision of a future society in which 'the higher standard of living of the most scientifically advanced and theoretically guided Western nations is combined with the compassion, the universal sensitivity to the beautiful, and the abiding equanimity and calm joy of the spirit which characterises the sages and many of the humblest people of the orient'. Today, such a view cannot help but seem to come too pat. Not only does there lie behind it the philistine presumption that, since what Asia brings to the bargain is intangible, the West, bringing tangible benefits, must assume the natural leadership, but it is an over-simplification of the situation. Only since the Industrial Revolution has the West seemed to be the leader. When 'spiritual' Asia has caught up with the 'scientific' West, as Japan has done and China soon will do, what becomes of the dichotomy then?

I have not once used the word synthesis in this book – not, at least, in this larger context – for the notion of synthesis implies something final and therefore static. To the Chinese view, it is not the synthesis of yang and yin, but the eternal, dynamic interaction of these opposite but complementary forces that is lifegiving. So also should we regard the interaction between East

and West, as a process in which the great civilizations, while preserving their own character, will stimulate and enrich each other. Such a condition for the meeting of Eastern and Western art seems to offer far more creative possibilities than a synthesis, which would be sterile if it were consciously pursued, and must, we may hope, be extremely remote if history takes its natural course.

Louis par agreem the average agreement that the state of the state of

Chapter 1

Useful general works on early European influence in Japan include the following: Sir George Sansom, The Western World and Japan (London, 1950); C. R. Boxer, The Christian Century in Japan (Berkeley and Los Angeles, 1967), and Jan Compagnie in Japan 1600-1817 (The Hague, 1950); also C. R. Boxer's 'Some Aspects of Portuguese Influence in Japan, 1542-1640', Transactions of the Japan Society, 33 (1936), 13-64. Donald Keene, The Japanese Discovery of Europe, 1720-1830 (rev. ed., Stanford, 1969), contains material on Shiba Kōkan, who is also the subject of an article by Arthur Waley, 'Shiba Kōkan (1737-1818)', Ostasiatische Zeitschrift, N.F. 5 (1929), 60-75, and of a catalogue of an exhibition at the Nara Museum in 1969, published by the Yamato Bunkakan. Honda Toshiaki, Seiki Monogatari ('Tales of the West') (1798), gives an eighteenth-century Japanese view of European art. See also Suzuki Susumu, Okyo (Tovo Bijutsu Bunko series, Tōkyō, 1941).

On early Christian art in Japan, see Nishimura Tei, Namban Bijutsu ('Namban Art', Tōkyō, 1958); and the volumes on Namban art currently being published by the Kōbe City Museum of Namban Art. See also Johannes Laures, S.J., Kirishitan Bunko, A Manual of Books and Documents on the Early Christian Missions in Japan (Tōkyō, 1957); G. Schurhammer, 'Die Jesuitenmissionäre des 16. und 17. Jahrhunderts und ihr Einfluss auf die japanische Malerei', Jubiläumsband der Deutschen Gesellschaft für Natur- und Völkerkunde Ostasiens, 2 (Tōkyō, 1933), 116–26; and James E. McCall, 'Early Jesuit Art in the Far East', Artibus Asiae, 10.2 (1947), 121–37, 10.3 (1947), 216–33, 10.4 (1947), 283–301, 11.1/2 (1948), 45–69. Kenji Toda, Descriptive Catalogue of Japanese and Chinese Illustrated Books in the Ryerson Library of the Art Institute of Chicago (Chicago, 1931) is a useful work, dealing chiefly with Japanese books.

The most influential European art manual in Tokugawa Japan was Gerard de Lairesse, Groot Schilderboek, waarin de Schilderkunst in al haar deelen grondig word onderweezen, various editions, 1707, 1728-9, 1746, etc.

Of the extensive literature on the Japanese print I have found particularly helpful Kikuchi Sadao, A Treasury of Japanese Wood Block Prints (New York, 1969). On particular artists and aspects, see John Hillier, Hokusai: Paintings, Drawings and Woodcuts (London, 1955), and Hokusai Drawings (London, 1966); Theodore Bowie, The Drawings of Hokusai (Bloomington, 1964); and B. W. Robinson, Kuniyoshi (London, 1961). On Nagasaki and Yokohama prints, see G. Kuroda, Nagasaki-kei Yōgwa (Osaka, 1932), and N. H. Mody, A Collection of Nagasaki Colour Prints and Paintings showing the Influence of Chinese and European Art on that of Japan (2 vols, London and Kōbe, 1939); Tamba Tsuneo, Yokohama Ukiyoe (Tōkyō, 1962); and H. P. Stern, 'America: A View from the East', Antiques, 79.2 (February, 1961), 166-9.

Chapter 2

An essential reference book on Ch'ing Dynasty personalities is A. W. Hummel, *Eminent Chinese of the Ch'ing Period* (2 vols, Washington, 1943); Harold Kahn, *Monarchy in the Emperor's Eyes* (Cambridge, Massachusetts, 1971) contains information

on the emperor as an art patron.

Of the very extensive literature on the missions in China, I have consulted chiefly the following: Louis Pfister, Notices biographiques et bibliographiques sur les Jésuites de l'ancienne mission de Chine, 1552–1773 (2 vols, Shanghai, 1934); various authors, Lettres édifiantes et curieuses (4 vols, Pantheon ed., Paris, 1843); and George H. Dunne, S.J., Generation of Giants (Notre Dame, 1962). The prime source on the early period is Pasquale M. d'Elia, S.J., Fonti Ricciane: Documenti originali concernante Matteo Ricci e la Storia delle Prime Relazioni tra l'Europa e la Cina 1579–1615 (3 vols, Rome, 1942, 1949). For the French missions, see P. H. Havret, S.J., La Mission du Kiang-nan, son histoire, ses œuvres (Paris, 1900), and Histoire de la Mission de Pékin (2 vols, Paris, 1933).

On individual missionaries relevant to this book but not themselves artists, see C. Deshaines, Vie du Père Nicolas Trigault de la Compagnie de Jésus (Tournai, 1864); Edmond Lamalle, S.J., 'La propagande du Père Nicholas Trigault en faveur des missions de Chine (1616)', Archivum Historicum Societatis Jesu, 9 (1940), 49–120; and A. Väth, Johan Adam Schall von Bell, S.J. (Cologne, 1933). The last phase of mission activity is covered

in C. de Rochemonteix, Joseph Amiot et les derniers survivants de la

Mission Française à Pékin (1750-1795) (Paris, 1915).

On the beginning of Christian art in China, the chief sources are: Pasquale M. d'Elia, S.J., Le Origine dell'Arte Cristiana Cinese (1583-1640) (Rome, 1939); Henri Bernard, 'L'art chrétien en Chine', Revue d'histoire des Missions, 129 (1935), 199-229; Paul Pelliot, 'La peinture et la gravure européennes en Chine au temps de Mathieu Ricci', T'oung Pao, 20 (1921), 1-18; and S. Schüller, 'P. Matteo Ricci und die christlische Kunst in China', Katholische Missionen, 69 (1936). Berthold Laufer, 'Christian Art in China', Mitteilungen des Seminars für Orientalische Sprachen, 13 (Berlin, 1910), concerns the six copies of European engravings, allegedly by Tung Ch'i-ch'ang, which are also discussed in J. Jennes, 'L'art chrétien en Chine au début du XVIIe siècle', T'oung Pao, 33 (1937), 129-33.

Material on European painters in China between 1600 and 1800 is drawn chiefly from the following: Feuillet de Conches. 'Les peintres européens en Chine et les peintres chinois', La Revue Contemporaine (Paris, 1856), 216-60; George Loehr, 'Missionary Artists at the Manchu Court', Transactions of the Oriental Ceramic Society, 34 (London, 1962-3), 51-67; Giovanni Gherardini, Relation du voyage fait à la Chine . . . par le Sieur Giov. Gherardini (Paris, 1700). Du Halde, A Description of the Empire of China, 2 (London, 1741), contains a long account, drawn from Jesuit sources, of Gherardini's illusionistic wall-paintings and painted 'dome' in the Cathedral at Peking and of the impression that they made on Chinese visitors; Matteo Ripa, Memoirs of Father Ripa during Thirteen Years Residence at the Court of Peking, trans. Fortunato Prandi (London, 1844), contains all the parts about his artistic activities in China that are in his three-volume account of the founding of the Chinese College in Naples, published in Naples in 1832; see also Kneeland McNulty, 'Matteo Ripa's Thirty-six Views of Jehol', Artist's Proof: The Annual of Prints and Printmaking, 8 (1968), 87-92.

The main work on Castiglione is Ishida Mininosuke, 'A Study on the Life of Lang Shih-ning (Giuseppe Castiglione)', Bijutsu Kenkyū, 10 (October 1932), 1–40, with additional notes and corrections in Sansai (1947) and in Ishihama sensei koki kinen tōyōgaku ronsō (1959), 18–22. See also George Loehr, Giuseppe Castiglione (Istituto per il Medio ed Estremo Oriente, Rome, 1940); and Gustav Ecke, 'Sechs Schaubilder Pekinger Innen-räume des achtzehnten Jahrhunderts nebst zwei Blumenstueckchen von Castiglione', Bulletin of the Catholic University of

Peking, 9 (1934). Michael Sullivan, 'The Night Market at Yang-ch'eng', Apollo, 88 (November, 1968), 330-5, contains material on Attiret. For Panzi, see Henri Cordier, 'Giuseppe Panzi, peintre italien à Pé-king (XVIIIe siècle)', Mélanges

offerts à M. Emile Picot 1 (Paris, 1913), 429-43.

For a detailed discussion of the illustrated books and engravings brought to China by the missionaries, and their possible influence on Chinese painting, see Michael Sullivan, 'Some Possible Sources of European Influence on Late Ming and Early Ch'ing Painting', which also includes the Chinese comments on Western art mentioned in this chapter, with sources, Proceedings of the International Symposium on Chinese Painting (Taipeh, 1972), 595-633, and James Cahill, 'Wu Pin and his Landscape Painting', Ibid., 637-720, and 'Yüan Chiang and his School', Ars Orientalis, 5 (1963), 259-72. See also, for Chinese sources, Hsiang Ta, 'Ming Ch'ing chih chi Chung-kuo mei-shu so shou Hsi-yang chih yin-hsiang' ('Western Influences upon Chinese Art in the Ming and Ch'ing Periods'), in Chinese, Tung-fang tsachih, 27.1 (1930), 19-38.

The contents of the former Jesuit libraries in Peking are discussed in J. Laures, S.J., 'Die Bücherei der älteren Jesuitenmission im Pei-t'ang zu Peking', Die Katholische Missionen (Düsseldorf, 1937), and 'Die alte Missionsbibliothek im Pei-t'ang zu Peking', Monumenta Nipponica, 2, 1 (1939), 124–39; see also P. Verhaeren, C.M., 'L'ancienne bibliothèque du Pét'ang', Bulletin Catholique de Pékin (1940), 80–6. An important analytical study is Henri Bernard, S.J., 'Les adaptations chinoises d'ouvrages européens: Bibliographie chronologique depuis la venue des Portugais à Canton jusqu'à la Mission Française de Pékin', Monumenta Serica, 10 (1945), 1–57 and 309–88, 19 (1960), 349–83. See also Henri Cordier, 'L'imprimerie sino-européenne en Chine, XVII'e & XVIII'es.', Publications de l'Ecole des Langues Orientales, Ser. 5, tome 3 (1901).

Two important articles deal with Wu Li, neither of which present any evidence that he was influenced by European art: M. Tchang and de Prunelé, 'Le Père Simon a Cunha, S.J.', Variétés Sinologiques, 37 (Paris, 1914); and Ch'en Yüan, 'Wu Yu-shan. In Commemoration of the 250th Anniversary of his Ordination to the Priesthood of the Society of Jesus', trans. Eugene Feifel, Monumenta Serica, 3 (1937–8), 130–70b.

On the influence of Western perspective on Chinese painting, see O. Franke, Keng tschi t'u (Hamburg, 1913), George Loehr, op. cit., and Paul Pelliot, 'Apropos du Keng tche t'ou', T'oung

Pao (1913), 65–7. I am grateful to Professor James Cahill for drawing my attention to the resemblance between Ch'en Hungshou's flowers and butterflies and those in Vallet's book, and to Dr Clarence Shangraw for the reference to the woodcut in the San-ts'ai t'u-hui. After this book was completed there appeared The Restless Landscape: Chinese Painting of the Late Ming Period, a catalogue of an exhibition at the University of California Art Museum, Berkeley, 1971; in 'The Problem of Western Influence', Yoko Woodson (14–18) discusses possible Western stylistic and technical features.

On engraving in China, see Walter Fuchs, 'Der Kupferdruck in China vom 10. bis 19. Jahrhundert', Gutenberg Jahrbuch, 25 (1950), 74-8, and 'Die Entwürfe der Schlachtenkupfer der Kienlung- und Taokuang-Zeit: mit Reproduktion der 10 Taokuang-Kupfer und der Vorlege für die Annam-Stiche', Monumenta Sinica, 9 (1944), 101-22. The most exhaustive study of the first 'Conquests' series is Paul Pelliot, 'Les "Conquêtes de l'empereur de la Chine", T'oung Pao, 20 (1921), 183-274.

Chinese painting in the European manner has not yet received much attention. A useful sourcebook is James Orange, The Chater Collection: Pictures Relating to China, Hongkong, Macao, 1655–1860 (London, 1924). See also C. Toogood Downing, Fan Qui in China in 1836–37 (3 vols, London, 1838; my quotation is taken from vol. 2, 108–9); and W. C. Hunter, The Fan Kwae in Canton before Treaty Days (London, 1911).

On Chinnery, see Henry and Sidney Berry-Hill, George Chinnery, 1774–1853, Artist of the China Coast (Leigh-on-Sea, 1963). George Chinnery 1774–1853 and Other Artists of the China Scene, Introduction by Francis B. Lathrop (Peabody Museum, Salem, 1967), includes a useful bibliography.

Chapter 3

Among the books that helped to form Europe's view of the arts of China are Athanasius Kircher, *China Monumentis*... *Illustrata* (Antwerp, 1667), and Joachim von Sandrart, *Teutsche Akademie* (Nuremberg, 1675–9), the first Western history of art to include a section on Chinese painting; see also Michael Sullivan, 'Sandrart on Chinese Painting', *Oriental Art*, 1, 4 (Spring 1949), 159–61.

On general cultural contacts with China, see A. Reichwein, China and Europe: Intellectual and Artistic Contacts in the Eighteenth

Century (New York, 1925), and Henri Cordier, La Chine en France au XVIIIè siècle (Paris, 1910). There is an extensive literature on chinoiserie, including Hugh Honour, Chinoiserie: The Vision of Cathay (London, 1961); J. Guerin, La Chinoiserie en Europe au XVIIIè siècle (Paris, 1911); H. Belevitch-Stankevitch, Le goût chinois en France au temps de Louis XIV (Paris, 1910); and A. Brookner, 'Chinoiserie in French Painting', Apollo, 65 (June 1957), 253-7. A scholarly study of early Italian collections of Oriental art is R. W. Lightbown, 'Oriental Art and the Orient in Late Renaissance and Baroque Italy', Journal of the Warburg and Courtauld Institutes, 32 (1969), 228-78.

On Chinese wallpapers, see Margaret Jourdain and Soame Jenyns, Chinese Export Art in the Eighteenth Century (London,

1950).

On cultural contacts between Europe and China before the arrival of Ricci, see Henry Yule, Cathay and the Way Thither (2 vols, London, 1866); Leonard Olschki, Guillaume Boucher: A French Artist at the Court of the Khans (Baltimore, 1946); and Ronald Latham, ed., The Travels of Marco Polo (London, 1958). I. V. Pouzyma, La Chine, l'Italie et les débuts de la Renaissance (Paris, 1935), attempts on the basis of the similarity of some landscape conventions to show that Chinese art brought by missionaries and merchants influenced early Renaissance painting. There is no evidence at all that Chinese paintings reached Europe before the sixteenth century, though it is just possible that some Chinese motives were transmitted - and transmuted - through Islamic art. Donald F. Lach, Asia in the Making of Europe, vol. 2, A Century of Wonder (Chicago and London, 1970), reproduces as plates 4 and 5 two Chinese paintings (called 'Indian' in an Inventory of 1596) which were in the collection of Archduke Ferdinand of Austria (1520-95) at Ambrass, and are now in the Kunsthistorisches Museum in Vienna. One is a fanciful palace-in-a-landscape; the other, geese amid reeds and lotuses; both are by anonymous Ming artists. A third, now lost, depicted 'Indian [sic] houses in which the Indians are sitting down together while one of them, clad in a red coat, is writing'. This book contains a mass of material on Oriental art in Europe in the sixteenth century, but in the total absence of any documentary proof to support it, I find it difficult to accept the author's suggestion that the buildings in the work of Hieronymus Bosch, and the fantastic landscapes in that of Niccolo dell'Abate and Pieter Brueghel the Elder, were inspired by Chinese painting. As Professor Lach himself points out (page 74, n. 89), although there were a number of Chinese illustrated books in Europe at the time, the pictures in them were mostly figure subjects. Jacques Bousquet, in his discussion of affinities with Chinese painting (Mannerism, New York, 1964, 270–1), cautiously, and I think rightly, remarks that 'to make these comparisons is not in any way to insist upon direct influence of Oriental painting. Rather, these visual analogies are cited to underscore the fact of a new sensibility to nature in Western artistic expression in the sixteenth century.'

On Chinese visitors to Europe, see J. Dehergne, S.J., 'Voyageurs chinois venus à Paris au temps de la marine à voiles et l'influence de la Chine sur la littérature française du XVIII°

siècle', Monumenta Serica, 23 (1964), 372-97.

On Chinese books in seventeenth- and eighteenth-century France, see Abel Rémusat, Mémoire sur les livres chinois de la bibliothèque du Roi . . . avec des Remarques critiques sur le Catalogue publié par Fourmont, en 1742 (Paris, 1818), and Henri Cordier, 'Catalogue des albums chinois et ouvrages relatifs à la Chine conservés au Cabinet des Estampes de la Bibliothèque Nationale', Journal Asiatique (September-October, 1909). On Chinese European-style drawings in the Bibliothèque Nationale, see also George R. Loehr, 'Peking-Jesuit Missionary-Artist Drawings sent to Paris in the 18th Century', Gazette des Beaux Arts, 60 (October, 1962), 419-28.

On individual artists referred to in this chapter I have found the following especially useful: Robert Schmidt, 'China bei Dürer', Zeitschrift des Deutschen Vereins für Kunstwissenschaft (Berlin, 1939), 103-8; Kenneth Clark, Rembrandt and the Italian Renaissance (London, 1966), which contains the inventory of Rembrandt's bankruptcy sale; Christopher White, Rembrandt as an Etcher, vol. 1 (London, 1969), 15-17, on his use of Japanese and Chinese papers. On Watteau, see de Fourcaud, 'Antoine Watteau', Le Revue de l'Art ancien et moderne (November, 1904); J. Mathey, Antoine Watteau; Peintures réapparues (Paris, 1959); Série Cabinet du Roi, Jean de Julienne et les graveurs de Watteau (Paris, 1921). Hélène Adhémar, Watteau, sa vie – son œuvre (Paris, 1950), reproduces the harpsichord panel in plate 57.

The possible Chinese source of the new informality of eighteenth-century garden design is discussed in Arthur O. Lovejoy, 'The Chinese Origin of a Romanticism', in his Essays in the History of Ideas (Baltimore, 1948), 99–135; see also Christopher Hussey, The Picturesque (London, 1927); Osvald Sirén, China and the Gardens of Europe of the Eighteenth Century (New

York, 1950), and *Gardens of China* (New York, 1949); and Rudolf Wittkower, 'English Neo-Palladianism, the Landscape Garden, China and the Enlightenment', *L'Arte*, 1969, 6 (June),

18-35.

Early European sources quoted or referred to are Sir William Temple, Upon Heroick Virtue (London, 1683); Sir William Chambers, Dissertation on Oriental Gardening (London, 1772); C. C. Hirschfeld, Theorie der Gartenkunst (Leipzig, 1779); and G.L.le Rouge, Details de Nouveaux Jardins à la mode: Jardins Anglois Chinois (20 'cahiers' in 2 vols, Paris, between 1776 and 1787).

Chapter 4

On Japan's response to the West since 1868, see Sir George Sansom, The Western World and Japan (New York, 1950); Edmund Skrzypczak, ed., Japan's Modern Century, A Special Issue of Monumenta Serica, Prepared in Celebration of the Meiji Restoration (Tōkyō, 1968); Marius B. Jansen, ed., Japan's Changing Attitudes toward Modernization (Princeton, 1965); Joyce C. Lebra, 'Okuma Shigenobu: Modernisation, and the West', in Edmund Skrzypczak, op. cit., 27-40. See also Donald Keene, ed., Modern Japanese Literature, an Anthology (New York, 1956); and Kokusai Bunka Shinkokai, ed., Introduction to Japanese Literature 1902—1935 (Tōkyō, 1935).

On Fenollosa and Okakura: E. F. Fenollosa, Epochs of Chinese and Japanese Art (2 vols, London, 1912), contains an account of his work by his widow Mary; the most complete study is Lawrence W. Chisholm, Fenollosa: the Far East and American Culture (New Haven and London, 1963); see also Taro Kotakane, 'Ernest F. Fenollosa's Activities in the Field of Art' (in Japanese), Bijutsu Kenkyū, 6, 7, 8 and 10 (1940); Okakura Kakuzō, The Awakening of Japan (New York, 1905); and Horioka Yasuko, The Life of Kakuzō, Author of Book of Tea

(Tōkyō, 1963).

Much has been published on art of the Meiji period during and since the centenary of 1968. I have found the following especially useful. Uyeno Naoteru, Japanese Arts and Crafts in the Meiji Era, English adaptation by Richard Lane (Tōkyō, 1968); Serge Elisséeff, La Peinture contemporaine au Japon (Paris, 1923); Fernando Gutierrez, 'Artistic Trends in the Meiji Period', in Edmund Skrzypczak, op. cit.; Haga Toru, 'The Formation of Realism in Meiji Painting: The Artistic Career of Takahashi

Yuichi (1828–1894)', unpublished paper from Seminar of the Conference on Modern Japan (Tōkyō, January, 1966). See also M. Bernardi, 'Antonio Fontanesi in Japan', Eastern World, 4 (1953), 109–16; and R. G. Jerry, 'European Influence on Japanese Design', Antiques, 73 (May 1948), 452–8. John M. Rosenfield's 'Western-Style Painting in the Early Meiji Period and Its Critics', in Donald H. Shively, ed., Tradition and Modernization in Japanese Culture (Princeton, 1971) is an excellent short account which reached me after this book was finished.

Wallace Baldinger, 'Takeuchi Seihō, A Painter of Post-Meiji Japan', Art Bulletin, 36.1 (March 1954), 45–56, is one of the few studies in English of a modern Nihonga painter. Baldinger gives an odd and tragic instance of the lengths to which Seihō would go 'in attempting to follow the nineteenth-century European custom of representing nothing until it was first consulted in nature'. In 1910 the Nishi Honganji temple in Kyōto commissioned Seihō to decorate the ceiling of the main gate with flying angels. The master insisted on drawing his figures from nude models, who were suspended in the air as if flying. He worked through the winter with only a hibachi (charcoal brazier) to keep the unfortunate girls warm, with the result that one fled and two died of pneumonia. The ceiling was never painted, but the temple has preserved Seihō's studies.

There is a vast literature on Japanese painting since the Second World War. I have found the following particularly useful: National Committee for the International Association of Plastic Arts, Who's Who among the Japanese Artists (Tōkyō, 1961); Nakamura Tanio, Contemporary Japanese-Style Painting, trans. and adapted by Ito Mikio (New York, 1969); David Kung, The Contemporary Artist in Japan (Honolulu, 1966); Oriental Art Press Company Limited, Masterpieces of Modern Art (Tōkyō, 1966); Wallace Baldinger, 'Westernization and Tradition in Japanese Art Today', College Art Journal, 13.2 (1954), 125-31. Kawakita Michiaki, Contemporary Fapanese Prints (Tōkyo, 1967), contains the most penetrating critique of modern Japanese art, from which I have quoted. See also Ulfert Wilke, 'Letter from Japan', College Art Journal, 18.1 (1958), 55-7; Hugo Munsterberg, 'East and West in Contemporary Japanese Art', ibid., 36-41; Elise Grilli, 'Japanese Art "Aprèsguerre", Art in America, 53 (June 1965), 140-1; and Y. Tono, 'New Talent in Tokyo', Art in America, 54 (January 1966), 94-5. See also Michel Tapié and Tore Haga, Continuité et avant garde au 7apon (Turin, 1961).

Among innumerable exhibition catalogues: Department of Education, Tōkyō, Catalogue of the Exhibition of Fine Art held by the Department of Education (4 vols, Tōkyō, 1938), and other similar official publications; National Museum of Modern Art, Tōkyō, Living Nineteen Japanese Artists [sic] (1955), Exhibition of Japanese Artists Abroad: Europe and America (1965), and Modern Japanese Art, Foreword by Kobayashi Yukio (1969); Museum of Modern Art, New York, The New Japanese Painting and Sculpture, Foreword by William S. Lieberman (1965); Solomon R. Guggenheim Museum, New York, Contemporary Japanese Art, Fifth Japan Art Festival Exhibition, Introduction by Edward F. Fry (1970); and Kawakita Michiaki, Japanese Expressionism, pamphlet Catalogue for exhibition (Tōkyō, 1960), from which the quotation on Mu ('nothingness') is taken.

On individual artists, see: Atsuo Imaizumi and Lloyd Goodrich, Kuniyoshi, catalogue of Kuniyoshi's posthumous Exhibition at the National Museum of Modern Art, Tōkyō (Tōkyō, 1954); Kawakita Michiaki, Kobayashi Kokei (1883–1957), English adaptation by Roy Andrew Miller (Tōkyō and Rutland, Vermont, 1957); various authors, Inshō Domoto (Kyōtō, 1965); Isamu Noguchi, Isamu Noguchi: A Sculptor's World, Foreword by R. Buckminster Fuller (London, 1967).

Chapter 5

Very little has been written so far on Chinese art since 1900. Michael Sullivan, Chinese Art in the Twentieth Century (1959), covers the period up to about 1955; see also L. Hájek and A. Hofmeister, Chinesische Malerei der Gegenwart (Prague, n.d.), and A. C. Scott's brief treatment in Literature and the Arts in Twentieth Century China (New York, 1963). Li Pu-yüan and others, Chungkuo hsien-tai i-shu shih ('History of Contemporary Chinese Art', Shanghai, 1936), deals chiefly with modern traditional painting. For the woodcut movement, see Jack Ch'en, Woodcuts of Wartime China (London, 1946); Pearl Buck, China in Black and White (New York, 1945); and Z. Hrdlicka, Contemporary Chinese Woodcuts (London, 1950). Mayching Kao's doctoral thesis at Stanford University, in progress as this book goes to press, contains valuable Chinese source material on this period.

Sources for reproductions of modern Chinese art are listed in the Bibliographical Note to my book, referred to above. For art in China since 1950, these periodicals are useful: China Reconstructs, Chinese Literature, Mei-shu, and Chung-kuo Hua. The most important work for the understanding of Chinese art since 1950 is Mao Tse-tung, On Literature and Art (rev. ed., 1967), which includes the 'Talks at the Yenan Forum on Literature and Art', given in 1942. Chou Yang, China's New Literature and Art: Essays and Addresses (Peking, 1954), represents an official view repudiated in the Cultural Revolution.

Tsung Pai-hua's essay, 'The Abstraction and Reality in Chinese Art', originally appeared in Wenyi Bao (Summer 1961); there is a translation in Chinese Literature (December 1961), 82-6. Chu Kuang-tsien's article, 'The Problem of Formal Beauty', appeared in Eastern Horizon, 3, No. 5, (May 1964). On Li K'o-jan checking his ts'un, see Fang Chi, 'A Myriad Hills Tinged with Red', Chinese Literature (1963), 11, 78-88.

Articles and exhibition catalogues devoted to the more prominent Chinese artists outside China and in Taiwan since 1950 are too numerous to list here. There are at least a score, for example, on Chang Dai Chien, and a dozen or more on Liu Kuo-sung. Catalogues that cover a group or a broader area include Alan Priest, Contemporary Chinese Paintings (Metropolitan Museum, New York, 1948); Vadime Elisséeff, La Peinture Chinoise Contemporaine (Musée Cernuschi, Paris, 1948); Chu-tsing Li, New Directions in Chinese Painting (University of Kansas Museum of Art, Kansas City, n.d.); and Michael Sullivan, Trends in Twentieth Century Chinese Painting (Stanford University Museum, Stanford, 1969).

Chapter 6

On nineteenth-century painting, John Rewald, The History of Impressionism (rev. ed., New York, 1961) and Post-Impressionism from Van Gogh to Gauguin (New York, 1950) are the most convenient general surveys, and I have found Aaron Scharf, Art and Photography (London, 1968), suggestive.

On individual artists I have consulted chiefly the following: L. Bénédite, 'Félix Bracquemond', Art et Décoration (February 1905), and Gabriel P. Weisberg, 'Félix Bracquemond and Japanese Influence in Ceramic Decoration', Art Bulletin, 51

(September 1969), 277-80.

E. R. and Joseph Pennell, The Life of James McNeill Whistler (2 vols, London, 1909); Denys Sutton, James McNeill Whistler (London, 1966), which includes the Ten o'clock Lecture, and

Nocturne: The Art of James McNeill Whistler (London, 1963); L. Bénédite, 'Whistler', Gazette des Beaux Arts, 33 (1905), 403-10,

496-511, 34 (1905), 142-58, 231-46.

Gotthard Jedlicka, Edouard Manet (Erlenbach-Zurich, 1941); Nils Gösta Sandblad, Manet: Three Studies in Artistic Conception, trans. Walter Nash (Lund, 1954); J. Richardson, Edouard Manet (London, 1958); Pierre Courthion, Edouard Manet (New York, 1961); Alain de Leiris, The Drawings of Edouard Manet (Berkeley and Los Angeles, 1969), and Ann Coffin Hanson's review of this book in The Art Bulletin, 53, 4 (December 1971), 543-5.

Julius Meier-Graefe, *Degas*, trans. J. Holroyd-Reece (London, 1923); Pierre Cabanne, *Edgar Degas* (Paris, 1958); Jean

Bouret, Degas (Paris, 1965).

William C. Seitz, Claude Monet (New York, 1960); Charles Morrill Mount, Monet, A Biography (New York, 1966); John Rewald, ed., Camille Pissarro: Letters to his Son Lucien (New York, 1943).

Robert Goldwater, Paul Gauguin (London, 1957); Paul Gauguin, Avant et Après (Leipzig, 1919), and Intimate Journals, trans. Van Wyck Brooks (London, 1923); Bernard Dorival, 'Sources of the Art of Gauguin from Java, Egypt and Ancient Greece', Burlington Magazine (April 1951), 118–22.

J. B. de la Faille, L'Œuvre de Vincent van Gogh, Catalogue Raisonné (4 vols, Paris and Brussels, 1928), Vincent van Gogh, The Complete Letters (3 vols, London, and Greenwich, Connecticut, 1958); Douglas Lord, ed., Vincent van Gogh: Letters to Emile Bernard (2 vols, New York, 1938).

Jean Bouret, The Life and Work of Toulouse-Lautrec, trans. Daphne Woodward (New York, 1966); Fritz Novotny, Toulouse-Lautrec (London, 1969); Douglas Cooper, Toulouse-Lautrec (Paris, 1955). Charles Chasse, The Nabis and their Period,

trans. Michael Bullock (London, 1969).

On Japanese influence on the Impressionists I have used three terms which sound similar but mean very different things. Japaneserie has to do with the creation of a Japanese effect in a picture by including fans, kimonos, vases, screens and other oriental paraphernalia; Monet's La Japanese is a good example. Japanese involves serious concern with Japanese pictorial techniques and may or may not include Japanese accessories; Manet's Zola is a fairly primitive example, van Gogh's Bedroom at Arles a very advanced one. Japanese is a word applied chiefly to rather frivolous objects made in the Japanese manner.

The literature on Japanese influence on the Impressionists and Post-impressionists is very extensive. I have found the following particularly useful: Ernest Chesneau, 'Le Japon à Paris', Gazette des Beaux Arts, 18 (1878), 385-97, 841-56; Y. Thirion, 'L'Influence de l'estampe japonaise dans l'œuvre de Gauguin', *ibid.*, 47 (1956), 95-114, and 'Le japonisme en France dans la seconde moitié du XIX siècle, à la faveur de la diffusion de l'estampe japonaise', Cahiers de l'Association Internationale des Etudes Françaises, 13 (1961), 117-30; H. Focillon, 'L'Estampe japonaise et la peinture en Occident', Congrès d'Histoire de l'Art (Paris, September-October 1921), 367-76; C. Graf-Pfaff, 'Zur Ausstellung "Japan und Ostasien in der Kunst," München, 1909, Münchner Jahrbuch der bildenden Kunst, 4 (1902), 108-26; Ernest Scheyer, 'Far Eastern Art and French Impressionism', Art Quarterly 6 (1943), 117-43; M. E. Trabault, 'Van Gogh's Japanisme', Mededelingen van der Dienst voor schone Kunsten der gemeente s'Gravenhage, 1-2 (The Hague, 1954), 16-40; Clay Lancaster, 'Oriental Contributions to Art Nouveau', Art Bulletin, 34 (December 1952), 297-310; T. S. Madsen, The Sources of Art Nouveau (Oslo, 1956); John Sandberg, 'Japonisme and Whistler', The Burlington Magazine, 106 (November 1964), 500-7; Henri Dorra, 'Seurat's Dot and the Japanese Stippling Technique', Art Quarterly (Summer 1970), 109-13. Mark Roskill, Van Gogh, Gauguin and the Impressionist Circle (London, 1970), Chapter 2, 57-85, deals with Japanese influence in some detail. Roskill also notes that van Gogh's notion of Japanese art was partly based on Theodore Duret's essay of 1884, 'L'Art Japonaise', reprinted in his book Critique d'Avant Garde (Paris, 1885).

On Kandinsky, see Wassily Kandinsky, The Art of Spiritual Harmony, trans. M. T. H. Sadler (London, 1914), and Concerning the Spiritual in Art (New York, 1947). See also Hilda Rebay, In Memory of Wassily Kandinsky (New York, 1945); J. Eichner, Kandinsky und Gabriele Münter: von Ursprüngen moderner Kunst (Munich, 1957); Lorenz Eitner, 'Kandinsky in Munich', Burlington Magazine, 99 (May 1957), 193-9; Will Grohmann, Wassily Kandinsky: Life and Work (New York, 1958).

The Chinese sources cited in this chapter are drawn from the following: Lu Chi: Ch'en Shih-hsiang, 'Literature as Light against Darkness', National Peking University Centennial Papers, No. 11 (1948; rev. ed., Portland, Maine, 1952); Tsung Ping, Wang Wei and Hsieh Ho: Michael Sullivan, The Birth of Landscape Painting in China (London, Berkeley and Los Angeles,

1962); the Sung scholar painters: James Cahill, 'Confucian Elements in the Theory of Painting', in Arthur Wright, ed., The Confucian Persuasion (Stanford, 1966); Tung Ch'i-ch'ang: James Cahill, Fantastics and Eccentrics in Chinese Painting (New York, 1967), 16–22; Wen T'ung: Osvald Sirén, Chinese Painting, vol. 2 (London, 1956), 14; Shih-t'ao: Pierre Ryckmans, Les 'Propos sur la peinture de Shitao', Mélanges Chinois et Bouddhiques, 15 (Brussels, 1970); the T'ang eccentrics: S. Shimada, 'Concerning the I-p'in Style of Painting', trans. James Cahill, Oriental

Art, N.S., 7.2 (1961), 66-74.

Most of the key texts on twentieth-century art from which I have quoted in this chapter are conveniently assembled in Herschel B. Chipp, Theories of Modern Art: A Source Book by Artists and Critics (Berkeley and Los Angeles, 1968). I have also found the following useful and suggestive: Herbert Read, A Concise History of Modern Painting (London, 1959); Wilhelm Worringer, Abstraction and Empathy, trans. Michael Bullock (London, 1953); Maurice Raynal and others, History of Modern Painting: Fauvism, Expressionism, trans. Douglas Cooper (Geneva, 1950); Bernard Dorival, Twentieth Century Painters: Nabis, Fauves, Cubists, trans. W. J. Strachan (New York, 1958); Michel Seuphor, Abstract Painting (New York, 1961); André Fermigier, Pierre Bonnard (New York, 1969); Renata Negri, Bonnard e i Nabis (Milan, 1970); Charles Chasse, Les Nabis et leur Temps (Lausanne, 1970); Emil Nolde, Jahre der Kämpfe 1902-1914 (Flensburg, n.d.), and Welt und Heimat: Die Südseereise 1913-1918 (Cologne, 1965).

On the relationship between modern art and science, see particularly C. H. Waddington, *Behind Appearance* (Edinburgh, 1969), and Peter Blanc, 'The Artist and the Atom', *Magazine*

of Art (April 1951), 145-52.

On America and Oriental art I have consulted Clay Lancaster, The Japanese Influence in America (New York, 1963). Constance Perkins, 'Fact or Fiction? The Legacy of Oriental Art', Art in America, 53.1 (1965), 42-7, deals chiefly with architecture, however, a subject which I have not touched on in this book, for it is a topic that would require a volume in itself.

On individual American painters, see Mark Tobey, 'Reminiscence and Reverie', *Magazine of Art*, 44 (October 1951), 228–32; William C. Seitz, *Mark Tobey* (Museum of Modern Art, New York, 1962); Henry J. Seldis, 'Exhibition Preview: Pacific Heritage', *Art in America*, 53.1 (1965), 27–33; Frederick S. Wight,

J. J. H. Baur and Duncan Phillips, Morris Graves (Berkeley and Los Angeles, 1956); George Michael Cohen, 'The Bird Paintings of Morris Graves', College Art Journal, 18 (Autumn 1958), 3–19. Shortly before this book went to press, I re-read Benjamin Rowland's Art in East and West (Cambridge, Massachusetts, 1954) and found that although I did not agree with all his interpretations, particularly those of Chinese painting, our views on the allegedly Oriental qualities in the work of Morris Graves were substantially the same.

A number of exhibitions have been devoted to the fruits of the East-West interaction, notably that organized by Professor Theodore Bowie at Indiana University in 1965, which resulted in a fascinating volume, East-West in Art: Patterns of Cultural and Aesthetic Relationships (Bloomington, 1966), with an Introduction by Rudolf Wittkower and contributions by Bowie and other scholars. See also Orient-Occident, Rencontres et influences durant cinquante siècles d'art (Musée Cernuschi, Paris, 1959).

List of Illustrations

- I Anonymous. Portuguese and Catholic priests. Detail from a six-panel *Namban* screen. Center of Asian Art and Culture, Avery Brundage Collection, San Francisco.
- 2 Anonymous. Horsemen at the Battle of Lepanto, 1571. Detail from a Namban screen. C. Murayama Collection.
- 3 Anonymous. Pastoral scene with shepherd and sheep. Panels from a screen. Atami Art Museum, Momoyama.
- 4 Anonymous. Westerners playing their music. Two panels from a six-panel *Namban* screen. Atami Art Museum, Momoyama.
- 5 Attributed to Hiraga Gennai. Young European woman. Colour on canvas. Municipal Art Museum, Kōbe. Photo the Museum Yamato Bunkakan, Nara.
- 6 Maruyama Ōkyo. Sketches of human figures (detail). National Museum, Kyōto. Photo Bijutsu Kenkyūjō.
- 7 Maruyama Ōkyo. Sketch of plants and animals. Nishimura Collection, Kyōto. Photo Bijutsu Kenkyūjō.
- 8 Maruyama Ōkyo. Pinetrees in the Snow. Mitsui Collection, Tōkyō.
- 9 Shiba Kōkan. Barrel Makers. Mori Collection. Photo the Museum Yamato Bunkakan, Nara.
- 10 Odano Naotake. Landscape with a vase of flowers. Ink and colour on silk. Photo the Museum Yamato Bunkakan, Nara.
- 11 Shiba Kōkan. The Serpentine, Hyde Park. Municipal Art Museum, Kōbe. Photo the Museum Yamato Bunkakan, Nara.
- 12 Watanabe Kazan. Portrait of Takami Sanseki. National Museum, Tōkyō.
- 13 Aōdō Denzen. Landscape with figures in a wood. Etching. National Museum, Tōkyō.
- I Tani Bunchō. Flowers in a vase, after a painting by Willem van Royen. Hanging scroll. Municipal Art Museum, Kōbe. Photo Mr Harumi Konishi, Kyōto.
- 14 Kawahara Keiga. The Blomhoff Family. Municipal Museum, Kōbe. Photo Mr Harumi Konishi, Kyōtō.

15 Katsushita Hokusai. Page of drawings of animals, from his

manual 'Quick Lessons in Drawing'.

16 Attributed to Okumaza Masanobu. A Game of Backgammon in the Yoshiwara. California Palace of the Legion of Honor, San Francisco, Collection Hayashi, L. 2971 Afga. Purchase, 1970.

- 17 Katsushita Hokusai. Spectral face. Formerly Tikotin Collection.
- 18 Katsushita Hokusai. View at Yotsuya. National Museum, Tōkyō.
- 19 Katsushita Hokusai. Mount Fuji from the Nihonbashi, Edo, from 'Thirty-Six Views of Fuji'. Victoria and Albert Museum, London.
- 20 Katsushita Hokusai. The Rape. Formerly Verver Collection, Paris.
- II Andō Hiroshige. Mount Fuji from Yoshiwara, from 'Fiftythree Stages of the Tōkaidō'. Victoria and Albert Museum, London.
- 21 Utagawa Kuniyoshi. Sosan returning to his Mother. Illustration from The Twenty-four Paragons of Filial Piety. B. W. Robinson Collection, London. Photo Victoria and Albert Museum, London.
- 22 Yoshitoshi Taiso. Yamauba and Kintarō. Willibald Netto Collection.
- 23 Andō Hiroshige. Sudden Shower at Ohashi, from 'Hundred Famous Views of Edo'.
- 24 G. Hofnagel. Mount St Adrian. Detail from an engraving from Georg Braun and Franz Hogenberg, Civitates Orbis Terrarum.
- 25 Mundator Leprosus. Engraving from Nadal's Life of Christ, Evangelicae Historiae Imagines.
- 26 Nuestra Señora de l'Antigua, Seville. Chinese woodcut print, after Jerome Wierix, in 'Mr Ch'eng's Ink Remains'. Percival David Foundation, London.
- 27 Chiao Ping-chen. Rural landscape (detail). Hanging scroll. Mr and Mrs Allen D. Christensen Collection, Atherton, California. Photo Stanford University.
- 28 Kung Hsien. Landscape. Ink on paper. C. A. Drenowatz Collection, Zurich.
- 20 Ch'en Hung-shou. Studies of flowers and butterflies (detail). Album leaf. Honolulu Academy of Arts, Honolulu.
- 30 Fraxinella and Ephemerum Matheoli. Engraving from Pierre Vallet, Le Jardin du Roy très Chrestien Louis XIII de France.

31 Mittuant Iudaei ad Ioannem. Engraving from Nadal's Life of Christ, Evangelicae Historiae Imagines.

32 Wu Pin. Occupations of the Months (detail). National Palace

Museum, Taipei, Taiwan.

33 Wu Pin. Occupations of the Months (detail). National Palace Museum, Taipei, Taiwan.

III Hsiang Sheng-mou. Bare tree. Album leaf. Mr J. T. Tai

Collection. Photo O. E. Nelson, New York.

34 Fan Ch'i. Landscape. Album leaf. Metropolitan Museum of Art, New York, Purchase 1969, the Sackler Fund.

35 Fan Ch'i. Landscape on the Yangtze River (detail). Handscroll. Staatliche Museen Preussischer Kulturbesitz, Museum für Ostasiatische Kunst, Berlin.

36 Chang Tse-tuan. Going up River at Ch'ing-ming Festival Time (detail). Palace Museum, Peking.

- 37 Ting Kuan-p'eng. Toyseller at New Year (detail). Handscroll. National Palace Museum, Taipei, Taiwan.
- 38 Yüan Chiang. Carts on a winding mountain road (detail). Hanging scroll. Nelson Gallery, Atkins Museum, Kansas City, Nelson Fund.

39 Aquapendente and Tarvisi. Engravings from Georg Braun and Franz Hogenberg, Civitates Orbis Terrarum.

- 40 Lu Wei. Landscape. Album leaf. Formerly in Dr Franco Vannotti Collection.
- 41 Anonymous follower of Lang Shih-ning (Giuseppe Castiglione). Foreign building in the Yüan-ming-yüan. Engraving. Bibliothèque Nationale, Paris.

42 Anonymous. Portrait of Hsiang Fei dressed en paysanne. Palace Museum, Peking.

- 43 Lang Shih-ning. Landscape with scholar reading. Hanging scroll. National Palace Museum, Taipei, Taiwan.
- IV, 44 Lang Shih-ning. A Hundred Horses in a Landscape (detail). National Palace Museum, Taipei, Taiwan.
 - V Anonymous. Court lady and her attendants. Panel on silk. By courtesy of Mrs Peter Quennell. Photo History Today Ltd.
- 45 Attributed to Lang Shih-ning. Night Market at Yang-ch'eng (detail). Stanford Museum Collection, gift of Mr and Mrs Allen D. Christensen.
- 46 Anonymous. Ch'ien-lung's conquest of Turkestan. Engraving made in Paris after a painting by Jean-Damascène Sallusti. British Museum, London.

47 Matteo Ripa. Copperplate engraving from 'Thirty-six

- Views of the Pi-shu Shan-chuang'. George R. Loehr Collection, Florence.
- 48 Anonymous. Page from one of a set of albums containing Chinese landscape paintings, executed for A. E. von Braam Houckgeest. British Museum, London.
- 49 Anonymous follower of Chinnery. Portrait of a Chinese girl. Oil. City Museum and Art Gallery, Hong Kong.
- 50 Lamqua. Riverside at Canton: one of a pair of paintings. Oil. A. B. Griswold Collection, Monkton.
- 51 Rembrandt van Rijn. Two Indian noblemen of the Mughal court. Pen and ink with touches of chalk gouache on Japanese paper. Pierpont Morgan Library, New York.
- 52 Rembrandt van Rijn. Winter Landscape. Fogg Art Museum, Harvard University, Cambridge, Massachusetts. Bequest of Charles Alexander Loeser.
- 53 Anonymous. Chinese deities. Engraving from Athanasius Kircher, *China Illustrata*.
- 54 Anonymous. Lady with a bird. Engraving from Athanasius Kircher, *China Illustrata*.
- 55 Anonymous. Higiemondo. Engraving from Joachim von Sandrart, Teutsche Akademie der Bau-, Bildhauer- und Maler-kunst . . .
- 56 Antoine Watteau. Chinoiserie. Panel from Château de la Muette.
- 57 Antoine Watteau. *Chinoiserie*. Panel from a harpsichord. Oil on panel. Collection Besançon de Wagner.
- 58 Pierre Giffart. Empereur Chinois. Engraving from Joachim Bouvet, L'Estat présent de la Chine en Figures.
- 59 Anonymous. Page from Collection précieuse et enluminée des fleurs les plus belles et les plus curieuses. Bibliothèque Nationale, Paris.
- 60 J. A. Fraisse. Etching from Livre de desseins chinois tirés après des originaux de Perse, des Indes, de la Chine, et du Japon.
- 61 F. M. Piper. Plan of Stourhead, Wiltshire. From a sketchbook. Kungliga Akademien för de Fria Konsterna, Stockholm.
- 62 Thomas Gainsborough. Mountainous Landscape with a Boat on a Lake. City Museum and Art Gallery, Birmingham.
- 63 G. L. Le Rouge. Engraving from Le Jardin Anglois-Chinois.
- 64 Anonymous. Page depicting rocks. Woodcut print from the Painting Manual of the Mustard Seed Garden.
- 65 Takahashi Yūichi. Portrait of the Meiji Emperor. Department of the Imperial Household, Tōkyō.

66 Takahashi Yūichi. Salmon. University of Arts, Tōkyō. Photo Takayasu Chino.

67 Hashimoto Gahō. White Clouds and Red Trees. University of

68 Takamura Kōun. Old Monkey. National Museum, Tōkyō.

69 Takamura Kōtarō. Hand. Private collection, Tōkyō.

- 70 Takeuchi Seihō. Holland, Spring Colours (detail). Mr Zenkichi Kuwabara Collection Guifu. Municipal Museum, Kyōto.
- 71 Kōbayashi Kōkei. The Tale of Kiyohima: Scene III, In the Bedroom. Yamatora Museum of Art, Tōkyō.
- 72 Nakamura Osaburō. At the Piano. Municipal Museum, Kyōto. Photo Japan Information Centre.

73 Kuroda Seiki. At the Lakeside. Bijutsu Kenkyūjō (National Property), Tōkyō.

74 Aoki Shigeru. Ladies of the Nara Court, Tempyō Era. Bridgestone Museum of Art, Tōkyō.

75 Yasui Sōtarō. Roses. Bridgestone Museum of Art, Tōkyō.

- 76 Kishida Ryūsei. Reikō at Five Years Old. National Museum of Modern Art, Tōkyō. Photo Sakamoto.
- VI Tokuoka Shinsen. Rain. Collection Zauho-Kanko-Kai Publishing Company. Photo Japan Information Centre.
- 77 Noboru Kitawaki. Spikenards. National Museum of Modern Art, Tōkyō.
- 78 Yokoyama Taikan. Wheel of Life. Eisei Bunkō (Hosokawa Collection). Photo Otsuka Kōgeisha, Tōkyō.

79 Kudō Kōjin. Hands and Eyes of Earth.

- 80 Oyamada Jirō. Sketch of an Ossuary. Iida Gallery, Tōkyō.
- 81 Kazuki Yasuo. To the North, to the North-west. Photo Shinchosha, Tōkyō.
- 82 Hashimoto Meiji. *Portrait of Marichiyu*. Shimbashi Embujō Theatre, Tōkyō.
- 83 Kayama Matazō. Winter. National Museum of Modern Art, Tōkyō. Photo Sakamoto.
- VII Umehara Ryūzaburō. Nude with Fans. Ohara Museum, Okayama. Photo Akio Nakamura.
- 84 Inoue Yūichi. Chinese character shu (Japanese: shoku). Artist's collection.
- 85 Domotō Inshō. Four Seasons of Garden. Private Collection, Kyōto.

86 Yoshihara Jirō. Circle.

87 Yamaguchi Takeo. Turn. National Museum of Modern Art, Tōkyō.

- 88 Miki Tomio. Untitled (ear). Cast aluminium. Charles R. Penney Collection, Olcott, New York. Photo David Garlock.
- 89 Yamamoto Kanae. *Breton Girl*. Courtesy of Shōbi-Sō Gallery, Ueno. Photo Bijutsu Kenkyūjō.
- 90 Onchi Köshirö. *Poem Number Nineteen: The Sea.* Honolulu Academy of Arts, James A. Michener Collection, Honolulu.
- 91 Kiyoshi Saitō. Wall.
- 92 Sugai Kumi. Snow.
- 93 Isamu Noguchi. Black Sun. Artist's collection.
- 94 Isamu Noguchi. Water source sculpture. Red granite. Sculpture Garden, National Museum, Jerusalem.
- 95 Hsü Pei-hung. The Foolish Old Man removes the Mountain. Chinese collection.
- 96 P'ang Hsün-ch'in. Portrait of the artist's son. Chinese ink on paper.
- 97 Kao Ch'i-feng. The Bridge in Drizzling Rain.
- 98 Ku Yüan. Denouncing the Landlord.
- 99 Wu Tso-jen. Yaks.
- 100 Wei Tzu-hsi. Wind and Rain can't stop them. Chinese collection.
- 101 Ch'eng Shih-fa. Under the Pipal.
- 102 Anonymous sculptors, Szechwan. Rent Collectors' Courtyard: Scene 3, 'Measuring the Grain'. Ta-yi, Szechwan.
- 103 Li K'o-jan. Mountain Village. Khoan and Michael Sullivan Collection.
- 104 P'an Yu-liang. Still life. Oil. Artist's collection.
- 105 Zao Wou-ki. Buds and Lotus.
- 106 Zao Wou-ki. Abstraction. H. H. Arnason Collection, New York. Photo Stanford University.
- 107 Lui Show Kwan. Soil Picture. 1962.
- VIII Chang Dai Chien. Ten Thousand Miles of the Yangtze River. Chang Ch'un Collection, Taipei, Taiwan.
- 108 Hung Hsien. Composition. Ink and colour on paper. Photo Nickerson.
- IX Liu Kuo-sung. Abstraction. Khoan and Michael Sullivan Collection. Photo Leo Holub, Stanford University.
- 109, 110 Ch'en Ch'i-k'uan. The Canal and (right) Chungking Steps.
- 111 Ch'en T'ing-shih. Abstraction. Print from banana-leaf fibre board. Khoan and Michael Sullivan Collection.
 - X Tseng Yu-ho. At Second Sight. Mr and Mrs Jacqueline Hume Collection, San Francisco.

- 112 Tseng Yu-ho. Tree Roots. Honolulu Academy of Arts, Honolulu.
- II3 Katsushita Hokusai. Insects. Page from sketchbook (Manga).
- 114 Katsushita Hokusai. Wrestlers. Page from sketchbook (Manga).
- 115 Edouard Manet. La Chanteuse des Rues. Courtesy Museum of Fine Arts, Boston, Bequest of Sarah Choate Sears.
- 116 Kaigetsudō Anchi. A Beauty of the Day. British Museum.
- 117 Edouard Manet. Portrait of Emile Zola. Louvre, Paris. Photo Giraudon.
- 118 Edouard Manet. Page of letter with sprays of bindweed. Watercolour. Cabinet des Dessins, Louvre, Paris. Photo Jacqueline Hyde.
- 119 Edgar Degas. Au Louvre. Collection Durand-Ruel.
- 120 Edgar Degas. Bains de Mer, Petite Fille Peignée par sa Bonne. National Gallery, London.
- 121 Claude Monet. La Japonaise. Courtesy Museum of Fine Arts, Boston.
- 122 Claude Monet. 'Nymphéas' series. Oil on canvas. Musée de l'Orangerie, Paris. Photo Eileen Tweedy.
- 123 James Abbott McNeill Whistler. The Golden Screen: Caprice in Purple and Gold. Courtesy of the Smithsonian Institution, Freer Gallery of Art, Washington, D.C.
- 124 James Abbott McNeill Whistler. Miss Cicely Alexander: Harmony in Grey and Green. Tate Gallery, London.
- 125 James Abbott McNeill Whistler. Old Battersea Bridge: Nocturne in Blue and Gold. Tate Gallery, London.
- 126 Vincent van Gogh. Copy of Hiroshige, Sudden Shower at Ohashi. National Museum Vincent van Gogh, Amsterdam.
- 127 Vincent van Gogh. Le Père Tanguy. Musée Rodin, Paris. Photo Bulloz.
- XI Vincent van Gogh. The Artist's Bedroom at Arles. National Museum Vincent van Gogh, Amsterdam.
- 128 Vincent van Gogh. Harvest: the plain of La Crau, Arles, June 1888. Pen and sepia ink. Mr and Mrs Paul Mellon Collection.
- 129 Andō Hiroshige. Cherry Blossoms at Koganei. Honolulu Academy of Arts, James A. Michener Collection, Honolulu.
- 130 Anonymous. Prince Siddharta cuts his hair, signifying his retreat from the world. Relief panel from Borobudur. Photo Rijksmuseum voor Volkenkunde, Leiden.

131 Paul Gauguin. Where do we Come from? What are we? Where are we Going? Courtesy Museum of Fine Arts, Boston, Arthur Gordon Tompkins Residuary Fund.

132 Henri de Toulouse-Lautrec. Jane Avril au Jardin de Paris.

XII Henri de Toulouse-Lautrec. Miss Loie Fuller. Black and white lithograph. Edition published by Marty.

- 133 Pierre Bonnard. 'Japanese' screen in four panels, depicting carriages, women and children with hoops. Lithograph in five colours. Museum of Modern Art, New York, Abby Aldrich Rockefeller Purchase Fund.
- 134 Maurice Denis. *Procession under the Trees*. Mr and Mrs Arthur G. Altschul Collection, New York.
- 135 Vasily Kandinsky. Light Picture, no. 188. Solomon R. Guggenheim Museum, New York.
- 136 Naum Gabo. Construction in Space with Balance on Two Points. Yale University Art Gallery, New Haven, Connecticut, Gift of H. Wade White.
- 137 Tung Ch'i-ch'ang. Mountain landscape for Sheng-pei. Ink on paper. C. A. Drenowatz Collection, Zurich.
- 138 Wang Yüan-ch'i. Landscape in the style of Tung Ch'ich'ang. Ink and slight colour on paper. Dr Franco Vannotti Collection.
- 139 Shih-t'ao. Landscape for Taoist Yu. Album leaf. Mr and Mrs C. C. Wang Collection, New York.
- 140 Attributed to Ying Yü-chien. Mountain Village in Clearing Mist. Commission for the Protection of Cultural Property, Tōkyō.
- 141 Pa-ta Shan-jen. Small fish. Album leaf. Sumitomo Collection. Photo Sakamoto.
- 142 Mark Tobey. Soochow.
- 143 Mark Tobey. Centre Agité Dominé. Artist's Collection.
- 144 Mark Tobey. Composition. Galerie Beyeler, Basle.
- 145 Henri Michaux. Painting. Chinese ink. Galerie le Point Cardinal, Paris.
- 146 Pa-ta Shan-jen. Small birds. Album leaf. Sumitomo Collection. Photo Sakamoto.
- 147 Morris Graves. Wounded Gull. Phillips Collection, Washington.

Index

Page numbers in italic type refer to illustrations

Abstract Expressionism 11, 12, 179, 245, 251 Académie du Midi, Nanking 168 Academy of St Luke, Nagasaki 15 Action painting 11, 193, 245 Acunha, Père, see Wu Li Aesop, Fables engraved in Japan 58 Akira, Kito 150 Aleni, Father 60 Amiot, Father 66, 67 Anchi, Kaigetsudō 201, 211 Annual Letter (1594) of Jesuits 16 Art nouveau 238 Association des Artistes Chinois en France 167 Astruc, Zacharie 198 Attiret, Jean-Denis 66, 67, 68, 69, 70, 72, 110 Aurier, G. Albert 239 Automatism 245

Baldini, Abate, Count 92 Barber, William 253 Barrow, John 87 Batignolles Group 200 Benoist, Father 67 Bibliothèque Nationale, Paris 60, 98 Bing, Samuel 198, 207 Blanche, Jacques Emile 201 Blomhoff family, portrait by Keiga 24, 32 Bonnard, Pierre 224, 239 Book of Odes 69 Borget, Auguste 87 Boucher, François 67 Bracquemond, Felix 197, 198, 200, Braun, Georg 57, 59, 63, 75 Breton, André 241, 243 Bridgestone Gallery, Tōkyō 143 Bry, Theodore de 58 Buddhist art 255-7 Bunchō, Tani 23, 32, 161 Buys, Egbert 22

Canterbury, Chinese vessel unearthed at 13 Canton, foreign trade with 86 Cappeletti, G. V. 117 Cardigan, Lady 96 Castiglione, Giuseppe see Lang Shih-Catherine, Queen of Portugal 15 Cézanne, Paul 261, 262 Chambers, Sir William 110, 111 Chang Dai Chien 181 Chang Jui-t'u 59 Chang Tse-tuan 64, 73, 249-50 Chao Meng-fu 90 Chao Tso 63 Chao Wu-chi, see Zao Wou-ki Chen, Michel see Shen Fu-tsung Ch'en Ch'i-K'uan 191, 194 Ch'en Hung-shou 52, 63 Ch'en T'ing-shih 192, 195 Ch'eng Shih-fa 175, 187 Cheng Ta-yu 59 Cheong Soo-pieng 178, 194 Ch'i Pai-shih 166 Chia-ch'ing, Emperor of China 72 Chiang Shao-shu 48, 61 Chiao Ping-chen 51, 61, 64 Ch'ien-lung, Emperor of China 67, 70-71, 72, 85 Chikurinji Temple, Koji 146 Ch'in K'un 69 China: western painters in 86-87; attitude to West 165; Cultural Revolution 173 Chinese art: first Western imitation 13; Nanga school 22; landscape painting 20, 63-65, 91-92; influence of Jesuits 16, 17, 46, 47, 57, 58, 60-61, 66, 70, 73, 85, 93; portrait painting 65, 68; Europe indifferent to 90; ceramics in Europe 90, 91; illustrators steal from 94; in Italy 95; spreads from Holland and France 95; gardens

aesthetic theory 243 Chinese literature 167 Chinnery, George 80, 87 chinoiserie 12, 97, 98, 113–14

176; calligraphy 176;

109-12; revolution in art 165;

foreign 'isms' attacked 170; influ-

ence of Russian realism 172; and

Cultural Revolution 173; art and

realism 174-8; artisan tradition

178; modern movements 193-6;

abroad

Chou Hsiang 166 Chou Ling 167 Chou Yang 173 Chronology, Far Eastern o Chū Asai 117 Chu Kuang-tsien 177 Chuang Che 193, 194 Chūryō, Morisima 21 Circle Group, Hong Kong 193 Claude Lorrain 111 Collection précieuse et enluminée des fleurs les plus belles et les plus curieuses 99, IOI College of Technology, Tōkyō 117 Cospi, Ferdinando, Marchese 92 Couplet, Father 94, 95, 97 Courtas, Jacques 70 Cubism 244, 258, 266 Cuppa 253

Daniell, Thomas and William 87
Degas, Edgar 203, 215, 219
Denis, Maurice 199, 225, 238, 239,
240, 243
Denzen, Aödö 21, 22, 32
Deshima 14, 24
Desoye, Mme 197-8, 202
Dorra, Henri 222
Dow, Arthur 251
Downing, Toogood 88, 89
Dragon Lake Society (Ryūichi-kai)
119
Dubuffet, Jean 252
Durét, Theodore 198

East India Company 96
Ecke, Gustav 110
Einstein, Albert 248
Elgin, Lord 72
Emosaku, Yamada 14, 18
Encyclopédie chinoise, L' 97
Enlightenment, the 12
Ernst, Max 195

Fa Jo-chen 65
Fan Ch'i 56, 64
Fan K'uan 65, 261, 262
Feilke, Herman 24
Fenollosa, Ernest 118, 119, 120, 121
Fifth Moon Group 193, 194
Fontanesi, Antonio 117, 118
Fraisse, J. A. 100, 102
Francis, Sam 146
Froes, Luis 15

Gabo, Naum 226, 241 Gahō, Hashimoto 106, 118, 120. 121, 137 Gainsborough, Thomas 103 Gauguin, Paul 45, 223-5, 223 Genichirō, Inokumo 150 Genkei, Araki 24 Gennai, Hiraga 20, 21, 24, 27 Gherardini, Giovanni 60, 61, 93 Giffart, Pierre 88, 100 Goering, Hermann 123 Gogh, Vincent van 45, 183, 207, 208, 220, 221, 222, 233, 234 Goldsmith, Oliver 109, 110 Gombrich, E. A. 257 Goncourt, Edmond and Jules de 198, 199 Goshun, Matsumura 23, 24 Gottlieb, Adolph 194 Graves, Morris 232, 253, 254 Grimmelshausen, Hans J. C. von 94 Gruber, Jean 93 Gutai Group 145-6

Halde, J. B. du 99 Hamilton, Charles 111 Handscrolls 246 Hangchow palace 46 Harunobu, Suzuki 21 Higiemondo (the Indian) 82, 94 Hirado 15 Hiromitsu, Nakazawa 139 Hiroshige, Andō 40, 44, 45, 162, 222 Hirschfeld, C. C. 111 Ho Shih-k'uei 71 Hogenberg, Franz 57, 59, 63, 75 Hoare, Henry 111 Hofnagel, Georg 49 Hōgai, Kanō 118, 120 Hokusai, Katsushita 33, 34, 35, 36, 37, 42, 43, 197, 205, 209 Hōryūji monastery 119 Hon Chi-fun 265 Hsia Chou 174 Hsiang Fei 76 Hsiang Sheng-mou 162, 164 Hsieh Ho 243 Hsü Pei-hung 158, 168 Hu Chiao-mu 171-2 Hu Shih 167 Huang Kung-wang 195 Huang Pin-hung 166 Hundred Flowers Movement 172 Hung Hsien 191, 195 Huquier, Jacques-Gabriel 97

Ibn Baţuṭa 46
Iemitsu, Shōgun 14
Ieyasu, Shōgun 14
Imperial Household Museum, Tōkyō
15
Imperial Palace collection, Peking
69
Impressionists 13, 45, 139, 141, 197,
200-207, 258
India 11
Ink paintings 89
'Ink Wang' 245
Inshō, Domotō 135, 146-7, 179
Italy, indifference of to Chinese art
92-93

James II, King of England 96 Japan: expels foreigners (1638) 14; Jesuits established there 14; persecution of Christians 14; Jesuit seminaries 15, 16; trade with the United States opened 115 Japanese art: Namban art 16; effect of rejection of the west 18-19; copperplate engraving 22; artists study western realism 23; prints 41-45, 148, 199; photography 45; twentieth century 123-38; after the Second World War 142; exhi-143; Japanese artists bitions abroad 149; Japanese cult in Paris 197-8; and Impressionists 200; catalyst for cultures of East and West 265 Japanese Creative Print Society 148 Japon artistique, Le 198 japonaiserie 117 japonisme 197 Jehangir, rebellion of (engraving) Jirō, Oyamada 131, 143 Jirō, Yoshihara 135, 145 Jogen, Araki 24 Julien, Stanislaus 114 Julienne, Jean de 97

Kakuzo, Okakura (called Tenshin)
118, 119, 120-21, 123, 124, 199
Kanae, Yamamoto 148, 154
Kanga-Kai society 120
Kandinsky, Vasily 225, 241, 243, 247
K'ang-hsi, Emperor of China 60, 66, 71, 96, 97
Kao Chien-fu 169

Kao Ch'i-feng 160 Kazan, Watanabe 23, 31 Kazuo, Shiraga 145 Keiga, Kawahara 24, 32, 41 Keiichirō, Kune 123 Kenji, Yoshioka 144 Kenjirō, Azumi 150 Kent, William 71, 110 Khanbalik palace, Peking 46 Kiangnan Ting ware 91 Kiangsu-Kiangsi Normal School, Peking 166 Kimura, Leonardo 15, 16 Kinetic art 194 Kinnosuke, Sakurada 45 Kircher, Athanasius 82, 93, 94, 99 Kitawaki, Nobura 129 Kiyochika, Kōbayashi 148 Kiyoshi, Hasegawa 148 Klee, Paul 244, 249 Kneller, Sir Godfrey 95 Kōjin, Kudō 130, 143 Kōkan, Shiba 21, 22, 23, 29, 30 Kōkei, Kōbayashi 125, 137 Kokka (journal) 120 Kollwitz, Kaethe 172 Kōmō Zatsuwa 21 Kōshirō, Onchi 149, 155 Kōtarō, Takamura 108 Kōun, Takamura 107, 122 Ku Yüan 185 Kuan Tao-sheng 90 Kumi, Sugai 150, 156 Kung Hsien 51, 63, 195 Kuniyoshi, Utagawa 38, 44, 149-50 Kuo Hsi 65 Kuo Mo-jo 170 Kuomintang 170, 171 Kyūichi, Takeuchi 122 Kyūjin, Yamamoto 144

Lairesse, Gerard de la 21
Lamqua 80, 88
Lan Ying 64
Lang Shih-ning (Giuseppe Castiglione) 21, 66, 67, 68, 69–70, 71, 77, 78, 86, 163
Le Bas, J. P. 71
Le Blanc de Vernet 199
Leng Mei 65
Leonardo da Vinci 91, 92
Lepanto, battle of (screen) 25
Le Rouge, G. L. 104, 113
Li Ch'eng 195, 249, 250
Li Chih-tsao 60

Li Chin-fa 169 Li Ji-hua 59 Li K'o-jan 178, 188 Li Tzu-yüan 195 Li Yin 64 Liao Hsin-hsüeh 179 Lindschoten, von 94 Lin Feng-mien 167, 171, 172, 178 Liu Hai-su 166, 167 Liu Kuo-sung 179, 181, 194, 195, 265 Liu Shao-ch'i 173 Livre de desseins chinois tirés après des originaux de Perse, des Indes, de la Chine, et du Japon 100 Lo Ming 262 Longobardi, Father 57, 58 Loti, Pierre 199 Louis XIV, King of France 96 Lu Chi 242 Lu Hsün 170 Lü Shou-k'un, see Lui Show Kwan Lu Wei 65, 75 Lui Show Kwan 190, 193-4, 195, 265

Macartney, Lord 87, 113 Manet, Edouard 200-202, 210, 212, Mao Tse-tung 166, 174, 175, 176 Mariette, Abécédario 61 Marigny, Duc de 70 Martinez, Pedro, Bishop 16 Masanobu, Kanō Eitan, see Fenollosa, Ernest Masanobu, Okumaza 33, 41 Masujirō, Omura 122 Matazō, Kayama 134, 144 Matisse, Henri 241 Matsudaira, Lord 18 Matsys, Quentin 15 Mazarin, Jules, Cardinal 95, 97 Mei-shu (journal) 173 Meiji, Hashimoto 133, 143 Meiji Art Society 122, 123 Mi Fu 63 Michaux, Henri 230, 252 Michiaki, Kawakita 115, 149, 264 Mieurs, Jacob de 94 Milton Hall, Northamptonshire 97 Monet, Claude 197, 204, 215, 216 Montagu, Lady Mary Wortley 256 Monte Corvino, Jean de 48 Moore, George 203, 206 Morie, Ogiwara 123 Moromasa 41

Museum of Modern Art, Kamakura 143

Nabis 238-40

Nadal, Father 49, 54, 58, 64 Nagasaki-e 24-25 Nanga ('Southern school of painting') 22 Naotake, Odano 21, 30 National Academy, Hangchow 172 National Museum of Modern Art, Tōkyō 143 National Palace Museum, Taipei 68, New Art Movement 168 New Painters Group 120 New York School 12 Niccolo, Giovanni, see Nicolao, Gio-Nicolao, Giovanni 15, 16, 17, 48 Nihonga 123-4, 137-9, 143 Niva, Jacopo 16, 57 Nobunaga, Shōgun 14, 18, 19 Nobutaka 18 Noguchi, Isamu 150, 151-2, 157, Northrop, F. S. C. 260, 266

O'Keefe, Georgia 251 Okyo, Maruyama 21, 23, 24, 27, 28 op art 147, 194 'Original Way' Group 193 Ortelius, Abraham 17, 57 Osaburō, Nakamura 126, 138

Pa-ta Shan-jen 174, 228, 231, 246, 253 Pacific Western Painting Society 139 Painting Manual of the Mustard Seed Garden 97, 104 P'an Yü-liang 179, 189 P'ang Hsün-ch'in 159, 168 Panzi, Giuseppe 72 Paris, Joseph 72 Passe, C. Van 42 Patinir, Joachim 91, 92 Péon, Ju, see Hsü Pei-hung Pereira, Emanuel 16 Perry, Matthew, Admiral 45, 115 perspective 41-4, 60-1 Pfister, Louis 62 photography 203 Picasso, Pablo 172, 195 P'ing-yang-fu castle, Shansi 46 Piper, F. M. 103, 111-12

Pissarro, Camille 200
Pliny the Elder 13
Poirot, Father de 72
Pollock, Jackson 195, 244, 252
Polo, Marco 46, 90
Pop art 194
Portugal 14
Post-Impressionists 207–238
Pozzo, Andrea 60
Porte Chinoise, La (shop) 197–8, 202

Ragusa, Vincenzo 117, 122 Read, Sir Herbert 169, 176, 247 Reader, The 205 Rembrandt van Rijn 81, 91 Renoir, Auguste 204 Ricci, Matteo 15, 47-48, 57, 58, 59 Ripa, Matteo 66, 71, 79, 110 Rodin, Auguste 123 Rosa, Salvator 113 Rossetti, William Michael 205 Rougemont, Louis de 61 Royen, Willem van 23, 161 Rugendas, Georges Philippe 70 Rusconi, Giovanni 58 Russian art 172 Ryūsei, Kishida 128, 140 Ryūzaburō, Umehara 140, 141, 164

Saburō, Aso 147 Saint Aubin, G. J. 71 Saitō, Kiyoshi 156 Saitō, Yoshihige 195, 250 Sakai chapel, Osaka 15 Sallusti, Jean Damascène 70, 78 Sambiaso, Father 60 San-ts'ai t'u-hui 64 Sandrart, Joachim von 93-94 Sanseki, Takami 31 Sassetta, Stefano di Giovanni 91 screens, painted 95 Seihō, Takeuchi 125, 137 Seiki, Kuroda 126, 138-9 Semedo, Alvarez de 94 Settala, Manfredo 92 Shanghai Art Academy 166 Shang-kuan Chou 65 Shen Fu-tsung (Mikeln Xin) 95 Shen Kua 249-50 Shen Nan-p'in 20 Shen Yüan 65, 69 Shigenobu, Okuma 265 Shigeru, Aoki 127, 139 Shih-t'ao 111, 174, 227, 245 Shinkurō, Kunisawa 117

Shinohara 147 Shinsen, Tokuoka 144-5, 164 Shintarō, Suzuki 139 Shiozuka, Father 15, 16 Shōitsu, Tamura 117 Shūkei, Naganuma 123 Shūzō, Takiguchi 141 Sichelbarth, Ignace 70 Siebold, P. F. von 41 'Simplicissimus', see Grimmelshausen, Hans J. C. von Sirén, Osvald 112 Société des Deux Mondes, Shanghai Société Japonaise du Jing-lar 198 Sōtarō, Yasui 127, 139 Storm Society 170 Su Tung-p'o 243 Surrealism 141-2 Swinburne, Algernon Charles 206 Symbolist art 236, 238-40, 243

Taikan, Yokoyama 130, 142, 147 Taiso, Yoshitoshi 39 Takeo, Yamaguchi 136 Tam, Lawrence 265 T'ang-tai 69 Tapié, Michel 145 Tchelichew, Pavel 195 Temple, Sir William 109 T'eng Ku 169 Teng K'uei 251 Tenshin, see Kakuzo, Okakura Thoms, P. P. 114 T'ien Han 168 Ting Kuan-p'eng 64, 69, 74 Titsingh, Isaac 21, 22 Tobey, Mark 194, 229, 230, 247, 251, 252, 253 Tōgai, Kawakami 116 Tōkyō Academy of Art 120, 121 Tomio, Miki 147, 153 Torajirō, Kojima 139 Toshiaki, Honda 24 Toshinotsu, Onosate 147 Toulouse-Lautrec, Henri de 184, 224, 237, 238 Toyoharu, Utagawa 41, 42 Trigault, Father 48, 57 Ts'ai Yüan-p'ei 167 Tseng Ch'ing 65 Tseng Yu-ho 182, 192, 195, 196 Tsou I-kuei 65, 85, 259 Tsune, Nakamura 139 Tsung Pai-hua 174

Tsung Ping 242, 252 Tung Ch'i-ch'ang 59, 226, 244 Tung-lin Society 59

Ujihirō, Okuma 122 Ukiyo-e art 124, 199, 200 Union of Rising Art 141 United States: trade with Japan 115; influence on post-war Japan 142; response to Oriental art 250 Utamaro, Kitagawa 199

Vallet, Pierre 53, 63 Verbiest, Father 60 Verkade 239 Versailles, palace of 96

Waley, Arthur 59
Walpole, Horace 110
Wan-li, Emperor of China 47, 57
Wang Hui 68
Wang Wei 242
Wang Yüan-ch'i 226, 244
Wathen, James 87
Watteau, Antoine 12, 83, 98, 99
Webber, John 87
Wei Tzu-hsi 186
Wen T'ung 243, 244, 245
Whistler, James Abbott McNeill 45, 197, 205–207, 217, 218, 219
White-haired Girl, The (ballet) 173
White Horse Association 139

Wierix, Jerome 18, 50 Wirgman, Charles 116 woodcuts 148 World, The 100 Worringer, Wilhelm 247, 248, 252 Wu Li (Père Acunha) 61, 62 Wu Pin 55, 63, 64 Wu Tso-j'en 185

Xavier, Francis 14 Xin, Mikeln, see Shen Fu-tsung

Yangchow 64, 65 Yasuo, Kazuki 132, 143 Yeh Hsin 98 Ying Yü-chien 227 Youqua 88 Yüan Chiang 64, 65, 74 Yüan-ming-yüan palace, Peking 66, 67, 69, 70, 71, 75, 87 Yuichi, Inoue 134, 146 Yuichi, Takahashi 105, 106, 116, 117 Yukinaga, Daimyō of Uto 15 Yung-cheng, Emperor of China 67, 68 Yushi, Ishizaki 24

Zao Wou-ki (Chao Wu-chi) 171, 179, 180, 189, 193 Zen Buddhism 253-4 Zola, Emile 198